TURN AROUND
BRIGHT EYES

TURN AROUND BRIGHT EYES

THE RITUALS OF LOVE & KARAOKE

ROB SHEFFIELD

!t
itbooks
AN IMPRINT OF HARPERCOLLINS PUBLISHERS

TURN AROUND BRIGHT EYES. Copyright © 2013 by Rob Sheffield. All rights reserved. Printed in the United States of America. No part of this book may be used or reproduced in any manner whatsoever without written permission except in the case of brief quotations embodied in critical articles and reviews. For information address HarperCollins Publishers, 10 East 53rd Street, New York, NY 10022.

HarperCollins books may be purchased for educational, business, or sales promotional use. For information please email the Special Markets Department at SPsales@harpercollins.com.

FIRST EDITION

Designed by Shannon Plunkett

Library of Congress Cataloging-in-Publication Data is available upon request.

ISBN 978-0-06-220762-3

13 14 15 16 17 OV/RRD 10 9 8 7 6 5 4 3 2 1

For my sisters Ann, Tracey, and Caroline

We make up what we can't hear
Then we sing all night.

Sonic Youth

CONTENTS

TURN AROUND BRIGHT EYES

ONE

8:04 p.m.:

Total Eclipse of the Heart

1

Once upon a time I was falling apart. Now I'm always falling in love.

By "now" I mean Saturday night, in one of the sleazy karaoke bars where I always seem to wind up. It's me and my wife, somewhere in New York City. We're here to sing the night away. It's just after eight, early enough to beat the midnight crowds, too late to talk ourselves out of what lies ahead. We're not going home before we get a few songs in. And we're not getting up on time tomorrow. Sometimes we drag some innocent bystanders along. Tonight it's just us.

Either way, we always come here for a fix of that transcendent experience we can only get from singing. The electric frazzle in the voices, the crackle of the microphones, the smell of sweat, mildew, vodka, and pheromones—the full karaoke experience.

Tonight we are setting out to belt some of our favorite songs. We'll do songs we've never tried before. We'll take on duets we haven't sung together. And we'll do the standards we always have to do. But when you take that karaoke microphone in your hand, you don't know what kind of adventure you're stepping into. So you just have to surrender and let the song take over. You start to sing karaoke, and some kind of psychic heart-switch flips. If you're lucky, and the beer doesn't run out, it's more than just a night of debauchery. It's a spiritual quest.

This spiritual quest, like so many spiritual quests, involves Bonnie Tyler.

2

Welcome to Sing Sing, our beloved karaoke den on Avenue A. Ally and I cherish this spot because it has everything you want in a karaoke place: great songbook, private rooms, surly bartenders, cheap drinks. Every time we head over to Sing Sing, I get that thrill of anticipation as we pad down Avenue A. As soon as I see that red awning over the door, even from a few blocks away, the adrenaline starts to flow. The awning has the classic yin-and-yang symbol of the Tao. Except it's at the center of a microphone.

From the sidewalk outside, Sing Sing looks like any other karaoke bar. There's always a picture of a microphone outside. There's a door guy checking drivers' licenses, probably wishing he could be the door guy somewhere swankier, maybe a club where they have a velvet rope and a strict no-Journey policy. Inside, it's dim fluorescent lights and red walls. The customers perch on their bar stools, just a few notes away from crashing

to the floor. There's usually a bartender. And there are always songs. That's why we're here.

I love the crowd at Sing Sing. It's part of the show. You can always hear rockers and rappers and disco cowgirls and smoothed-out crooners. Despite the early hour, there's already a bachelorette party full of blitzed bridesmaids teetering on their heels, ready to start splashing their Disaronno-and-Sprite on everyone. There are some lurkers in the shadows, too wasted to remember whose birthday they came here to celebrate. Maybe none of us can sing on key, but nobody minds. We're not here to judge, right? Nobody's here because they're a great singer. We came because we want to be stars for a night.

Some places have a stage; other places you sing at the bar or grab a table. One of the reasons we love Sing Sing is they have the private rooms, which is definitely the way we want to go tonight. If you get there soon after 8 p.m., you can usually score one, but by ten, you'll get stuck on the waiting list.

Karaoke has lots of rituals. The first, naturally, is showing up. The second: Ally and I check in at the front desk to get our room. It's eight dollars an hour per person for the room, or two dollars per song if you sit at the bar. But it's cheaper to rent the room, which means you stay later and sing more. You can sign up for a specified time, or you can sing until the bartenders throw you out at closing time. I can already tell tonight is going to be the second kind. But hey—it's Saturday night, so I guess that makes it all right.

The karaoke host leads us down the hall. I get that familiar tingle as we head downstairs, across the black and white tiles,

under the flickering bulbs associated with prison movies or Ministry videos. Sing Sing has a few dozen rooms in the basement—it's a labyrinth down there. Ally and I have sung in every one of those rooms by now. The host turns on the karaoke machine and makes sure the remote control works. The TV screen has the lyrics and the goofy karaoke videos. There's also a buzzer on the wall we can press to order more drinks.

This room was obviously decorated by a color-blind stripper in 1982. It's halfway between "suburban rec room" and "motel meth lab." The couch has been jumped on by so many wasted girls over the years, you know it's indestructible. And the day it gets vacuumed will be the day Buddy Holly shows up to sing "Peggy Sue" for you in person. If you're Catholic, this room might remind you of a confessional. But no, the rooms are never pretty. Why should they be? The owners know why you keep coming back here, and it's not the décor. It's that raw, primal need.

There's never a clock, never a window. It's just like a casino where they want to keep the suckers playing as long as possible. After a few songs, you'll have no idea how long you've been singing, or how much longer you can last. If you've ordered a few rounds, you can use the empties to measure how long you've been there.

Down in the karaoke room, the first order of business is to grab yourself a songbook. They're fat binders, the size of cinder blocks. Some of the books might be soggy from the previous occupants' spilled cocktails. Others might smell funkier than the couch. The pages are laminated, which might have to do with the amount of human bodily fluids that get splattered on them.

But I've flipped through every page of this book with love and reverence. For some of our favorite tunes, we don't even have to look up the number. "Ziggy Stardust," that's 117718. (The version without the video. It's always better without the video.) Those magic numbers are fried onto my brain. I mean, I couldn't tell you my blood pressure right now, but I can tell you my favorite Aaliyah song is 119283.

Ally and I already know our first song tonight. She just takes the remote and punches in 117498. That's "Total Eclipse of the Heart." Everybody has their warm-up song, their go-to jam, the one that gets the blood pumping. This one is ours. For all kara-oke freaks around the nation, "Total Eclipse of the Heart" is one of those sacred anthems. It's the kind of song that announces, "Dearly beloved, we have so totally gathered here today." It's the entrance antiphon of the ceremony.

But for Ally and me, it's the first duet we ever sang, ten years ago, right after we met. Our first karaoke date was a Lower East Side loft party. (Certain friends of mine still remember this as "liquid mescaline night.") The place was thick with clubsters and models and writers, plus a couple of karaoke hosts, Sid and Buddy, dressed up as their favorite dead rock stars. Ally and I made our debut with "Total Eclipse of the Heart." The piano intro began and we took up our mikes. Ally took the hard part, i.e., the half of the song that has several million words crammed in there. Me, I took the easy part. I began to sing the mantra: "Turn around."

It's funny—ten years ago, this song was just another eighties oldie to me. I probably heard it all the time, yet never noticed

it. I figured I already knew it. But I had never sung it with this woman. And after that, it was a whole new song. *Turn around.* So I hear it now and it reminds me of this woman I love. It's just one of the many insane adventures we stumbled into together. *Turn around.* No matter how many times I hear it, the song will always flood me with memories of all the times we've sung it. Next time I hear it, tonight might be one of those memories. *Turn around.*

The song always starts the same way. Those same four piano notes, over and over. But I can already tell this is just the first shot of a marathon epic karaoke quest. I don't care how late we have to stay to get our fix. We will torch one great song after another, until they pull the plug and kill the lights and beg us to go home. *Turn around.*

One long night of karaoke, looping the clock around. And forever's gonna start tonight.

3

My voice has never actually killed anyone. I am positive of that.

But yeah, did I mention I can't sing? I can't. It's bad. I have loved music all my life, and as they say, you always hurt the one you love. So I have spent my whole life trying to sing, while other people try to escape. I have been described variously as a "hard trier," a "good sport," and a "vocal Chernobyl." But oh, it's bad. And hence my karaoke problem. I am hopelessly obsessed with karaoke because it lets me do the one thing I've craved every minute of my life. It lets me sing.

It's not like I haven't tried before. I've always been an obsessive pop fan. I write for *Rolling Stone*, so I blast music all day,

every day, constantly on the prowl for my next favorite song. But I never had the talent to sing or play an instrument. Here's a complete list of my credentials as a singer: A kindhearted music teacher let me sing baritone in the high school chorus. I am fantastic at remembering the lyrics to every song. I rarely gush blood from the mouth. I have both of my lungs. And let me emphasize: My voice has never killed anybody.

But that's it for my credentials. Tacos will grow on Christmas trees before I learn to carry a tune. Fortunately, it doesn't matter. In karaoke, talent means nada; enthusiasm is everything. What I lack in talent, I make up for in passion. Hence my karaoke problem.

If you're someone like me, a fan who loves music but could never hack it as a musician, karaoke changes everything. It unlocks the door to center stage. It's a safe and welcoming place where anyone can join in the music. So even if you never summoned the courage or skill to cross that line from fan to participant, karaoke is something anybody can do. Your only limits are emotional. Indeed, it forces you to keep upping your emotional ante, as you voice your innermost feelings out loud. And that's the weirdest thing about karaoke—sometimes you can feel like you're experiencing some of the most honest, most intimate moments of your life, while butchering a Hall & Oates song at 2 a.m. in a room full of strangers.

That intimacy is what makes it such an addictive vice. With karaoke you're really putting yourself out there. People are going to watch you and stare. But the whole culture around karaoke creates a temporary environment of total acceptance. When we

do karaoke, we sing along with songs we hate. We cheer for the weirdos across the room. We high-five strangers. You dim the lights, crank the volume, and you can get away with anything.

Over the years, I've gotten totally obsessed. Like I said, I have a karaoke problem. But admitting the fact that you have a problem is the first step toward making it an even bigger problem.

4

I got obsessed with karaoke around the time I got obsessed with Ally. It's a fact: Getting obsessed with a girl is a good way of getting obsessed with anything.

For us, karaoke is one of our shared passions, and it's one of the ways we communicate. Ally is an astrophysicist and a glam rocker, so I always keep learning new things about the universe from her. And even after years of marriage, I still find out strange new things about this girl when we sing together. Every time we get our microphone cords tangled up, I get a little more obsessed with her.

I got into karaoke at a time when I felt like my life was a used firecracker. I was only in my early thirties, but I figured it was all too late for me. I was a miserable widower with no idea how to muddle on. The happy chapter of my life was over, and the world had run out of surprises. But it turned out my life was just beginning. I fell in love, I got married, I found a new life and a new home. Karaoke was just one of those surprises. But for me, it turned out to be a way of finding my voice. Something about it opened up doors for me emotionally. For me, it was part of coming back to life.

Right now, here in the basement of Sing Sing, Ally and I are in for the night. We're punching in the numbers and loading up the machine for hours to come. We don't know where the songs will lead us, what kinds of memories or sensations they're going to trigger. But we will clutch the mike and feel the surge. If friends show up to join us here, all the better. That just means more songs. We'll blast each other with requests and duets until they kick us out at 4 a.m. Then it's good-night hugs and cabs. There will be friends dropped off until it's back to just Ally and me. As soon as we get home, we'll fix some toast with cheddar on it, before we fall asleep to dream of rock & roll.

Is this thing on? Good. Because I am. We're here to sing. Every now and then we come together. Every now and then I fall apart.

TWO

8:09 p.m.:

Mama Tried

Yucca Valley, California: the dead of winter, on Route 62, out in the Mojave Desert, under the stars. The parking lot of a barn-size roadhouse called the Joshua Tree Saloon. The sign outside proclaims, "Wednesday Karaoke Night."

We're a couple of strangers in town, but we give it a try. A booth, a pitcher of beer, a plate of fries. It's full of mostly cowboys, bikers, local ladies, nobody under thirty. It's hard to know who's here for the tunes, and who's here just because it's the local watering hole.

The stage has a mirror ball, and a giant clown face overhead: We're talking full-on serial-killer clown face. The karaoke DJ is a friendly young guy who resembles Billy Ray Cyrus back in the "Achy Breaky Heart" days, with muscles, a flowing mullet, a cowboy hat, and a salmon tank top. His DJ rig has a discreet microphone for him, so he can cover the vocals in case the singer freezes or loses her voice. The lady who sings "Whose Bed Have

Your Boots Been Under?" starts giggling hysterically with fear, so he turns her volume down and takes the song himself. You get the sense he's handled this before.

There's a long line of folks waiting to sing, mostly the ladies. They do "Chain of Fools" and "Crazy Ex-Girlfriend" and "Hell on Heels." A silver fox named Smitty whose cowboy hat is older than I am does a lightning-fast country chestnut I've never heard, "The Auctioneer" by Leroy Van Dyke. A fiftyish guy who gives off that preacher vibe does a somber version of "Live Like You're Dyin'." "Good evening, Joshua Tree," he says. "I think it's about time for *you*, time for all of us, to finally learn to live . . . like you're dyin'!" A surly gent named Grant follows that with "Lay Lady Lay."

The song I write on my slip is "Mama Tried," the country classic by Merle Haggard. Great karaoke pick: easy, short, fast, to the point, rousing chorus. But it's also kind of a sacred song, so I'm nervous not to screw it up. You want the regulars to like you, to know you respect their house rules. My slip's been in the pile for a while when the DJ comes over to get my initial, since there's already a Rob here tonight. Another Rob? That makes me sweat a little. So I'm Rob S. now, and Ally's decided she's not going near the stage, since one of the older women just did this mega-hostile Miranda Lambert song about slapping the crap out of sassy young ladies who come sniffing around your man.

The table right in front of the stage is six cowboy hats, six beards, Waylon and Willie and Paycheck songs. These guys are the only hell their mamas ever raised. But the really tough patch of the crowd seems to be the fifty-something mamas, who are out for blood. They brought their own karaoke CDs, which means 1)

they rehearsed all week, 2) they don't trust the DJ to play a version that meets their standards, and 3) he knows enough to take their orders. It's a heavy local scene. You remember in *Dogtown and Z-Boys* when the skater punks talk about their "Locals Only" surf spot? Where if you try to invade the waves, they come up to you right on the beach and hand you the carburetor out of your car? It felt like that.

When the DJ calls Rob S., I feel a sudden pang of I-hope-they-like-me tingles. I picked this song because the saloon reminded me of all those years I lived in Virginia, my Blue Ridge Mountain days. That's where I first heard this song, learned to love it, learned what it meant. It reminds me of friends and family. I spent years learning to speak the language in the South. On the road, no matter where I go, I always seem to slip into this temporary accent I think of as "travel Southern." The accent that says, "I'm a mellow Virginia boy, not one of those uptight out-of-towners. I have a burning desire to get along and be accommodating. I am not hassling you about how long this rental-car transaction is taking, honest. I am absolutely not from Boston."

Up in the spotlight, for some reason, my voice box chooses this moment to lapse into the most nasty-ass Boston accent I've ever heard out of my own mouth, as I tell the crowd, "I'd like to do a song by Mister Merle Haggid."

Great. I may as well sing, "Mama Tried Wicked Haaahd."

It's all granite faces from the cowboys up front now. I can't tell if I'm bombing. You always think you can scope out the vibe of a karaoke crowd from your chair, but you don't know them until you sing. Maybe I'm ruining the song. Maybe I'm get-

ting my ass kicked as soon as I'm done. Then comes the chorus and everything is golden. We all love this song, nobody's here to judge because this is karaoke night, moron, just keep my eyes on Ally, she smiles, reminds me to smile, Mama tried, Mama tried, this is the best, when it's done people will clap or nod politely because that's what people do, and that leaves only me to blame because Mama tried. Wait, it's over already? Already. Good night, everybody.

A few hours later, we're deep in the desert. We have a telescope in the trunk. Ally ordered it from an ad in the back of an astronomy magazine. A Galileoscope, a replica of the one that Galileo himself used to discover the moons of Jupiter. She assembled it back at our cabin. Tonight we park way out in the desert, where the visibility is astounding. By day, you can look around, see for literally miles, and know for a fact you're the only two human beings on earth. At night, the sky is wide open. I've never seen stars like this, glittering in a sky as long as your arm. Ally sets up the telescope on the roof of the car. She finds the four Galilean moons of Jupiter, the ones he discovered in 1609: Io, Europa, Ganymede, Callisto. We take turns on the telescope, shivering in the January wind. Dead silence, just the sand crunching under our feet. She makes sure I can tell the moons apart. So many stars and constellations visible tonight, so many that are new to me. Castor and Pollux, the Gemini. Rigel—I've heard of that one, because it's mentioned in an old song by Game Theory. Bellatrix, the Amazon warrior. The belt of Orion.

Ally bets she can find Lepus, the rabbit constellation, south of Orion. It's a race against time, whether our eyes can acclimate

and pick out these tiny gleams of light before the constellations shift and some of them drop out of view. I've never heard of Lepus before, but I see it now. We stand there with our knees shaking, rewrapping our scarves tighter as the night gets desolately cold. The night is ours, just us and the yucca trees. No audience, no stage, nobody else on earth. No light except the stars, which explode out into many more different lights than I ever could have imagined, gleaming back at us.

Good night, everybody. Please tip your waitress. Sure did talk to you. Sure did see you. If you're driving tonight, please take your car. Good night.

THREE

Sing Your Life

Why do I get so obsessive about karaoke? Two reasons, which I'm pretty sure are the only reasons to get obsessed with anything on God's green earth:

1. Music
2. Girls

What else in life is there to obsess about? There be music, and there be girls. Everything else is paste.

My girl Ally is my karaoke queen, and we have greeted a thousand dawns together with mikes in hand. We will greet many more dawns this way, unless either of us ever comes down with a throat infection or a sense of shame. Music is just one of our shared obsessions. There are many categories of geekdom we share (noisy indie rock, the Smiths, Japanese gangster movies, narwhals) and many categories of geekdom that neither of us has picked up yet (comics, *Star Trek*, interior design). We have

individual geekdoms that we've turned the other one on to and individual geekdoms we prefer to enjoy alone. There are also the geekdoms that inspire us to try to convert each other. We have a lifetime to work on that. She got me into the greatness of Richard Feynman. I have given up trying to get her into the greatness of Bob Dylan. Karaoke is a good one to share.

We have followed this obsession into some strange places. We did "spa-raoke" in Chinatown, at a spot where you can get a pedicure and sing at the same time. Ally busted out the Morrissey jams while she got her nails done. When she was out of town, I took the laptop to the bar for a round of Skype-aoke. We've sung across the country, from the Korean barbecue joints of Rhode Island to the tumbleweed taverns of the Nevada desert. A seniors' retirement community in Fort Myers, Florida. The heart of New York City. We have followed our microphone lust all over this land. And everywhere we ramble, we find some place to pop in for a song or two, because that's just how karaoke fiends roll.

It's a lot more fun with two of us. Before I met her, I was working hard on learning how to open up and sing my life. But singing *our* life is better.

Ally is an astronomer who loves music as much as I do, so she can help me comprehend the music we share in terms of the entire universe. She makes all this music I thought I knew sound different. She can explain that when Radiohead sings the line "Gravity always wins," in the song "Fake Plastic Trees," they are not correct, because gravity is just one of four cosmic forces: gravity, electromagnetism, the strong nuclear force, and

the weak nuclear force. Gravity *sometimes* wins, like when black holes form or galaxies collide. Sometimes the other forces trump gravity, like inside the neutron, where the strong nuclear force prevails.

As soon as I met Ally, I could tell her gravity was going to win. Her nuclear force was something I couldn't resist. I was drawn into her gravitational pull, and that drew me into my entire future.

Ally got thrown out of Sing Sing with her friend years ago, after they did a dance routine to the Monkees' "(I'm Not Your) Stepping Stone," hopping from stool to stool. The Monkees would have approved, but the security guys did not. Awesomely, right afterward Sing Sing put up posters in the hallways warning DO NOT STEP ON THE FURNITURE, with little cartoon drawings of these women's heads. They haven't tried to throw Ally out since then, even though she *always* dances on chairs during Monkees songs. Dancing girls win, furniture loses: way of the world. Sing Sing gave up the fight. It's one of the many reasons we love this place.

Morrissey sums it all up in "Sing Your Life." If it seems scary to open up and step to the microphone, that's because it *should* be scary. These are emotionally dangerous adventures to go on. Singing what's in your heart? Naming the things you love and loathe? You can get hurt that way. Hell, you *will* get hurt that way. But you'll get hurt trying to hide away in all that silence and leave your life unsung. There's no future without tears. Are you really setting your hopes on not getting hurt *at all*? You think that's an option? You clearly aren't listening to enough Morrissey songs.

So I have to sing what is in my heart. In other words, music and girls.

I WOULD LOVE TO CLAIM that all these years of karaoke helped me discover my buried talent as a singer. Hey, I found a way to unleash the inner beauty of my voice. The ugly duckling of my tonsils turned into the swan of my esophagus. I opened my mouth one morning and fluffy pillows of sound came out. I'd like to thank the Academy.

This is not that kind of story.

Listen to my "turn around's." There are three notes in the words "turn around" and I am blowing five of them. There are also three notes in the words "sing your life" and I don't even want to tally up the damages. It doesn't matter. This is my voice. They say you have to invest ten thousand hours into something to achieve greatness. I have put in my ten thousand hours of singing badly, so I guess by now I might even be a virtuoso at singing badly. Maybe that should bother me. It doesn't. This is what they call "hitting rock bottom," and they call it that because it rocks.

What I get out of karaoke is a little weirder than mere musical competence. It's a love ritual that keeps me coming back, craving more, because this is where the songs are. And the songs are full of stories. Every one we sing is charged up with memories of the past or dreams of the future. Every song reminds me of good times or bad times. Yet they all hold surprises.

When you sign up for a whole night of this, you can't really predict how the music is going to feel. You begin to sing a song expecting to get one story out of it, then you get another. You pay

for this but they give you that. Every tune tells me a different tale. Every song I sing makes me feel what it's like to be a son, a brother, a lover, a husband, a fan. There are famous singers I have spent my whole life pondering, but after I pick up the mike to try their songs, I'm more fascinated by them than ever. Some of these singers are legends, yet when I slip into their songs, I feel like they're helping me figure out some of my own basic questions. Some of these singers mean the world to me; others are just vessels for the song. One is Billy Idol. But their voices are burned into my soul.

Some of the memories I'm not so crazy about, especially the ones that involve beginnings and endings. I'm more of a "middles" guy. But I know it took some of these painful beginnings to launch me into the middle where I am right now. In a radiant, ever-expanding universe with this particular girl in it. Just us and the songs we like. Loads of those.

I have a photo of me singing karaoke, from my birthday last winter. Of course, it's a private room at Sing Sing. As the TV monitor shows, the birthday boy is singing TLC's classic slow jam, "Red Light Special." That means it's still early in the night. I am wearing a tiara and carrying a bouquet of roses. My sash says Sweet Sixteen. In all candor, this birthday bitch is not a pretty sight, not to mention nowhere near sixteen. I look like a holy mess and I know I must sound that way. Yet I can see how blissed out I am in this picture. I am enraptured in the song. I am powered by the red-light special. I am a singer, damn it.

I look at this picture, and I know for a fact I look ridiculous when I sing. But I look closer, and I see there is no shame in my eyes. No fear. No trouble at all. I wonder why.

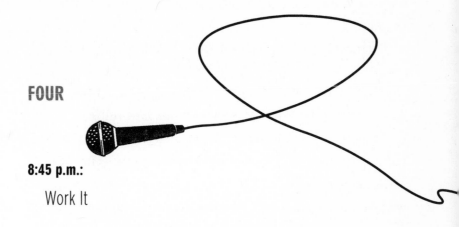

FOUR

8:45 p.m.:
Work It

I live in Greenpoint, Brooklyn, which is loud and crowded and frantic and my favorite place ever. It's full of punk rockers, Polish immigrants, feral cats, three-deckers with saint statues, fliers for cat reiki, and bars that offer "Morrissey speed-dating" nights. Music is everywhere, whether it's the Eurodisco thumping in the nightclubs or just the old dude who dances on Manhattan Avenue outside Bakery Rzeszowska, with his radio blasting doo-wop oldies from the fifties.

I moved here in the summer of 2002. I got a creaky, narrow, dusty railroad apartment on the second floor over a diner, with the sweet smell of kielbasa in the air. I took the sad-to-look-at pictures out of their boxes and put them up on the wall because I needed to do a little more crying over them and I was building a safe place to get some of that done. I'd been living in downtown Manhattan for a couple of years and I was sick of that scene. My new favorite song was Missy Elliott's "Work It," the kind of song

you need in your corner to pump you up when you're trying to put your thing down, flip it, and reverse it. I certainly had a lot of working it to do.

My landlady tried to teach me a few Polish phrases to get by— "excuse me," "thank you," "please do not punch me in the face." She did her best but I couldn't hack the accent. I could spend hours looking out the back window: the yard full of wild kitties, trees buzzing with birds, the laundry hanging on the lines, the auto shop on McGuinness Boulevard with the yellow Chevy Nova parked on the roof. It was a quiet place to stay up and write all night, drinking coffee until the cheerful traffic started to rumble around dawn. That's when the birds started, too. (I had forgotten all about birds. I guess birds and I had some catching up to do.)

I thought Eckford Street would be my spot for a Bowie-in-Berlin year of isolation and rejuvenation, but it turned out to be something more mundane, a home. I walk around my block and see the Japanese pizza guy, the Yemeni deli guy who sells me coffee and tries to teach me to pronounce *mocha* correctly, the skater kids blasting Polish hip-hop. A few of us were born here, but most of us had to travel a while. This is a neighborhood people come to with a dream, whether that's getting a job or writing the world's greatest song or raising a kid who has a favorite Gun Club record. My big dream? I came here hoping to hit the ground running, though I would settle for just hitting the ground.

This has been my home for ten years, four thousand nights, hundreds of rock shows, two of Britney's weddings. There is always some crazy shit going on here. If I wanted a two-foot-tall

bottle of Polish vodka shaped like a statue of the late Pope John Paul II wearing his miter and carrying a shepherd's staff, with a lamb at his feet, I wouldn't even have to leave my fucking block.

The Saturday I moved in, I stumbled sun-dazed up Driggs and down Wythe and back up Humboldt and bought a dictionary at the used-book store that is now a cheese shop and ran into some rocker kids on the sidewalk selling homemade lapel pins for a quarter each. I bought one that had Paul McCartney's face (I react to auguries of Paul McCartney's face the way Greek warriors in *The Iliad* respond to the sight of a heron—it is a propitious omen from the gods) and stuck it on my sweater. I wore the sweater all day even though the sun was out and played my Walkman and told myself, *Okay, maybe now is when you should start breathing,* and for once I got the *now* part right.

There is a girl here, too. She's my favorite thing about this neighborhood. But she wasn't here yet, and once upon a time, I wasn't, either.

WHEN I MOVED TO NEW York in 2000, I was in fragile condition. I was only thirty-four but I felt old and tired. At an age where many of my friends felt their lives were just beginning, I felt mine was over. I was married early in my twenties, and then my wife died suddenly when we were both thirty-one. I was a man who had found love at a young age, and I thought I had the perfect life. I was a rock critic who got to spend every waking moment listening to the music I loved, living with another writer who shared all this music and joy with me. We felt right at home in Charlottesville, Virginia, surrounded by friends and music. It all

changed so abruptly, when she died of a pulmonary embolism, in May 1997. Without her, everything was different. Three years later I still wasn't handling grief well, or at all, and I needed to make some changes. So I left Charlottesville, where I'd lived for more than a decade, just because it was so laden with memories. I wanted to try a fresh start in another town.

I left Charlottesville, the place I thought would be my home forever, and went out looking for another one. I went to New York to start over again. Most of my friends lived there, and *Rolling Stone*, the magazine I wrote for, was there as well. I pictured myself looking out at the city lights, while the sax solo from "Walk on the Wild Side" played in the distance. I was afraid of getting trapped in the past, turning my life into a shrine to the good things that used to be alive in me. I knew the future would be a challenge, as well as an adventure, and I knew it would be difficult. But I couldn't keep hiding forever. I needed to make changes and I needed a safe place to make them.

So I moved to lower Manhattan, into one of those creepy, griefy, deathy, white high-rise apartments that people in their early thirties move into when they've decided to give up on life for a while. Big windows. Shiny wooden floors. High ceilings. A lobby downstairs. No dust, no mold, no bugs, no noise from next door or upstairs or downstairs or *anywhere*. The kind of white room where astronauts go to die at the end of Stanley Kubrick movies.

I lived downtown on John Street, right under the World Trade Center. My new neighborhood was not yet known as "ground zero." It was merely the "financial district," a place where nobody

really lived, or even set foot except for jury duty, which meant in terms of real estate it was euphemistically described as "up and coming." The streets reeked of dashed hopes and emptied bladders, with no view of the sky and barely any oxygen in the air.

It was a bleak little neighborhood, even at the time. Getting blown up by terrorists did not sweeten its personality, believe me. Every now and then, maybe a couple of times a year, I pass through the financial district and marvel that it somehow keeps getting more depressing. They closed the Strand Bookstore Annex? Now it's a Lot-Less Closeouts? I give up, financial district— how *could* you get any worse? Wait—the Dunkin' Donuts is gone? Congratulations, financial district! You *did* it! And I'm so proud. Who's a grim little hellhole? Who is? That's right—*you* are!

Now I guess I know why my grandfather never wanted to go back and visit Ireland after he got out. When you chew your way out of a steel trap, you don't return for a receipt.

The problem with moving is that you tend to take yourself with you, so when you get there and you're still unhappy, you know the problem is you. To my surprise, I found that my new life in Apartment 7Q had most of the same issues as my old life. Now I lived on the seventh floor, where the view out the window was the office building across the street. I kept the blinds closed, or open—it didn't matter. I had to turn on the Weather Channel to see if the sun was out. For the one and only time in my adult life, I got into housekeeping, and kept the apartment squeaky clean. ("Spotless," in the words of a friend who visited, and she knew me too well to mean it as a compliment.) No dust bunnies here. I finally took off my wedding ring and kept it off. I didn't

put any pictures of my dead wife up on the fridge, because it hurt too much to see her face. I packed up the photos, the journals, the letters, the tapes, barricaded it all in the closet. I boxed up my past—and I had a lot of past.

By day, the streets were packed with pedestrians, competing for each step on the tiny sidewalks; a walk around the block was like waiting in line at the post office, except getting hit with bikes now and then.

I got obsessive about work, which became my drug of choice. When I didn't have any magazine work to do, that's when my mind would wander and I'd get sad. Most nights I sat on the couch, listening to records I bought on eBay while watching TV with the sound down. Like eBay, TiVo had just been invented, and I had plenty of *Designing Women* reruns to catch up on. My kitchen had a dishwasher, but since I had nobody to cook for and no appetite myself, I mainly used the dishwasher as background noise to try to lull myself to sleep at night.

Some nights I would go sit beneath the World Trade Center, a couple of blocks down John Street. A very strange skyscraper to have for a neighbor—even though it was the most visible landmark in the city, nobody ever came to look at it. There were never any tourists around; the entire neighborhood was *Omega Man* empty on nights and weekends. After dark I could sit with my Walkman for hours by the WTC, where I knew I wouldn't see a soul. I'd perch on the stone plaza next to the water fountain and look up at the lights. You could see the twin glass towers shiver whenever the wind rustled. Sometimes the towers reminded me of the old *Sesame Street* song about the lowercase *n* that stands on

a hill, weeping because it's all alone, until a rocket ship lands and brings another lowercase *n* to keep it company.

A lowercase n. *Standing on the hill. The wind is very still. For the lowercase* n.

The towers weren't so ugly, really. For obvious reasons, of course, nobody talks about the World Trade Center being ugly anymore, not the way they used to. By 2000, the towers were a quarter-century old and nobody resented them anymore, yet they weren't sentimental icons like the Empire State Building or the Chrysler Building. They were just tall and silent and luminous and cold, and it's strange for me now to think of how many hours I sat beneath them, watching the glass lights blink on and off, semi-mesmerized by the sparkling surface, but not really feeling very much at all. *The wind is very still, for the lowercase* n.

America had an election that fall, more or less. On election night, I watched as George W. Bush began his acceptance speech. Desperate for a laugh, I switched to Comedy Central. As it happened, they were showing a *Saturday Night Live* rerun from 1993, the Charles Barkley episode with Nirvana as the musical guest. So I flipped right from the meltdown of the democratic system to Kurt Cobain singing "Heart-Shaped Box." I turned it off and stared blankly at the wall for a few hours. It seemed obscene to think the nineties had ever happened. As for the election results, nobody ever found out, because a few weeks later, on December 12, the Supreme Court blocked the state of Florida from counting its ballots and appointed a new commander in chief. That isn't supposed to happen, is it? In America? It happened.

After 12/12, the bad news just kept coming. I flew down to Washington, D.C., to cover the inauguration for *Rolling Stone*, which remains hands down the most miserable assignment of my career, and I say that as someone who saw Limp Bizkit live. I shivered in the rain by the Lincoln Memorial, as Wayne Newton sang Neil Diamond's "America" and Ricky Martin asked, "Mr. President, may I have this dance?" There was a "Salute to America's Youth" concert, where I sat through speeches from Colin Powell and the little kid from *Jerry Maguire*. Jessica Simpson stomped around the stage and changed the words of her songs so they were about George Bush. Destiny's Child performed, too. Beyoncé kept trying to rally the crowd with the chant, "When I say George, you say Bush! George! Bush! George! Bush!" The new president came out at the end to say, "Thanks to all the entertainers. Pretty darn good entertainers, aren't they?"

A couple of months later, in March 2001, the stock market crashed. Magazines started going out of business like going out of business was going out of style. The nineties boom was over. I was backstage at *Saturday Night Live* with Aerosmith, whom I was following around for a cover story; we watched from the greenroom as Tina Fey did Weekend Update. "And in the stock market this week . . ." She pulled a flask from her blazer and took a drink, bursting into tears. "Whyyyy? Why, Lord, oh whyyyy?" We all laughed. Then Aerosmith went out and did "Big Ten Inch Record." What else was there to do?

Everywhere I went in New York, people went out of their way to be kind and generous to me. This city had more kind people per square foot than any place I'd ever seen. The guy at my lo-

cal coffee shop always called me "Please," because he approved of my manners. *"Please* is a good word," he told me. "You're not from around here, are you?" I went to a record store in the West Village, Rockit Scientist, and bought a Television live bootleg from 1978. The dude didn't charge me because the record was scratched. I took it home and played it all night, and of course it played fine, so I went back the next day to pay for it. "Keep it as your 'Welcome to New York' present," the guy told me. "You're new in town, right?"

People always meant "you're new here" as praise. They were obviously seeing something human on my surface that made them want to do me favors or give me a break, but it was obviously the trace of that girl who had loved me, molded me, shaped me into whatever I was, the girl who had died. I felt like a fraud traveling under those pretenses. I didn't want to talk about death, so I tried to avoid the topic of being a widower and dodged the subject of my past. I got so anxious about it coming up that being around people made my head rattle.

That Jim Morrison song gets it all wrong. People *are* strange when you're a stranger, but it's not because they ignore you—it's when they notice you and smile, that's when you realize you're alone out here. Their kindness is what makes you notice how weak you are. That's when you know it's not the city's fault, it's yours. These people are in the same strange town, but they're not letting the strangeness eat them up and turn them into robots. That's just you.

In my twenties, I had counted on my wife to make friends for me. She was vivacious and chatty and extroverted; she did the

people-finding for both of us and pimped me out for my social life. Now I had to learn on my own, without her to guide me. The powers that be left me here to do the pimping. Connecting to other people was yet another job I didn't know how to do for myself, tied up with all the decisions I'd always counted on her to make.

I spent so many hours listening to music under the twin towers, but I didn't take much of that music with me when I left and moved out to Greenpoint. The songs I listened to there were mostly ruined for me, because a chill got into them. At least I did myself a huge favor by not liking the new Radiohead album, *Kid A*, because when I started playing it a few years later, it wasn't tainted by association. One song struck me as especially bad at the time—"Idioteque," with those gauche clunky beats straining for significance. I agreed with the negative review in the British music mag *Select*, which singled out "Idioteque" for ridicule: "What do they want for sounding like the Aphex Twin circa 1993, a medal?"

I love that song now. Sometimes I wonder if I would have gotten anything out of it—the high melancholy voice, the awkward beats, the way Thom Yorke yelps "This is really happening"—if I'd tried singing it with my own voice. Maybe that would have helped me hear what they were trying to say. Maybe that would have even helped me hear myself in that song. But I doubt it. I wasn't really happening.

I was convinced the rest of my life would be a bitter dwindle. I did nothing to suggest I deserved any better. I'd been a depressed teen, but this was different because I was old enough to know

better, an adult who had loved and been loved. I was old enough to know what I wanted and to know I wasn't making things any better for myself. Every day in New York I kept having moments of good luck, but assembling those moments into a new life was my job. All I needed was to go ahead and work it.

FIVE

8:54 p.m.:

Livin' Thing

When I had to live by myself, I found out that I could do it. I was surprised, and in a way disappointed, that I was up to the challenge. Living alone wouldn't ever be my first choice, but I learned to hack it. For me, it entailed a lot of late nights eating microwave soy burgers and watching Lifetime movies. I honestly hope I will never have to live alone again. Because at this point, I have seen all the Lifetime movies that have ever existed and eaten my way through 80 percent of the world's microwave soy burger supply.

The main difference between the burgers and the movies? Sometimes you take the first bite of a burger and you don't know how it's going to end.

One of the things I love about Lifetime movies is that these ladies like slow transitions. The heroines of these movies find life as daunting and complicated as I do, and when they get into a mess, they react the way I tend to react, by not reacting at all.

They are resistant to change, to say the least. When the heroine finds out her sorority sister is a machete-wielding killer, as well as the mother of her ex-husband's stepdaughter's guidance counselor's baby, she inevitably says something like "I feel like this might affect our friendship."

You know *Poison Ivy 3: The New Seduction*? Oh, stop lying, for once in your life: Yes, you do. Well. In the classic *Poison Ivy 3: The New Seduction*, the mild-mannered racquetball champion invites her new best friend, Jaime Pressly, to move into the family mansion, never suspecting Jaime has a few dark secrets. If you've ever watched any Lifetime movies, you can guess how that friendship turns out.

Racquetball Girl eventually discovers that Jaime has:

1. seduced her father
2. murdered her father
3. murdered her boyfriend by injecting him with a fatal cocaine overdose
4. after blowing him in the pool
5. seduced her racquetball partner
6. murdered the housekeeper
7. ruined her performance in the championship racquetball match by spiking her Gatorade with rum, and most heinously of all,
8. worn her mother's earrings without permission

So how does she respond to this discovery? She says, and I quote, "Maybe you should start looking around for another place to stay."

That's why I relate. Assertiveness can be a challenge for the doggedly lame ladies of Lifetime. They shy away from conflict. They avoid confrontation. They suck at moving on.

The point is, sometimes we plucky little Lifetime heroines need a shove to embark upon difficult transitions. We need backstabbing, bloodletting vixens, or their philosophical equivalents, to force us to move. We need a strong personality, or a cataclysmic force, kind of like Jennie Garth in *An Unfinished Affair*. You've seen that one too—Jennie Garth has an affair with her art professor, Tim Matheson, but the cad goes back to his wife, so Jennie Garth comes up with an elaborate plan to destroy his life. She proceeds to seduce his son, make best friends with his wife, and join the family around the fireplace for a cozy game of Scrabble. While Tim squirms, Jennie spells out her word: "INVIOLATE." Hey—fifty-two points!

I watched a lot of Lifetime movies when I lived alone, because I was inevitably up all night, gnarled on the couch in a ragged old pair of Priority Records promotional sweatpants I'd gotten in the mail once to celebrate a Snoop Dogg record. Even if I could have gone to sleep, I didn't see anything I wanted there or any place I belonged. There was nothing in my dreams, just some ugly memories. So I killed those nights staring at the ceiling, waiting for a sleepy feeling that usually didn't say hello till dawn, bad blood pounding in my temples with nowhere to go except down my backbone and back up to my scalp. Sometimes that noise in my head seemed so loud it was echoing off the walls.

I could stay in bed and sweat it out, or I could move to the couch. It's usually a good idea to get up and find a distraction,

something to drown out that noise and change the colors in your brain. Sometimes music works, but sometimes certain songs bring back the same painful memories that got you to this sorry state, so TV is often a safer bet. So what's on at 2 a.m., 4 a.m., 6 a.m.? There's always something on Lifetime, and it's always a movie with a title like *Shattered Trust* or *A Daughter's Lies* or *It Was Him or Us IV: The Slapping*.

When one of those movies ended, another would begin. Lifetime ladies, they were my people, keeping me company as if we were cycle sisters via the airwaves. These gals took the same pitifully cautious approach to their pitifully cautious tomorrows as I did. When the future looks bad, they stick to the script and hope the future will go away. They're always surprised when it doesn't. They ignore all their looming disasters for the better part of two hours—if they noticed danger faster, there wouldn't be a movie, now would there? The killer sorority sister has to start chasing them down the hall waving the machete before they blink and realize, "Oh wait, this is an *and suddenly*, isn't it?"

I am not an *and suddenly* person. I am a *gradually, reluctantly, and begrudgingly* person. I look before I leap, count to ten before I pop off, all that stuff. I don't act on my first instinct, because my first instinct is usually idiotic, so I like to think things over for as long as possible. I distrust flashes of light or moments of clarity. Stealth is my jam and guile is my butter.

How much of this comes from being Catholic? A lot, I suspect. We do not give a lot of extra points to dramatic conversion narratives. The mentality has more to do with the plodding offer-it-up everyday grind, where every day has its saints and every trivial

annoyance is a spiritual exercise, giving you the chance to get a few degrees incrementally holier. (When you're a Catholic kid, the nuns teach you that when something is annoying you, you "offer it up," as a sacrificial gift, which admittedly is far from terrible advice to high-strung children, even if it's just an attempt to shut up a rowdy CCD class.) It's always funny to hear a Catholic congregation sing "Amazing Grace"— nothing could be less emotionally Catholic than "I once was lost but now am found / Was blind but now I see." I was raised with this sort of implicit idea that there's something showy about religious experiences that depend on emotional climaxes. I distrust grace when it's amazing. I like my grace to be drab and ordinary and manageable. And I prefer the universe to be methodical and tedious, making its moves one at a time, with change as something I can see coming in the distance, a slow train round the bend.

In my everyday life, I've always been prudent and careful. Talking myself out of half-baked impulses is a specialty. I like to feed myself soothing reminders like "better safe than sorry" or "haste makes waste" or "the reward for patience is patience" or "a no you regret is better than a yes you regret."

There are upsides to being wired this way: I rarely punch cops, I never kick a hole in my furniture, I am more than capable of chuckling at provocations without taking them personally. So there are upsides. But the downside means sometimes you can let entire months of your life ooze by without eating anything except microwave soy burgers or making human connections or realizing that you are ignoring a few of the *and suddenly*s lurking under your couch. You are becoming inviolate, which is a sad fate for anyone.

So what turned out to be my Jennie Garth? What was the vixen that chased me off the couch and out into the world? What forced me to say "yikes, this is what *and suddenly* looks like" and run for my life? Karaoke.

The first time I sang karaoke, what startled me most was that it turned me into the sleaziest villainess you could ever encounter in any Lifetime movie. It brought out my pushy, slutty, noisy side like nobody's business. Where does all my good sense go when I sing? Out the window, that's where. And karaoke rooms don't even *have* windows. The sensible shoes I wear when I'm walking the line in my mind, they turn into stilettos, kicking holes in the walls I've gone to so much trouble building. Within a few songs, I go from being the Lifetime heroine to the Lifetime psycho. I might start out like Josie Bissett in *Deadly Vows*, or Nicolette Sheridan in *The People Next Door*, or even Hilary Swank in *Dying to Belong*. But hand me the microphone and I turn into Rose McGowan in *Devil in the Flesh*.

The first time I made that leap, it was a Tuesday night in the East Village. I was dining with my friends Nils and Jennie at a fancy restaurant, Craft. I wish I remember what I ate, because people always talk about that place, but I have to admit I can't recall a single thing I ate during the meal, not a single condiment or garnish, yet I remember every Natalie Imbruglia song I sang later that night. (Two of them! Two different Natalie Imbruglia songs! Yes, "Torn" and *another* one! Her second hit, "Wishing I Was There." Google it, bitches!) Hey, we all have our different relationship to different sensual pleasures, and as much as I enjoyed the dinner, what jumps out of my memory is that we ended

up going for karaoke afterward, when someone observed that we were merely a block from a (now-defunct) Japanese karaoke bar.

This place was swanky but no fun—the martinet karaoke drill-master was just not giving our table any love. We waited for more than an hour for one of us to get a turn, but no matter how many pricey cocktails we ordered, there was no "Piña Colada Song" for us. The tingle of our turn coming up (our song! maybe next!) turned to rancid adrenaline in our stomach. Different karaoke jocks have different ideas about crowd control, but this house style was apparently to make one table sing for twenty minutes at a time, then exhaust another table, instead of bouncing around. It was fun watching the table in the corner do "Good Morning Starshine" and "She's Not There," but we didn't even get thrown a piña-colada-flavored bone.

Nils had obviously set his mind on karaoke satisfaction, because he rose to his feet abruptly and announced, "We are *leaving*." He whisked us off to a place in Koreatown where we could get a private room, and we stayed until ten the next morning, rampaging through the songbook. There were mirrors all over the walls, a white shag carpet, brass candelabras, two vinyl couches, and a big glass table, giving off a *Boogie Nights* ambience of shabby indulgence, except the only drug was music—I had never sung so hard for so long in my life and all I could think the next morning, as we dragged ourselves down Sixth Avenue to our respective subway stops, doing the walk of Commodores-induced shame, was that I wanted more.

The next afternoon, I woke up and retraced all those steps in my head, writing down the title of every song I could remember

singing. Some of these were songs I'd sung to the bathroom mirror for years; others were songs I had just fantasized about singing. I sang David Bowie's "Young Americans." (Not so hard, if you remember most of the words.) I sang Cameo's "Word Up." (I was sucking wind by the chorus.) I sang "You Are So Beautiful," which is easy since it has six words and lots of breathing room in between. I sang Neil Diamond, which felt like home—this, *this*, was the voice I was born to sing with. This was me, or at least some song-sung-blew version of me.

I had tackled "Torn." I had gotten tackled by the *St. Elmo's Fire* theme. And I had tonsil-humped the shit out of Electric Light Orchestra's "Livin' Thing," reaching into my voice box for some strange magic that would take me higher and higher, baby. "I'm taking a diiiive!" I had yelled, to the canned cellos on the backing track, with two of my friends clapping in time on the couch. "I am taking a *diiiive*! Because I can't stop the *sliiide*!" Yes, truly, I had sung myself some "Livin' Thing." And every song I remembered singing just reminded me of a dozen others I wanted to sing *right now*.

It had been a long night. It had been a crazy night. When could I do it again? Where was I going to look for it? Who was going to stop me? Where are all the people singing, and how can I get there? This night has opened my eyes, and I will never sleep again.

One night of song had kicked open a few doors for me emotionally—I could tell that already—clueless as I felt about what was hiding on the other side. It was one of those *and suddenly*s that shove you into the final ten minutes of the Lifetime movie, the part where the heroine makes a bold move to escape out the passenger-side window or hit back with the shoe. It wasn't the

end of a story, just a twist, one of the transitions I dread in advance and resent after they arrive. Except this time there was no resentment whatsoever. Only anticipation.

This was my first time, and other times soon followed. Once I got a taste of what karaoke was, I wanted more, and I began looking into places where this sort of thing happened. Staying out late reminded me how much I loved staying out late. There were still a lot of movies on TV; I just wasn't home watching them as often. Obviously, singing Natalie Imbruglia songs wasn't any kind of cure for the blues. It was just a sign of life. Whatever lay outside my room, it was time to go looking for it. I'd kept myself locked up too long.

I felt like Keri Russell in *The Babysitter's Seduction*, the one where she's a high school diving champion who gives up her athletic career to have an affair with the dad from *My So-Called Life*, except she doesn't realize until the last ten minutes that he's not just a regular Lifetime dad-skank, he's a *psycho killer bastard maniac* and he is in fact *chasing her through the house with a knife* and *like, right now* so she runs up to the roof where she blinks and gets an *and suddenly* where she remembers that *she knows how to dive*. So she dives. Off the roof, into the swimming pool, out of danger. She always knew how to dive—it just took a while for her to remember.

Once I remembered how to stay out late, I did it every chance I could. I guess I never forgot how to stay out late; I just hadn't noticed I needed to. There are things we know how to do when we're on a roof. There are times when we have to remember what they are. If we get lucky, something reminds us to move.

SIX

8:59 p.m.:

Livin' on a Prayer

Let's get a couple things out of the way right now. One of these things is called "Livin' on a Prayer," and the other is "Don't Stop Believin'."

These are easily the two most popular karaoke songs. Indeed, as far as many of my fellow revelers are concerned, they seem to be the *only* two karaoke songs. Once, spending a night at Sing Sing with my friend Dave, who works as a wedding videographer, he got stressed by all the believin' and livin' we heard through the walls. "These same two songs all night," he said, shaking his head. "This is like being at work."

But that's because these two songs express the karaoke worldview at its most extreme. The idea of a lost and lonely solitary voice, fading into a massive communal chorus, lifted up by all these other streetlight people. We're all just strangers wandering through the night, with nothing except the song to bring us together. But we've got each other, and that's a lot.

Bon Jovi really nailed this karaoke ethos in their video for "Livin' on a Prayer"—the first verse is the band in rehearsal, and the film is in black-and-white. Then, just in time for the second chorus, the audience arrives, and *boom*—it goes from black-and-white to color. That's the essence of Bon Jovi right there, and it's also the essence of karaoke. Any of us can sing by ourselves any time we want to, alone in our rooms. We go to karaoke for something more. It's the crowd that brings the color.

Going out to sing means you have to adopt a staunch pro-believin' stance. But it also means you have to suspend your rational doubts. "Don't Stop Believin'" isn't about actually believing in anything, just as nobody in "Livin' on a Prayer" prays for anything in particular. The belief is in belief itself; the prayer is just for more prayers; the song is just an excuse for people to make noise. Samuel Beckett could have invented karaoke for one of his existential dramas, except if he had done so, *Waiting for Godot* would have ended with Didi and Gogo linking arms to sing "You Give Love a Bad Name."

It makes all the sense in the world that in the 2000s, Journey became the first band ever to hire their new lead singer after hearing him do Journey karaoke. The guitarist Neal Schon went on YouTube, looking for people singing his songs, and found one from the Philippines who did a perfect Steve Perry imitation. Does anybody care who is officially singing "Don't Stop Believin'" or "Livin' on a Prayer"? The singer can't own them. The whole point of them is that they're *our* songs.

It also makes sense that the karaoke state of mind is so perfectly encapsulated in these twin apostrophe-abusin' anthems

from the eighties, pop's most extroverted and bombastic dec-
ade. That's when songs got big, cheesy, overstated, with long
fade-outs and shamelessly contrived group sing-alongs. In other
words, songs perfect for a room full of hoarse, rowdy strangers
who can scream "Whoa-ho!" on cue. It seems so strange, in ret-
rospect, that karaoke didn't factor into how Americans heard
music back then. We didn't even know it was coming. But the
karaoke train was on its way—a midnight train, going anywhere.

A brief timeline of the dawn of karaoke:

1981: Journey release the album *Escape*. I buy the tape as a
Christmas present for my sister Tracey, at the Straw-
berries record store in Boston's Downtown Crossing.
Then I walk a couple of blocks to the underground head
shop Stairway to Heaven and purchase two spiffy new
buttons for my jacket, endorsing the Pretenders and the
Psychedelic Furs. That's a good day of commerce.

1986: David Byrne directs the Talking Heads' "Wild Wild
Life" video. Always ahead of the game, the Heads set
their latest video in a Japanese karaoke club, where var-
ious oddball characters step to the mike to sing a line
or two. It's the first appearance of karaoke in American
pop culture, as far as I can tell, and it's also a great song.
I see this video several hundred times while waiting
for the next Whitney or Madonna clip. At no point do
I ever think, "Hmmmm, that looks like fun." Instead, I
think, "Wow, what a strange and exotic phenomenon.

But where are you, Madonna? Open your heart already! *Ritorna, Madonna! Abbiamo ancora bisogno di te!"*

1986: A music industry news item from *Billboard*, dated April 6. Headline: JAPAN EXPECTED TO APPROVE SINGALONG CLUB LICENSE FEE. The article explains to U.S. music-biz insiders that there's this new fad happening in Japan—"public establishments with 'karaoke,' or sing-along equipment." *Billboard* estimates that "there are about 200,000 bars and halls equipped with karaoke hardware." It also notes that "customers are charged from 55 cents to $1.10 for each song with karaoke accompaniment."

(Note: I only found this news item because I was having an idiotic drunken argument over the real reason why the pop group Wham! broke up, and I wanted to prove I was right, so I went searching in the Billboard archives, where I happened to find this article on the same page. Lesson: Talking about George Michael makes you learn things!)

1987: Lip-synching becomes popular as an organized youth-group activity, with high schools holding contests in which kids dress up and act out. In rural Rhode Island, a girl I know wins top prize at her high school for dressing up as Sting, with a derby and umbrella, to lip-synch "Englishman in New York."

1988: Bon Jovi release *New Jersey*. Everybody agrees this al-

bum is nowhere near as good as *Slippery When Wet*, the 1986 smash that included "Livin' on a Prayer." But it contains my favorite Bon Jovi ballad, "I'll Be There for You," with the chorus, "I'll be there for you / These five words I swear to you." It becomes the big *Dial MTV* hit for the summer of 1989. I talk a couple of friends into joining me when Bon Jovi come to town in June with Skid Row opening up, and this is the song that gets all the lighters out. These days nobody seems to remember "I'll Be There for You." I always want to sing it at karaoke, and nobody even pretends to like it. Sample crowd-sourced review: "These five words I swear to you: This song sucks my balls."

Someday, history will vindicate me. Until then, everybody likes "Livin' on a Prayer" better, and that's fine with me.

1990: I get my first look at karaoke in real life. It's a family reunion with my in-laws, at a theme park in South Carolina called Carowinds. Since it's the summer of 1990, *The Simpsons* is new, and the park is full of tourists wearing bootleg Black Bart T-shirts. The mayor of Washington, D.C., Marion Barry, just got busted smoking crack on camera in a hotel room, so lots of people sport the summer's other big T-shirt: "The Bitch Set Barry Up."

On Saturday night we all trek out to the Long Branch Saloon, a country bar down the road in Rock Hill. There's a cover band onstage doing all the hits of the

summer, as well as the regular crowd-pleasers. They play "A Country Boy Can Survive" and "The Devil Went Down to Georgia" and "Dumas Walker" three times apiece. It's the kind of place where last call is 4 a.m., but they reopen the bar at 5 a.m., so they just make announcements that everybody needs to buy extra pitchers of beer for the hour when the bar is closed. To make sure nobody leaves, that's when the saloon hosts its karaoke contest. People get up and sing, while the house band plays.

Aunt Caroline does the family proud with a tear-jerker from the sixties I've never heard before, "Don't Touch Me" by Jeannie Seely. This is easily the best performance of the night. Most of the others are pure tone-deaf drunken bravado. One guy wheezes through Travis Tritt's "Country Club," while another does David Allan Coe's "You Never Even Called Me by My Name." A blond lassie in the Lucy Ewing/Tanya Tucker mold does "San Antonio Rose," tossing her skirt ever higher to win over the crowd.

But the winner in terms of audience applause is the Elvis Guy. As I will later learn, every Southern karaoke place has the Elvis Guy. A couple of other contestants are doing Elvis songs, but only this man is the true bona fide takin'-care-of-business peanut-butter-and-bananas Elvis Guy. This guy has the shades and the 'burns; more than anything, he has the conviction. He does "American Trilogy," which I've never heard before. He begins

with "Dixie," segues into "All My Trials," then unites the nation with "The Battle-Hymn of the Republic." Here is the entire Civil War in five minutes, ending with a pietà of the Elvis Guy holding President Lincoln's body in one arm and Elvis Aron Presley's body in the other, sobbing over both fallen kings, yet somehow rising above to proclaim, "Glory, glory, hallelujah. His truth . . . is . . . marching . . . ONNNN!"

At our table, nursing our nearly-sixty-minutes-old pitchers of Bud, we all still think Aunt Caroline deserves the trophy. But I'm not really surprised when the Elvis Guy wins.

1992: *The Crying Game* hits the Seminole Theater on Route 29 in Charlottesville, Virginia. It's an Irish film about an IRA assassin who discovers his humanity—where else?—in a karaoke bar. He falls for the femme fatale, at the place where she sings "The Crying Game."

The movie is surprisingly forgotten these days, especially considering how many other movies have copied the karaoke-as-exposition motif. But at the time, it's a huge crossover hit. Boy George sings the theme song, doing for karaoke what *Casablanca* did for "La Marseillaise." Karaoke is officially a "thing now," in the nineties idiom of "that's such a thing now." Such establishments in the United States might still be scarce as hen's teeth, but this movie plays in malls and multiplexes around the country.

My local Top 40 station in Charlottesville gives away a movie poster, autographed in a gold Sharpie by Boy George himself. I win by being the first listener to call into Z-95 when the morning DJ plays "Karma Chameleon." The *Crying Game* poster hangs proudly in my bathroom for the rest of the nineties. Boy George's handwriting is as fabulous as everything else about him.

1993: My town finally gets a karaoke joint, when Mingles opens on West Main Street, across from the Greyhound terminal and the statue of Lewis and Clark. At Mingles, the slogan on the napkin is WINKIN', DRINKIN' AND EATIN'! The napkin doesn't mention "singin'," but that's the novelty that brings most of us in. It's a mixed crowd, mostly happy-hour partiers straight from the office in suits and heels. Feisty paralegals hop on the tiny stage to sing "Bang a Gong," while their tipsy bosses go for "Love on the Rocks." Gongs get banged; drinks get spilled. The manager likes to get up and do mid-period Billy Joel songs such as "Tell Her About It." And the Elvis Guy sits by himself at the bar, brooding, awaiting his turn at "American Trilogy."

Do I ever get up the nerve to sing at Mingles? Not in my ungodliest nightmares. Do I have fun watching everybody else express themselves? Always. Mingles goes out of business within a year.

1997: Julia Roberts stars in *My Best Friend's Wedding.* Straight

male America's long, slow, denial-ravaged march to the reluctant realization that Cameron Diaz is not going to appear naked in this movie is only partly ameliorated by Rupert Everett's climactic rendition of "I Say a Little Prayer."

As a Hollywood rom-com, this gets much bigger exposure than *The Crying Game*. It's safe to say that this movie is the real fountainhead of the Hollywood karaoke scene as we know it. From now on, what the "recognition scene" was to Shakespearean drama, the "awkward eye contact during oldies duet scene" is to the garden-variety worse-than-rubella romantic comedy. At this point, even normal people know what karaoke looks like.

(Postscript: A couple of years later I interview Rupert Everett and he is possibly the grumpiest brat I ever have to spend twenty minutes being polite to. But Christ, I have to admit he's hot. I see why they say a little prayer for you, Rupert.)

2002: I learn about the existence of home karaoke machines. You mean, you can sing all night and not leave the house? Or even put your pants on? Apparently, that's what they do in L.A. I hear this bombshell from Jimmy Kimmel when I interview him for *Rolling Stone*. "The friends all come over," he tells me. "If I get drunk, I just pass out and somebody drags me upstairs. When I really mean business, I whip out the Neil Diamond. That's when the clothes come off and everybody goes

home. You can't just sing those songs. You have to live those songs."

2013: Somewhere in your town, tonight, right about now, there is a karaoke dump that stays open far too late. These two songs are getting sung. One of them is revving up right this minute; the other is just a few minutes away. Find that place. Breathe in the air. It's where those songs belong, and it's probably where you belong, too. Journey and the Jove, on repeat. They offer sanctuary to us all.

SEVEN

9:52 p.m.:

Crazy in Love

Dirty secret: I know a guy who sings karaoke for cash. He's a pro, working out of a bar in a mobbed-up corner of Brooklyn. I wouldn't believe him if I hadn't seen him with my own eyes, but this guy is good. The bar he inhabits has a twice-weekly karaoke night, with a slightly posh clientele, the kind of folks who would rather be in an upscale wine haven. These patrons have rehearsed their pronunciation of "rioja." Some night they need a little encouragement to stop chatting about *Homeland* and artisanal cheese and make it rain at two bucks per song. So the bar owners secretly hire my friend, let's call him J.J., to help break the ice. He sits at the bar, looking like just another mild-mannered customer. But when the room gets quiet, that's the cue for J.J. to go to work. He gets paid to do the wild thing.

I have watched him on the job many times, and I have never seen him fail. He has two proven routines, both classics of eight-ies booty-hop: Salt-N-Pepa's "Push It" and J. J. Fad's "Supersonic."

But his knockout is Beyoncé's "Crazy in Love." This wiggly dude busts out his pom-pom moves, and you can see why his pockets got the mumps. Watching him work the mike makes you want to be part of the fun. He isn't a great singer, but that's how he reminds people there aren't any quality standards when it comes to karaoke. He makes you think, "Hey, it's easy." Then he sits down. He's good, which is why we're all broke and he's so paid.

How much do the owners pay him? Forty bucks cash, plus his bar tab, plus all the clams and french fries he can eat.

I am kind of obsessed with his hustle, since I had no idea there was any such thing as a k-pro. It requires covert-op skills, as well as a weapons-grade ability to demolish inhibitions. In fact, J.J. puts the "bitch" in "leave your inhibitions at the door." Nobody would suspect he's working undercover. When he lets me spy on him, I have to keep remembering not to high-five him.

Sometimes he makes me wonder, "Who else is a pro? How many people in this bar are secretly pros? Maybe I'm the *only* amateur here tonight, the only mark getting shilled? What if my whole life is an elaborately staged prank where I'm the only person I know who isn't on the payroll of some secret *Matrix*-style karaoke conspiracy?"

But watching J.J. also makes me wonder about the amateur aesthetic in general. That's the essence of karaoke if anything is: never for money, always for love. In the many years I've been interviewing performers for *Rolling Stone*, one of my go-to questions is "What's your karaoke jam?" Nobody ever has to think about it. They name a song right away, or start singing it, or confess they get too shy—that seems to be surprisingly common for

actors and comedians, which is fascinating in itself. (Bill Hader, one of the funniest people on earth, told me he can't do it at all because of his circle of friends. He gets too intimidated by how good Will Arnett and Jason Sudeikis are. All I could think was "Amazing. You do the Stefon routine on TV in front of millions of people, but karaoke is where you get the bashfuls?")

It's a useful interview question, not because the subjects give me a quotable answer—it never makes it into the article, since my editors really don't give a crap how much everybody loves the same Bon Jovi songs. But somehow it makes them relax, slaps them out of interview mode. It gets their enthusiasm flowing. It has nothing to do with their job, or with the project they're promoting, but *everything* to do with why they started doing their job in the first place. It taps into the most innocent kind of enthusiasm. For some of these showbiz troupers, karaoke must be one of the few times they're off the clock.

When I watch J.J. shill, I know he's doing songs he's done before; I know he planned all this; I know what he's going to do in an hour or so; he has the tricks in his stash. I know I'm just a sucker. But it works because whether he's in the mood or not, he convinces me he loves it. He makes me believe he'd do it for free. They say you have to fake it till you make it, but maybe you also have to make it to fake it. It's like the old country song says—a lap dance is better when the stripper is crying. I feel certain the same must be true of karaoke.

SO WHAT MAKES A GOOD karaoke shill? Clearly, you have to have the performer thing. The showgirl thing. The frontman thing. The

flair that separates a star from the rest of us. You have to be able to turn it on at will.

I've always been fascinated with people who have that, not to mention jealous—musicians, dancers, performers of any kind. A few years ago, I was at an after-party for a friend who was doing a one-man dance theater project in New York, at the Kitchen. I was making my goodbye rounds early—I had an article due the next day. He wasn't buying my excuse. He said, "You just have to work tomorrow. I gotta *be* somebody!"

And that totally nails the difference between performers and the rest of us. We need them to be somebody. And occasionally, we need to be them so we can be somebody, too.

There's a specific kind of personality, or maybe just some kind of genetic mutation, that these people have. People in bands call it LSD, or Lead Singer's Disease. This pathology was perhaps best diagnosed by the noted British psychologist Dr. Frederick Mercury. An interviewer asked Freddie in 1977, "Why do you think people like David Bowie and Elvis Presley have been so successful?" Freddie replied, "Because they give their audiences champagne for breakfasts. 'Coz they're what the people want. They want to see you rush off in the limousines. They get a buzz."

That buzz separates performers from the rest of the human race. It's a special mentality that requires you to give yourself to the audience, in a theatrically overstated way, despite the fact that they know it's a performance. The mechanical manipulation has to be part of the charm. Even when you're feeling the same emotions every night in the same order, hitting your marks and reciting your rehearsed patter, the glamour is real for you

and the audience, converting artificial tricks into human tears and blood. I always envy performers who can do this; whether or not I like their music is secondary to my envy for the fact that they can actually do it.

For the rest of us, karaoke is as close as we get. We have much to learn from these people, even if we can be grateful we do not share whatever psychosexual quiddities drive them to crave this much attention. I wouldn't want to be Beyoncé full-time. I couldn't handle it. Even Beyoncé has her hands full trying to be Beyoncé full-time. I'm only Beyoncé for about ten minutes a month, when I pick up the mike to sing "Crazy in Love" or "Halo" or "Countdown" or "Say My Name." I don't know if I could take a solid hour of being Beyoncé, not without doing serious damage to my halo. She was Destiny's Child—I am Density's Child. But she has that charisma that inspires the rest of us to fake it. I fake it so real, I am Beyoncé.

I don't have the frontman chromosome. Whatever the frontman is in front of, I am more comfortable lurking somewhere in the back of that. That has to be part of why I'm drawn to karaoke, the way it lets me sparkle with a little shabby second-hand glamour stolen from these true stars. No lurkers allowed, no parking on the dance floor. "If you can't fix it, flaunt it" is a motto that's built right into the mentality.

SO MUCH OF IT COMES right down to the microphone. So let's talk about that for a minute. The thing itself. The electrical instrument. The magic wand that turns those who clutch it into gods and goddesses.

Everybody loves microphones. As soon as they were invented, singers loved them. Frank Sinatra and those forties crooner guys used to bend the mike over tenderly like a dame they were kissing on V.J. Day. As Old Blue Eyes told *Life* magazine, "It's like a geisha girl uses her fan." That has never changed. Singers love microphones. Rappers love microphones. I've seen indie guys press their lips up and slobber on the microphone so they get electrical shocks and I've seen rock stars bear-hug stage-rushing fans as they all crowd around the mike stand.

Microphones are outdated technology, in a sense; if you want to, you can mike a performer so the audience doesn't see the equipment. Singers only flaunt the microphone because they want to. In the nineties, people from Madonna to Garth Brooks began using the wireless headset mike thingaroo, which creates a whole different iconography. The headset is businesslike, above all. It says, "I'm not some pop floozy up here, I'm the CEO of an entertainment enterprise, I'm a brand, I'm working my ass off," etc. But you can't *become* a star that way. You have to already be a star to wear the headset, because it does not in itself confer star status. The microphone does. That's why little girls learn to sing into the hairbrush before they even learn to brush their hair with it.

The air guitar makes sense on a pragmatic level because a guitar *does* things. When you play air guitar, or beat out a drum solo on the dashboard, you're miming a mechanical operation. But the air mike, that's a different statement. And it usually is the trusty hairbrush. In the excellent 2002 Britney Spears film *Crossroads*, she uses a spoon while she's in her room belting Ma-

donna's "Open Your Heart," which is interesting for a number of reasons, the two toppermost being 1) WTF? They didn't have a hairbrush? They're not hard to find and teenage girls have them in their rooms, always, and boys usually do, too, whereas teenagers generally do not stash the silverware in their sleeping chamber unless their "cry for attention" game has reached condition red, and 2) Britney always used a headset, not a handheld mike, so rocking the mike like this must be a long-standing fantasy that she could never satisfy in her actual day job as a singer, only in the movies when she plays an amateur fan who can only dream of being a singer, which could be the whole karaoke ethic in a nutshell.

Stars love to put pictures of themselves holding the mike on their albums, whether it makes them look cool or ridiculous or so far past ridiculous it's magfriggenificent. (Like Morrissey on the inner sleeve of the first Smiths album, where he's making microphone love so intently, he practically pins and mounts it like a butterfly.) The best had to be George Clinton of Funkadelic, on the cover of his 1979 classic, *Uncle Jam Wants You*. George is some kind of dictator-king sitting on his wicker throne in his red beret, military fatigues, and white platform go-go boots, with a giant microphone next to him as if it's the royal scepter, except it's bigger than the throne.

From the earliest days of hip-hop, holding the mic was a sacred responsibility. No MC has ever worshipped it like Rakim, who boasted "I hold the microphone like a grudge" and used it to move-move-move the crowd. He was the original microphone fiend, and in his hand it was the third rail on the subway line

into the cosmos; he made the mic smoke and then slammed it down to make sure it's broke. (Hip-hop was the first culture I know of to spell it "mic," to signify that a rapper's mic was a different instrument from anybody else's mike.)

Biggie has that great song "Mo Money Mo Problems" about being onstage, looking out at the crowd, with all the girls sitting on the guys' shoulders, screaming his name. In the song, all the girls look like microphones to him. The ladies watching him amplify his voice, make it mean something. The thrill of looking out into an audience of those girls, so many rock stars have written poetry about that from Chuck Berry to Patti Smith, but I think Biggie was the first to recognize those girls as microphones. "Mere mics to me"—I think about that line every time I go to a show and see the singer bask in the screams.

But mike or mic, if you're in the audience, the microphone is what the singer has that you don't, and some part of you wants it. Holding the mike transforms you into a star, makes you say things like "one-two, one-two" or "testing" or "testes" or "There's gotta be some people out there who like to drink tequila." If you're Billy Joel, the microphone smells like a beer. If you're Steven Tyler, it's a place to tie your scarves. If you're Trent Reznor, you fling it to the floor to signify your alienation. Joe Strummer was the first rock star I ever saw do the move where they hold the mike stand into the crowd so it picks up our voices rather than theirs. It was my first Clash show and we were all singing "Garageland" and it was so touching (Joe Strummer wants to listen to *us*?) that it's always stayed with me, even if I've seen that move a thousand times since then. That machine can make anyone a star.

But you can't step to the mike with fear in your heart. You have to love it, the way J.J. does, and you have to make the crowd love how much you love it. It's like Hunter S. Thompson said about politicians—"maybe the whole secret of turning a crowd on is getting turned on yourself by the crowd." Watching J.J. turn into Beyoncé, it's not merely that she turns him into a star—he turns her into a star. You have to grab that mike like the song is desperate for you to bring it to life and wear it like a halo.

EIGHT

10:16 p.m.:

Rebel Yell

We've already spent a couple of hours in Sing Sing. But I have the untamable hunger for more, like a girl in a Billy Idol song, which is only right and natural, since for a few minutes I am going to *be* the girl in a Billy Idol song. My rebel yell can't be stopped: You give me the midnight hour, I'll give you the mo-mo-mo.

Right now I am a rock star. I am living the dream as Ted Nugent described it in the title of his live album *Intensities in 10 Cities*. Except in my case, it's Intensities in 10 Shitty Versions of Other People's Songs. But nothing can slow us down. The night is under way. In karaoke, there is no right or wrong. There is only mo, mo, and more mo.

But here's the big question: Where did karaoke come from? How did it get so popular so fast? How did this become acceptable behavior? Why do we do this to ourselves?

There's the simple historical answer: It began in Japan, where the word *karaoke* means "empty orchestra." But I'm looking for

bigger answers, digging into the primal aspects of the question. Where did the karaoke *mind-set* come from, and what does it mean that America fell madly in love with it?

Karaoke is a relatively new development in Western culture. It might seem like it's been around forever, but it didn't arrive until recently, and we still don't know its long-term effects, like some new drug that hits the market before it's properly tested. Even in the late eighties, it was obscure in English-speaking countries. But as soon as people found out that it existed, it caught on fast. Once we got a taste, we needed more.

It has a long history in Japan, a country I've never visited. Ally used to live in Tokyo, so she's done karaoke in the motherland, with middle-aged salarymen singing Beatles and Elton John songs while consuming their weight in sake, which they're destined to regurgitate on the train tracks. The first time I ever heard the word *karaoke* in the eighties was from my friend Marc, after he visited Japan; he said it was their equivalent of an American 1950s drive-in theater, a place where kids go to make out in the dark. "American karaoke is about as authentic as American sushi," he assures me. "It's California-roll karaoke."

But it's the American ritual of karaoke that fascinates me. Of all the amateur passions that thrive in the American psyche, singing seems to be the only one that has found this kind of mass expression. Karaoke is a throwback to a time before records, where families gathered around a piano and unfolded sheet music of the latest hit song. It's a place where no-talents and low-talents and too-low-for-zero talents tolerate each other, even enjoy each other, as we commit brutal crimes of love against music. We're

all free to turn and walk the other way at any time, yet we stay to applaud each other.

I can't think of any other forum like this in our culture. There's no acting equivalent of karaoke, where an amateur thespian can get up on a public stage after shotgunning a few tall boys and perform the trial of Hermione from *The Winter's Tale*. There is no restaurant karaoke where anyone can hop on the stove, burn dinner, and serve it up to the other customers. Imagine a bartending equivalent. You order a Rob Roy, and I'll pour you a cup of Shasta Raspberry Zazz and Absolut Pepper with a shot of Four Loko plus a raw oyster. Would you drink it? No way—but this is what karaoke is. There is simply no other American ritual that rewards people for doing things they suck at doing.

Yet we stick around, before and after our song, cheering each other's flaws. The only real bores in a karaoke bar are the ringers who can sing, like the eternal "Me and Bobby McGee" lady. In a karaoke bar, the closest you can come to unforgivably bad taste is competence.

The community created around karaoke is a sacred thing. It's a universally supportive environment—nobody goes to scoff or judge. It's not like a pool hall or bowling alley where the regulars glare at you for taking up valuable space. It's a temporary but intense bond between strangers, a shipboard romance, a republic we create where we gladly consent to treat the other people around us like rock stars. How does music bring all this out of us?

Last fall I was in a crowded karaoke joint on St. Mark's Place, waiting in line for the men's room, surrounded by strangers with their arms around each other singing this country song I'd never

heard before (Alabama's "Dixieland Delight") and by the time the second chorus rolled around I could sing along, too. It was a birthday party for a guy named Taylor, who was turning thirty-three. I'll never meet you, Taylor, but judging from the friends you've made, and the gusto with which they sing about redtail hawks and whitetail buck deer and makin' a little lovin' and turtle-dovin' on a Tennessee Saturday night, I'd wager you have spent your thirty-three years wisely. It was a grand experience. And that was just the line for the bathroom.

It's a totally democratic environment. We all show up, bringing our different and unequal talents, and then we start even. I think that's why actual rock stars *love* karaoke. It's one thing for nonsingers to revel in a chance to sing, but it seems to be a whole different trip for actual singers, slumming it in the trenches with the rest of us. Robert Plant told a funny story once in *Rolling Stone* about doing karaoke at a bar in China, where nobody recognized him. "In China it's a big deal, so I said, 'Let me do "It's Now or Never," by Elvis, so I can really bring the house down!' But this guy from Taiwan was better than me. He did 'Tie a Yellow Ribbon,' by Tony Orlando and Dawn. When he was done I thought, 'Fuck me! I was outdone by a Taiwanese guy singing Tony Orlando!' "

When I got to meet Simon Le Bon and Nick Rhodes of Duran Duran, after some gracious comments about my previous book, they asked what I was working on next. As soon as I mentioned my karaoke book, they started telling stories about the first time *they* sang karaoke. "It was Malaysia in 1988," Nick Rhodes said. "Everyone was singing Elvis songs—'Are You Ronesome Tonight?' "

Simon Le Bon sang Madonna's "Material Girl," while Elton John's manager danced around doing a striptease.

As they're telling me these stories, I'm astounded, because these are *actual rock stars.* They've had their own spotlights, on their own stages, for thirty years now. They've played their own songs for millions of people around the world. Why do they even remember a night of karaoke? Why did this experience make an impression on them, out of all the countless nights they've spent making music? Simon Le Bon never needs to sing anyone else's songs to get applause. So why does he cherish fond memories of his night as a material girl?

MY FRIEND TANYA, WHO GREW up in Sri Lanka during the civil war, remembers going to sing karaoke all the time with her grandmother. All the old ladies would gather in the basement of the Kalumbo Hilton to sing "Tie a Yellow Ribbon" (the same Tony Orlando song that foiled Robert Plant). They never did Sri Lankan songs—only American pop chestnuts. Tanya's song was Elvis Presley's "In the Ghetto." "Karaoke only got big when the war started," she told me. "Karaoke and casinos. It wasn't safe to go out on the streets anymore, so those were places to go after curfew time. It was a way of expressing joy, when people really needed one."

What a picture: a little kid in a war zone, with all these old ladies holed up in a hotel basement karaoke lounge, singing "In the Ghetto" to tune out the gunfire outside.

That same power translates everywhere, all around the world, because nothing expresses joy like singing together. That's why

it inspired such fervor in America as soon as it arrived. To enter into that karaoke mind-set, you have to leave behind all your notions of good or bad, right or wrong, in tune or out of tune. The *kara* in the word *karaoke* is the same as the one in *karate*, which means "empty hand." They're both "empty" arts because you have no weapons and no musical instruments to hide behind—only your courage, your heart, and your will to inflict pain.

In any age, there are social practices that seem acceptable at the time, until future generations decide they're barbaric. Watch any old movie with a hospital scene and you'll see doctors chain-smoke in the OR. Even in *The Hunger*, the David Bowie horror movie from the eighties, you can see Susan Sarandon lighting up in her white medical coat. (She's having hot vampire sex with Bowie *and* Catherine Deneuve, so smoking may be the least dangerous thing she'll do all day.) It looks bizarre to us, but are we really so different? Have we evolved? Or have we just changed our blind spots?

In our time, there are many equivalents to the "smoking in hospitals" fad, such as "jogging on the sidewalk," "texting at rock shows," or "ruining a perfectly pleasant evening by saying 'get home safe.'" I never heard anyone say "Get home safe" until the mid-nineties, then boom, it was everywhere. How did this become acceptable as a way to say goodbye? I hate when people question my ability to get from one place to another without mutilating myself. It's tantamount to saying, "Try to get home without screwing it up like last time, dummy," or "Farewell, for I may never see you again, given the mortality that awaits us all like a crouching panther."

I will never understand. But I hate "get home safe." As valedic-

tory clichés go, I would trade it to the seventies for "have a nice day." Hell, I would swap it to the eighties for "later." I have no idea why this chatty little curse got so popular, so quickly. But it did. And it's evil.

Certain fads can show up and seem like they've been around forever. It may be shocking, but the thumb-and-pinkie "call me" gesture? Did not *exist* before the nineties. People had been holding their phones that way for decades, yet nobody thought to wiggle a thumb-and-pinkie as a social invitation before. First time I saw it was on *The Arsenio Hall Show*, in 1992. (David Alan Grier, star of *In Living Color*, was the guest, greeting a foxy lady in the studio audience.) Then it spread until the novelty wore off. You still see it today, even though there aren't any phones you hold that way anymore.

I don't know how it works, but sometimes that's how it happens: Abnormal behavioral quirks get normal overnight. People singing along with machines, to instrumental tracks, reading the lyrics off a screen—once it might have looked sick, even sinful. Yet people fell in love with it fast, so they decided to see it as normal, the way previous generations regarded bow ties, shuffleboard, Quaaludes, or witch-burning. You go to the movies, you expect a karaoke scene, just as forties audiences weren't fazed to see a World War II pilot light a stogie while gassing up his Tomahawk.

Sometime soon, be it two or twenty years from now, people will stop saying "get home safe," and then we'll all make fun of our earlier selves for saying it. But we still haven't realized this about karaoke. That's one of the most glorious miracles of our time.

NINE

10:35 p.m.:

99 Luftballons

As the summer of 2001 ended, with a string of hundred-degree dog days, I was still living downtown, by the World Trade Center. Apartment 7Q felt like a dead white box in the sky, and I still felt like an alien in my steel-and-glass ice chamber. But I didn't have the energy to move out, so I renewed my lease for one more year, effective September 1. When my hunger pangs got stronger than my inertia, I walked a block down the alley to the Thai restaurant, in a strip mall called the Excelsior Plaza, to eat in a brightly lit white room—much like the one I slept in—not even tasting the noodles, just sitting in my table next to the air-conditioning vent and listening to myself breathe and thinking, "These people are near you but they can't hurt you. They can't see you or hear you. It's okay. They will go away. They will leave this room. We will all leave this room. Nobody will remember you were here."

The Thai place always had the Top 40 station on, usually playing something by Destiny's Child, who were a rare sign

of life on the radio. The girls sang like machines until they turned into machines, chanting "say my name, say my name" in heavy rotation. The lyrics were about paranoia and jealousy, but the music was about calming down and chilling out and not giving a fuck. The production was scientific and precise. I loved it.

None of the machines around me seemed to function *except* Destiny's Child. My time was spent rushing from one narrow metal tube to another—apartment, staircase, sidewalk, subway, street. The subway station led to a maze of underground tunnels. It could take up to an hour to find my way up to the sidewalk, or longer after dark, when they started closing off exits. I got used to feeling lost, wandering the tunnels under the World Trade Center. They had an entire mall down there, catering to other disoriented travelers looking for a way out. There was a Gap, a Body Shop, an Urban Outfitters. You knew you were close to escaping when you smelled the Krispy Kreme.

They even had a record store, a Sam Goody. One Friday afternoon I found an old hair-metal artifact there that brought back fond memories. It was a CD by the band Blackeyed Susan, the side project by former Britny Fox singer Dean "Dizzy Dean" Davidson, absurdly overpriced at $4.99. I already had a copy at home, which I snagged for two dollars on a visit to Berkeley in 1992. But I got a sentimental rush holding that Blackeyed Susan album in my fingers, marveling at how far it must have journeyed to end up here, a bargain bin in the basement of a skyscraper. I decided I would have to come back and rescue it someday. It was September 7, 2001.

• • •

A FEW DAYS LATER, THE neighborhood was rubble. There was a column of smoke where the towers used to be. I spent the evening at Chelsea Piers, an athletic complex that had been quickly set up as a makeshift hospital, with a bunch of other volunteers. The doctors had us form a fire line to load medical supplies off a truck. (Nobody knew these supplies would never get used; the next day, they'd all have to get loaded back onto the truck.) A cop came around to instruct us on how to identify wounded officers by their badge numbers. We sat on the floor all night with the doctors and watched CNN, waiting for the ambulances to bring the survivors. But there weren't any ambulances, because there weren't any survivors. Around 2 a.m., they told us to leave. There was nothing to be done.

It was a few weeks before I could get back into my apartment; there were tanks rolling down my street. I slept on couches for a month, borrowed socks, got to know my local public men's rooms, went into the *Rolling Stone* offices to work whenever they had a spare desk. Two days after the attacks, I was walking to the office in midtown, up Sixth Avenue. The streets were full of pedestrians, since there weren't any cars or trains operating. Then, somewhere in the upper 30s, everybody began to run like crazy. I ran, too. Total stampede, blind panic. Did somebody see something in the sky? Was it a sudden noise? Literally thousands of us in the street took off, running for our lives.

We stampeded for two blocks, and then the panic died down, as rapidly as it had begun. People started to walk again, looking around nervously, out of breath. Nobody made eye contact, obvi-

ously; there was no conversation. I never did find out why we all started running. I didn't mention it when I got to the office. I hunted in the papers the next day, but there was nothing about any midtown scare on Sixth Avenue. It was just another moment of fear nobody would ever talk about.

Everybody around the world knows this was a time when New Yorkers rallied together, rose to the occasion, hugged it out, etc. Unfortunately, we also got stupider, like the rest of the country except more so. We got more insane, volatile, paranoid, and unstable, which (understandably) nobody likes to remember. Two weeks later, when the 1 train was running again, I was riding uptown with a bunch of friends, planning a Saturday afternoon walk in Central Park. A one-legged homeless guy with a crutch confronted me and accused me of being one of the twin towers. (I'm really tall.) He kept clobbering me with his crutch while he yelled about how I'd fallen on the city and killed everyone. I had no room to slide away, so I just held on to the pole and pretended this wasn't happening. Everybody on the train looked away. My friends didn't step in because . . . well, who the hell wants to argue with a one-legged hobo swinging a crutch? We got off at the next stop, which took forever. Nobody said a word. My friends felt awful. I felt awful. We sleepwalked through the park until I slunk away. None of us mentioned it again, not that day, not ever.

There were a *lot* of scenes that never got mentioned. We all witnessed things daily we wanted to forget. If you looked in the paper, you saw that in Washington, D.C., they were dismantling the Constitution. If you wanted to see if it was okay to go back

to your apartment, the only way to find out was to walk downtown, stop at the checkpoints to show soldiers your ID, and see how far you got. (You walked down the East Side because they were more lenient letting people through in Chinatown.) Nobody knew if the air would ever get safe to breathe. Bad news was arriving faster than anyone could absorb it.

By the time the soldiers let residents return, my neighborhood was one of the world's most famous tourist attractions. The streets were congested with visitors, lined up for blocks to gawk and take pictures of the hole in the ground. Leaving the apartment meant putting on my dust mask and elbowing through the crowds. Sticking around meant breathing in the smoke, and knowing that the smoke was the dead. I still couldn't see anything out of the windows, but now it was because they were caked with that smoke. There was a bike still chained to a lamppost on my street; the messenger had gone into the WTC and never come back. Every wall was plastered with pictures of the people who disappeared in the explosion, photocopied fliers with faces and phone numbers to call if you found them. Dead eyes followed you everywhere.

It was hard to live with, day by day. It was everything I had moved to New York to get away from. I'd left Virginia to escape the shadow of death; now I lived in a shrine of mourning, surrounded by cameras. Everybody wanted to talk about death all the time. I stared uncomprehendingly at the swarms of people who came here every day, more than the tiny sidewalks could hold, eager to be part of it. I looked at them the way a hopeless drunk probably looks at the crowds on New Year's Eve: amateur

night. This is what grief looks like for normal people? How does it feel for them? Do they go home and sleep it off?

Some of the dead faces on the walls were young wives. One husband had added her last words on the phone to the flier ("They're telling us to leave, I have to go now") as if it would help people identify her when they found her. "This husband could be in this crowd," I thought. "Looking for a trace. We could walk past each other and never know it." I tried not to look at the fliers as I walked past, breathing through my mask and feeling the smoke settle into my bones. I tried more desperately than ever to avoid the topic of my past, because if I confessed I was a widower, people changed the subject to 9/11. Now I wasn't just reeling from the grief of a personal apocalypse; I was witnessing mass grief with no idea of how to fit into it. There were so many topics I wanted to dodge, I could barely hold a conversation.

It was a month or so before rock shows started happening again. There was something uneasy about groups of people gathering in public, especially at downtown venues like the Bowery Ballroom, where you could smell the smoke for months. I met up with some Virginia friends who came to see the British band Clinic, but my friends got so spooked by the way lower Manhattan smelled, they turned around and drove home. Clinic came out in their standard high-concept stage costumes, wearing gas masks as a symbol of modern alienation. Poor guys, they were a little late to impress us. We'd all worn those masks to the show.

Jonathan Richman played the Bowery Ballroom that fall, on October 12. There was a hush in the crowd, watching Jonathan on guitar with just his stand-up drummer. With no introduction

or explanation, he sang a song from one of his earliest albums, "Lonely Financial Zone," a song I'd loved as a teenage boy but hadn't thought about in years. He sang to a silent room. "In the lonely financial zone, by the sea, I have walked under moon and stars."

MY FRIEND CRAIG HOSTED HIS birthday party, a karaoke bash at Sushi Desse in the East Village. The original date had been Friday, September 14; when he rescheduled for a couple of weeks later, he sent out an email with the subject heading "The Return of Irony." But irony didn't show up at all. For most of us, it was our first night out in public, in the city, in a crowded room, in quite a while. There was a giddy kind of release about it, and also something anxious. The way we laughed and hooted for each other's songs was more than catharsis—it was more like hysteria. We cried sometimes, too. Everybody sang that night, including friends who *never* sing. The first song I did was a Neil Diamond ballad, "I Am . . . I Said." When I got to the line about New York, which I hadn't even remembered was in the song, people screamed so loud it was startling. A roomful of adults hollering along with "Sweet Home Alabama" sounded like group therapy.

Obviously, everybody was trying to avoid sad songs, since the whole point of us gathering together that night was that we all needed some relief. But even the silliest songs were hitting a nerve. When the birthday boy sang "Love Grows Where My Rosemary Goes," a seventies bubblegum ditty, people seemed to go through emotional convulsions.

I met Craig's friend Rebecca that night, who'd been in a nine-

ties band I liked a lot. I thanked her for some of the songs she'd written, and she made me tell her husband stories about how awesome her band was. We flipped through the songbook and she laughed about Nena's "99 Luftballons," the classic German new-wave antiwar song. We cracked up about what a wildly inappropriate choice that would be. So instead, we had a drink and sang a duet on Dolly Parton's "Here You Come Again." But a couple of hours later, and more than a couple of drinks later, the joke about "99 Luftballons" had spread all around our corner of the room. We all started daring her to sing "99 Luftballons" until Rebecca finally put in her request, though even when the bartender put it on, as the last song of the night, I didn't think Rebecca would actually go through with it.

She did. She was clearly nervous (and this was a pro), as people recognized the tune. *Oh right*, you could see it sink in. *Really? This one? The song about the girl who watches her city get destroyed by bombs? Somebody's really going to sing this?* Rebecca started to jump up and down, because we were crying and laughing and clapping along. She was singing the English-translation lyrics, not the German, though most of us didn't know any words beyond the chorus, "ninety-nine red balloons go by." I remember feeling terrified, too. Is this bar going to get shut down? Are we going to get bombs dropped on us, right now? Then it was all over and we were standing pretty, in this dust that was a city.

The song didn't have any answers. But the way everybody sang along—it felt like maybe there were some answers in there somewhere.

TEN

10:47 p.m.:

Church of the Poison Mind

Every karaoke love story has a Boy George. And sometimes Boy George is a girl, which is how it goes tonight. Like so many other girls who grew up in the eighties, Ally always had a raging crush on the Boy. She daydreamed about dressing up with him, sharing his lipstick, borrowing his frocks. She mooned over his videos, studying the evolution of his hair. Tonight she gets to be him for a few minutes.

Ever since we started hanging around in karaoke joints, Boy George has been her karaoke twin, her go-to guy. His hits with Culture Club are a perfect match for her low, throaty voice. So the first thing she does with a songbook is flip through the C's. If she feels like rocking out, she goes for "Church of the Poison Mind." If she feels a little saucier, she does "Karma Chameleon" or "Miss Me Blind." If she craves a slow jam, it's "Do You Really Want to Hurt Me?" When she sings the line "Choose a color, find a star," she is the star I find and the color I choose, the ziggiest stardust in my sky.

If we didn't have karaoke to bond over, we would have found something else, no doubt. Her grandparents, who have been married almost sixty years, are really into bird-watching, and Ally and I sometimes look forward to the years when we will take up birding, even though at this point we can't tell a cactus wren from a yellow-rumped warbler from a rubber chicken. But right now, karaoke is one of the places where we go to form our own culture club, which is one of the millions of things a relationship is—building a shared language out of the things that fire up your blood. Couples need as many of those languages as they can get. That's why Ally and I spend some of our happiest moments together trying on disguises and pretending to be rock stars. Stepping into these voices and wearing them for a while— that's one of the ways we communicate.

Boy George might have sung about "kissing to be clever," but everybody knows you can't kiss and be clever at the same time. Clever can get you only as far as the kiss. Beyond that point, you're on your own.

ALLY OPENED UP NEW WORLDS to me—new galaxies, new solar systems, new Oort clouds and Bok globules and Eggenites. Everything looked different, seeing it and hearing it with this theoretical girl. She split the strong nuclear force holding my protons together, right down to my subatomic realms.

My wife is an absurdly cool mix of completely girlie traits and total dude traits. On one hand, there's her fashion sense, her love of pencil skirts, her thirty thousand pairs of shoes. On the other, there's the side of her that resembles a nineteen-year-old

boy. When we're eating pizza, instead of tearing a paper towel off the roll, she might wipe her fingers on the roll. Once, after dinner, she took a half-empty can of soda, put a baggie over it, and fastened it on with a rubber band. Then she put the can in the fridge. I couldn't believe my eyes. I felt like the luckiest guy in the world. I couldn't even tell any of my male friends about this story, or it would just make them wistful.

She loves indie slop and postpunk and math rock and all kinds of spazzy noise bands. She cannot tolerate folk music in any form. She loves all these goth industrial bands that I assumed only appealed to wizened leather satyrs with beards and tattoos. She's the only person I've ever met who has a favorite Pailhead song that *isn't* "I Will Refuse" (which I thought was the *only* Pailhead song, like most of the other .001 percent of the populace who have heard of Pailhead). She loves Pigface almost as much as she loves the Monkees. Ask her what Schrödinger's equation is, and she has an answer. "Look, you just solve for the wave function and take the complex conjugate and square it and integrate over some area to get the probability. Done! It's easy!"

Once we were in a pizza place where the Gwen Stefani song "Hollaback Girl" was blasting on the radio, and Ally asked, "Why is Gwen singing about the Hall effect? She keeps saying, 'I ain't no Hall Effect Girl.'" Then she explained to me what the Hall effect is—it has something to do with negative charges moving around in a metal and a magnetic field. I liked the song better Ally's way. I'd seen the movie *2001: A Space Odyssey* dozens of times before I met her, but it was a whole new experience

watching it together. They only knew about *seven* of the moons of Jupiter then? And they thought it had a solid surface? Jupiter has dozens of moons, and it's made of gas, so it doesn't have lakes or trees or dinner tables. Was I supposed to know that? Well, now I did.

Her career as an astronomer has taken her many different places, from telescope to telescope. She lived for a while in Tokyo, which is where she first got into karaoke. She was the first person who ever informed me about the whole "Pluto not being a planet" thing. She pointed out that the sun is going to burn through all its hydrogen in about five billion years, a process that's already been under way for billions of years so there's nothing we can do about it, and that the universe might be shaped like a Pringles chip. She also told me about the night one of her astrophysics friends went to a bar trivia contest where the final question was "What does Kelvin measure?" The winning answer was "heat," but her friend explained that Kelvin measures temperature, not heat, since heat is energy and is measured in energy units like joules or ergs. The astronomer refused to back down, until the battle had to be settled with a chug-off. These astro people are hard-core.

Ally made everything seem new. So many familiar things about my world were different now that I was seeing them through her eyes. Falling in love with an astronomer made me fall back in love with all the songs I'd ever heard about looking up at the stars, whether it was Hüsker Dü's "Books About UFOs" or Madonna's "Lucky Star" or Lois's "Capital A" or Barry White's "It's Ecstasy When You Lay Down Next to Me." For so long, I'd

been in the dark searching for a star; now the search is over, and here we are. Like Boy George says, choose a color, find a star.

AS A SCIENTIST, ALLY KNOWS a lot about the courtship rituals of different species. It always seems to involve a song. For instance, the male frog has one song that he uses for his mating call, and it's the same for every frog. They croak the same notes, in the same order. No room for creativity or improvisation. Any frog who tries to freestyle is not getting lucky tonight. When it comes to love on the lily pad, slavish accuracy is the male frog's game.

For birds, it's different. When a bird has love on his mind, he needs a song to separate himself from the flock (or pack or murder or whatever it is). For finches, every male sings his own distinctive courtship song. Every breeding season, he perches in his nest and lures the female finches with his individual love song. (It's usually the same tune his father sang, and he sings the same one his whole life). The female finch hears him sing, and that's how she decides whether she wants a piece of his beak. The males and females repeat this ritual every breeding season, no matter how many times they've mated before. The song is what seals the deal.

Other birds have a more varied repertoire. Perhaps the most seductive bird in the forest is the lyrebird, which has an uncanny ability to mimic any sound it hears. It can imitate other birds or human voices; it can even beatbox. In some documentaries about the lyrebird, you can hear the bird mimic the sound of the cameras rolling. Ally's also into this death-metal band called Hatebeak, who have a parrot for a lead singer. There are two

human dudes in this band, plus an African gray parrot named Waldo, who squawks over their guitars. Hatebeak never perform live, of course, because the guitar volume would be too much for a parrot's delicate ears. But they make records with titles like "Hell Bent for Feathers" and "The Number of the Beak."

But whether it's love or hate, the bird's song is a crucial part of the way it relates to other birds. Ally and I are birds, not frogs. We knew we belonged together because of the songs we loved. In the karaoke room, we're lyrebirds, trying on different voices. Ally's favorite kind of rock star to adopt for karaoke is the swishy mod English rock boy, the same way I love to sing songs by brassy mega-femme sex warriors. She loves to do the hits of Placebo and Pulp and Franz Ferdinand; she's drawn to the androgynous femme-boy voices like I'm drawn to girlie dames like Taylor Dayne and Chaka Khan and Sheena Easton. It's probably a mix of lust and identification. She loves to do Prince's "Darling Nikki," a song about an androgynous young rock star who meets his match at the well-lubricated hands of Nikki the Sex Fiend. She takes Prince to her castle and grinds him until his eyes spin like a pair of one-armed bandits. That's the same kind of intensity Ally brings to karaoke. She'll show you no mercy, but she'll show you how to grind.

Music is just one of our fundamental obsessions. And that's part of what music is for—bringing people together. Every couple has their songs, and they're not always the songs you'd expect. They don't have to be goopy love songs, either. I know a couple whose wedding dance was AC/DC's "Let Me Put My Love into You." People can turn anything into a love song if it helps keep

them together. The artist doesn't really get a say in the matter—it definitely doesn't matter what the artist might intend the song to be about. Bono used to complain about people using U2's "One" as a wedding song, since for him it's a song about conflict and self-doubt. ("Love is a temple, love's a higher law"—make up your mind, guy!) Sting used to complain about people thinking "Every Breath You Take" was a romantic ballad, the same way Michael Stipe complains about how people hear "The One I Love."

These guys might think the fans are misreading the dark, ironic subtext of their lyrics. But as far as I'm concerned, the fans are right. Anything can be a love song as long as two people care about it. We can twist any artifact to our romantic purposes. Friends of mine, for their first date, saw *Dr. Death*, a documentary about a guy who makes electric chairs. I thought, That's a first date? If there's a *second* date, there is definitely going to be a wedding. (There was.) And they both owned copies of the album Crispin Glover made in the nineties. That's a beautiful thing, and it's exactly why the Crispin Glover albums of the world exist—to help total freakazoids find each other.

We need those shared obsessions, whether it's bird-watching or motorcycles or cooking or shoplifting. A friend of mine once told me, "Larry Storch is the guy who saves my marriage." He and his wife are obsessive fans of the long-forgotten sixties TV comedian. They love Larry Storch so much, they bond by hiring a babysitter and checking into motel rooms where they can stay up all night watching Storch do his thing on their videos of the sitcom *F-Troop*. Hey, it works for them. I'm not such a huge Storch-head myself, but I knew exactly what my friend was talk-

ing about. Every couple needs their Larry Storch or their Crispin Glover.

For Ally and me, it's always the song. It was our favorite songs that first helped us notice each other and recognize that we were birds of a feather. Music is a huge part of our lives, with countless songs we think of as *our* songs. And that's why Boy George is an essential element in our marriage. He never fails to remind us that we belong together in the church of the poison mind.

ELEVEN

10:59 p.m.:

Heartbreak Hotel

I get my singing voice from my dad, who got it from his dad, who got it from some other Irish guy with a terrible voice. I come from a long line of these guys. My grandfather, Ray Sheffield, was a president of his local chapter of the Society for the Preservation and Encouragement of Barbershop Quartet Singing in America. (My grandmother, Peggy Sheffield, was in the sister organization, the Sweet Adelines.) A barbershop quartet generally consists of a tenor, a baritone, a bass, and a crow, who is the guy they stick in the back because he can't sing. My grandfather was a crow among crows. We had records of him in the house growing up, dating from the fifties days of private-press shops where you could make your own ten-inch 78 records.

My dad sings in church and likes to tell the story of when he was in high school, singing onstage with his local chapter of the Catholic Youth Organization, when they would do their annual show. This involved dressing up as a hobo to sing "That Lucky Old Sun."

(Side note: The CYO called its annual production the "Minstrel Show." This was the 1950s, so it raises the historical question: Did this minstrel show involve white kids putting on blackface? That's an excellent question. And I have never asked my dad, because I don't want to know. Irish males are very good at not asking questions when we already know we couldn't deal with the wrong answer. I suppose it's a survival strategy for living with Irish females.)

My aunts like to tell stories of my dad's teen enthusiasm for vocalizing. When he was fifteen, in 1956, he would spend hours in his bedroom singing along with Elvis Presley records. He sang "Heartbreak Hotel," "Love Me Tender," and the little-known country weeper, "Old Shep," which was his special favorite to sing. It's about a farm boy and his beloved dog. It has a plot with a long spoken-word recitation. (Spoiler alert! The dog dies.) This song was too sad for me to tolerate, even when I was a kid, but I always love the picture of my dad playing that one record over and over, fifteen years old, sneaking cigarettes until his mom had to ask why the shades in his bedroom were turning brown.

My dad and mom, as fifties high school students, were fond of Elvis and doo-wop, the hits they grew up on. They both used to sing "In the Still of the Night" with their high school friends—my mom sang the melody, my dad sang the "shoo wop, shooby doo" part. My dad still sings along with the radio, and I have always loved hearing him—he would amuse my sisters and me by doing the bass voice from oldies like "Little Darlin'."

As his (lucky old) son, I have inherited his enthusiasm for singing. Alas, I have also inherited his talent. I have inherited

many of his other traits, which become more mysterious to me the more clearly they emerge. My dad is the kind of Irish male that Irish females call "easy," or "aizy" as they pronounce it— the biggest compliment we can get from the Irish females in our families. Being called easy means we are easy to please, easy to get along with, easily amused. We're fine with that, whatever "that" is right now. And my dad is extremely easy, a guy who never gets ruffled, never loses his temper, never seems the least bit awkward or uncomfortable even in the strangest situation. He knows what he likes and it doesn't take much to make him happy. When we were kids, we took a road trip through Italy, and my dad brought along his little jar of Taster's Choice freeze-dried instant coffee. He didn't like the cappuccino or the espresso they offered him. Anywhere we went to eat, my dad would ask for a cup of boiling water and produce his private stash of Taster's Choice. His children rolled their eyes, but it didn't faze my dad. Nothing really does. He puts people at ease. People would rather be kind to my dad than mean to him. He gets away with things the rest of us can't get away with. He gave me unrealistic ideas of what a grown man can charm his way out of. I don't know how he does it. He won't tell me.

I am named after him, except he is Bob and I am Rob. He is the most Bob man who has ever existed. (There is no way we could trade first names.) He has lived in the same town his entire life, except for when he was at Fort Dix in the army, and two years he spent in Boston when he first married my mom. He lives barely a mile from the house where he grew up. Everybody in town knows him. When I first got my driver's license, I got

pulled over by the cops because they wondered why some kid was driving Bob Sheffield's car. When they saw my license, they said to tell him hi.

He and my mom have been married since 1964, after meeting at Boston College. The summer of 1989, when it was their twenty-fifth anniversary, he and I went for a walk at Castle Island by the sea in Boston, and I asked him point-blank: How do you keep a marriage together? What's the secret? How do you do it? He said, "Well, it's heaven if you marry the right one, and it's hell if you marry the wrong one, and you don't find out which one you got until it's too late." Oh. Thanks, Dad. I was angling for something a little more useful.

My mom has a slightly different answer. "I'm only saying this because I'm on the second stinger," she said. "But the secret is, your father has a short memory."

When I try to imagine what their secret is, this is the image that comes to my mind: Sometimes we go out to dinner, just the three of us. I sit in the backseat. A song will come on the radio— Elvis, Neil Diamond, something like that. My parents will be up front singing along. And I have to ask myself, what year is this? It could be 1974, it could be 1996, it could be some other time.

HOW CAN I EXPLAIN MY dad? Let me put it this way. I have never seen the movie *Jaws*.

And I'm not afraid of sharks. If anything, I'm a shark fan. They're cool, right? I watch them regularly on Animal Planet, and whenever Jessica Alba makes a movie where she plays a shark wrangler. I once favorably reviewed a Great White album

for *Spin* magazine. "Barracuda" will always be my third-favorite Heart song. I have nothing against sharks at all. My soft-on-sharks credentials are solid.

But I've never seen *Jaws* and it's because of something my dad told me one day. I was in fourth grade when this movie came out, and I wasn't a fan of scary movies, so I declined to go see it. *Jaws* was the first movie I can remember that people went to see repeatedly—although *Star Wars*, a couple of years later, would solidify that trend. It was kind of a status thing to brag about how many times you'd seen *Jaws*, which after all was a PG movie with a sex scene. Hardly any kid I knew *didn't* see it. (And our fourth-grade art teacher, Miss Slodden, was said to be an extra in one of the scenes where people in swimsuits are running out of the water in mortal terror.) Most of my friends went to see *Jaws* multiple times, but I kept saying no over and over. I was embarrassed by this, because it seemed childish.

One Saturday around noon, when the cartoons were done, even *Fat Albert*, and the third bowl of Boo Berry had turned to a glob of fuchsia slush, a couple of friends called to invite me to *Jaws*, which they'd already seen four times. I said no thanks. I hung up the phone in the kitchen, while my dad was sitting with a cup of Taster's Choice. I told him about the invitation and how I declined. He said, "You know, I'm really proud of you for not letting anyone push you into doing something you don't want to do."

And then . . . well, that's what I always wonder about. It's the kind of thing those of us who aren't parents can only guess. *Then* what? What *did* my dad think after saying that? Was it something he planned to say, or did it just slip out? Did my dad even

remember saying it ten minutes later? Did he think, "Hey, I just gave my son a major compliment here, one he'll remember the rest of his life. Now I can rest on my parenting laurels and spend the rest of my weekend on the couch watching Steve Grogan pass to Sam 'Bam' Cunningham"? Or did he think, "Maybe I should have pushed him to go see the shark movie and confront his fear? What kind of a creampuff am I raising here?" Did he think, "Uh-oh, I overpraised, I gave him too big a compliment. I gave up some leverage. I have failed as a dad. Is my only son destined to grow up as a spineless ninny who chickens out of everything and blames his parents?" It wasn't rare for my dad to give his children compliments—in fact it was extremely common. So maybe he wasn't even that impressed with himself. Maybe he was already thinking, "Any Cheerios left?"

That's something I always wonder. What was that moment like for him?

I could ask, but my dad's too much of a natural-born diplomat for that, and besides, he's a lawyer. You can't ask my dad a question like that about the past. First, he'd ask me how I remember it, and as soon as I told him, he'd claim he remembered it the same way. Then a week later he'd tell *me* the story as if he just remembered it, except he'd change *Jaws* to *The Towering Inferno* or something.

I could ask my friends who are dads, but it would seem like I was implicitly dropping a hint or critiquing their parenting style, so I can't ask them, either. So I still have no idea. What did my dad think after he said that, and did he realize he was making a big impression on me?

I do know this. I still have never seen *Jaws*. When my dad gives you a compliment for doing something, it very much makes you want to keep doing it. When my dad smiles, which is often, it makes you want to repeat whatever you were saying or doing that made him smile. I thought a lot about what my dad said, so I treated it like a decision I had made and was sticking to, even after I started liking scary movies. I saw *Jaws 2* in the theater, having been assured it was about one-third as scary as *The Bad News Bears in Breaking Training*. I read the *Jaws* paperback, or at least the opening sex scene. I had a college buddy with the nickname "Mako." I enjoyed the Dickie Goodman novelty record "Mr. Jaws." I loved the Bob Hope parody special *Joys*, starring Vincent Price and Freddie Prinze. It's not like I don't get the joke if somebody says, "We're gonna need a bigger boat."

But not seeing that stupid movie everybody else in the country has seen is just a habit I perpetuate, simply because of something my dad spent five seconds telling me thirty-five years ago. In a way, that's scarier than any shark could be.

I WAS WELL INTO ADOLESCENCE before I realized that other boys did not necessarily have dads like mine. The summer after freshman year of college, one of my roommates came to visit (we listened to Live Aid on the radio) and when I was off to drive him to the train station home, my dad gave him a hug goodbye. My friend broke down in the car and cried all the way to the Amtrak station—he told me he'd never hugged his *own* dad.

The older I got, the more stories like that I heard, and the more bewildering my dad seemed. How did he get this way?

Did he decide to be this way, or did it just happen to him? As I grew up I began to appreciate how strange my dad was, yet it's still something I'm still learning about, and it's still something I feel like I've barely begun to figure out. His kindness is not something I could ask him about, because it's not something he would ever acknowledge or admit. Like my mom says, he has a short memory.

When I was a Cub Scout, I entered the annual Pinewood Derby contest, which involved carving a race car out of a little block of wood. I had no idea how to carve, sand, saw, or use any kind of tools whatsoever—I'm the kind of guy whose knowledge of how to build or fix things runs dry after "righty tighty lefty loosey." So I just kind of scraped the edges off the side of the car and painted it this awesome shade of purple.

The evening of the race, I got a look at the other kids' cars, which were sleek little Stingrays and Mustangs and Corvettes with historically accurate detailing. I got a vague sense that I was punching above my weight, automotively speaking. When they put all our little wooden cars on the slide track to see them race to the bottom, mine did not reach the finish line. In fact, it didn't budge—I didn't realize I was supposed to sand the *bottom* of the car, so the plastic wheels on my model didn't even touch the track. It just kind of sat there, quivering. The race was over in thirty seconds and my car hadn't even left the starting gate.

Yet the Cub Scout troop masters gave me a purple ribbon anyway. First they handed out the trophies for first, second, and third place, as well as various ribbons for exceptional woodwork. Then they announced I had won the ribbon for a previously un-

mentioned category: "Best Homemade Car." It was obvious they just made up that award, and I had the vague sense they were making fun of me, but I was glad to accept the ribbon anyway.

On the drive home, when I asked my dad what "Best Home-made Car" meant, he just laughed. "It means you were the only kid who did the car himself. Most of those kids weren't even allowed to *touch* their cars."

My dad's a good sport, always up for an adventure, letting his kids talk our easily-talked-into-things dad into things. When I started reading books, he'd bring me books like *Tom Sawyer*, and when I started singing along to the radio, he brought me records like "American Pie." When he was forty, working in a bank, he decided to go to law school at night, but he still coached my sisters' basketball teams. (How did he do that? It'd be pointless to ask him. Maybe he doesn't even know.)

He eventually quit his day job and started practicing law on his own when he was fifty. He has worked hard to make his life happen, but he doesn't acknowledge any stress or strain about it at all. He has never worried about whether things will work out. He's easy. He likes his habits—listening to the radio, drinking coffee, pronouncing the word *California* wrong (he calls it "Califonia." Why? Nobody knows), calling blue jeans "dungies," and speaking in his unreconstructed accent. When he was in the army, he went to Mass once and gave the responses in Latin, like everybody did back then. When the service was over, the chaplain asked, "So what part of Boston are you from?" That's right: My dad's Boston accent could make a man wince even when my dad was speaking Latin.

• • •

MY DAD WAS NEVER MUCH of a disciplinarian. He never told us *not* to do anything, because he figured, why put ideas into our heads? It was infuriating, like being in jail. So we never did *anything*. We had no idea what we were missing, really.

And we had absolutely no idea that my dad had been a bit of a hell-raiser in his youth at St. Gregory's. We never heard any of these stories, because my aunt, who knew them all, lived in the convent as a Carmelite nun, with a vow of silence. Until I was seventeen, I'd only seen her during visiting hours at the convent, in full habit, talking through a screen like in old prison movies. After twenty-five years as a Carmelite, she changed vocations and became a Dominican, which meant she could now do counseling for hospital patients and wore groovy white pantsuits instead of a habit. She also came to visit more, and told us stories of my dad's wild youth. We were appalled to learn how much trouble we had missed out on; maybe the secret of parenting is having your big sister take a vow of silence.

He gave us permission to take a day off from school whenever we wanted, with the result that none of us ever took a day off from school. His way of parenting my sisters and me was to compliment us for things we weren't even doing, but his compliments made us want to start doing them. If he was annoyed by my impatience, he would compliment me on my patience. Somehow that would instinctively make me strive to be more patient. Why? I don't know. Things that come so torturously to me are a breeze for him.

My dad assumes the best in people. It can be maddening. He

voted for Gerald Ford for president in 1976, even though he was a Democrat. Why? Because 1) he felt bad for Ford, 2) he knew Massachusetts was going Democrat anyway, and 3) he didn't want Ford to be completely humiliated in the popular vote. He still thinks Ford did the right thing by pardoning Nixon. We argue about this every couple of years. My dad says it was important for Ford to pardon everybody and put all that trouble behind us. When I point out that this is not what happened—Nixon was the *only* Watergate conspirator who got pardoned, and the others went to jail for him, while he got a mansion out in Southern California with a fat pension and a valet—my dad counters, "But that doesn't make sense."

That's how my dad sees the world. He is kind to people because to him it just makes sense. That doesn't make sense at all.

He always had confidence in me, so when he taught me things, like driving in the rain or tying a tie, he assumed I would get them right. He's always amused when I don't. The night he taught me to shave, I wish I'd asked more questions. I didn't know this traditional father-son interaction was happening until he came home from work one night with a bunch of shaving supplies. He'd rehearsed for our lesson, but I hadn't, and I'm still not sure I learned the right technique. Shaving is a daily task that I manage to get wrong every single day. There's a spot on my right jaw that I never reach on the first pass, forcing me to reshave my jaw three or four times. I wish I'd asked my dad when I was sixteen whether this was a family trait, or a standard shaving glitch, or just me. But the main thing my dad wanted to emphasize is that

shaving isn't a "do it all at once" task—it's a "do it every day" task. His shaving credo, which he repeated at least three times, was "Whatever you don't get today, you'll get tomorrow."

I am a "do it all at once" kind of guy. I am not a "do it today, then start over from scratch and do it again tomorrow" kind of guy. I get flustered at tasks I am unable to complete, which is almost all of them. Things like grief and love and mourning. Things like being a husband, or being a son. The hard work of life that doesn't get done, because there's always more of it to do—I have trouble wrapping my head around these things. Whenever I was overwhelmed by the job of mourning, I recalled the words of the comedian Stephen Wright, who boasted, "I walked my dog all at once. I took him to Argentina and back, then I told him, 'You're done.'" I wish.

Dogs do not accept this logic, which is one of the reasons humans seem to need dogs around, just to remind us that nothing works this way, unfortunately. You have to walk that dog every day, with no mileage credit for what you did yesterday. Work doesn't get finished, and neither does play. You start over every day, and what you don't shave off today will be waiting tomorrow, until you run out of tomorrows and leave behind more work for others to do. You fight the sensation of getting overwhelmed by the repetition of things. You build up some momentum but you don't get a climax. You don't even know if you've done your day's work right, because nothing's ever really done. That's very disconcerting to me.

That's what being an adult is like, at least in the version of it that my dad passed on to me. The work of fatherhood must be

like that, too—when he was the age I am now, I was already a sullen college student, and I can barely imagine the aggravation of having to live with a nineteen-year-old version of me, who was just like me now, except more so. That nineteen-year-old boy and I have our differences, but we both like to focus on one task, do it all day, do it to death, do it clean, and see it through to completion before moving on to the next task. It's constantly a challenge to leave today's work undone for tomorrow. We think adulthood would be simpler and more efficient if the world had the sense to conform to our rules.

My dad has done all sorts of tasks for me that I will never live long enough to find out about, thing I'll never notice, much less thank him for. These are the tasks that do not have heroic completions or satisfactory results or purple ribbons. These are adult tasks that call for patience and diligence. These things seem to come so naturally to my dad; he always seems amused at the way others of us—like his son—have to keep learning them.

TWELVE

11:19 p.m.:

Bold Thady Quill

"Bold Thady Quill" is an old Irish drinking song about the ad-
ventures of a hell-raising boyo who carouses and blackguards
and chases women and fights and barely staggers into the next
verse. "For rambling, for roving! For football and courting! For
drinking black porter as fast as you fill! In all your days roving,
you'll find none so jovial, as our Muskerry sportsman, the Bold
Thady Quill!"

This song reminds me of my mom, because it's the song I sing
for her on special occasions. I sing it on the phone and in person,
on birthdays, wedding anniversaries, any time we're together
and the hour gets festive. When it's Thanksgiving and the fire is
lit and the stingers are poured, it's only a matter of time before
my mom declares, "Let's have a sing-song," and we all start sing-
ing the old Irish songs. Over the course of any holiday weekend,
I will sing "Bold Thady Quill" for my mom until everyone's sick
of it.

I didn't realize how much my mom loved this song until one day years ago when we were visiting cousins in Ireland. On the road west out of County Cork, the car broke down, so we stood waiting for the tow truck by the banks of the River Lee. I casually sang a few lines from this song—"the great hurling match between Cork and Tipperary, / 'Twas played in the park on the banks of the Lee"—and my mom recognized the tune. So I sang it until the tow truck came, and if you've ever waited for an Irishman to show up, you know that gave us plenty of time to get though all the verses. My mom and I were each surprised to discover how much the other one liked the song. I've been singing it for her ever since.

We know this song from an old Clancy Brothers record that her mother had, called *Come Fill Your Glass with Us: Irish Songs of Drinking and Blackguarding*. The liner notes claimed Thady Quill was a real-life athlete from Cork, still alive at the time the record came out, a star in the Irish sport of hurling. (Ever watch a pack of grown men attack each other with clubs for thirty seconds? That's what a hurling match looks like.) But I really know nothing about Thady Quill, or whether any of his exploits in this song ever happened. For me, he's just the guy in this song, and I feel like I've come to know him, because he's part of my duties as a son. I take my mother's car to Jiffy Lube, I go through her fridge and throw out all the expired salad dressing, and I sing her "Bold Thady Quill." I always will.

I'M ALWAYS SINGING FOR MY mom, in a way. She only has the one son, so she doesn't have the luxury of having both a loud son and a

quiet son. I started out quiet, but I've learned to get louder for her. For my last birthday, when Ally and I were heading out to Sing Sing for karaoke, she asked me to sing an Elvis song for her. (I did "Can't Help Falling in Love.") My mom likes her children loud; she made us this way. So I feel close to her when I sing. I'm always trying to impress her. Singing is just one of the ways.

She's the most passionate person I have ever encountered in my life, and when she has something important to say, she doesn't beat around the bush. One day, right after I moved to Virginia, she called me up. I had just started my graduate studies in the English department. I was brimming with plans and ambitions. She listened to me rave for a few minutes about everything I had gone there to achieve.

"You know, you have impressed me," she said. "You have impressed me, permanently. Your father and I are both very pleased with you. You don't have to do anything else the rest of your life to impress me."

Why did she say that? I don't know. I've never asked her. I'm not as good as she is with a blunt question like that. But I wonder all the time. How did she know to say that? Did she realize she had just said a few words that I would remember for the rest of my life? For that matter, did *I* realize? How could I? I was only twenty-three. How could I begin to have any idea how many of my friends would live their whole lives in hopes of hearing their mother say something like that?

I mean, I already knew I impressed my mom. She's not shy. She had loved me fiercely my whole life and she never let me (or anyone else in earshot) forget it. So I knew. But hearing it out

loud is different. And I will never suffer those particular fears and doubts. I can go right on trying to impress my mom, because I'm never worried about whether it will work. I always know, because she came right out and said so.

Again, it's one of those moments that probably can't be fully understood by those of us who aren't parents. What did she think after she said that? Did she understand she had just changed my life? Did she know it was a big deal? In her case, I absolutely think she did. My mom isn't shy about saying things, when they need saying. But she knew this was something she wanted to say. Whatever happens the rest of my life, I will never *not* hear these words.

Once in my teen years, in the classic style of any ostentatious and insufferable adolescent seeker, I gave my mom a copy of the *Tao Te Ching* for her birthday. She opened to a random page and read aloud, from chapter 13: "Accept being unimportant." Then she closed the book, handed it back to me with a smile, and said, "See, I could *never* accept being unimportant."

She never is. She has always been involved and decisive. She raised me to distrust limp handshakes. One of the things she imprinted on me was flinching when people say "myself" as a euphemism for "me." The way my mom sees it, if you're talking about yourself, saying you want something, saying you don't like something, making a demand—go ahead and say "me." It saves time. My mom worked all her life as a teacher in the Boston public schools—she values direct communication, and she's good at it.

Mom takes pride in telling people, "I am a shaped-up mother."

When she was training student teachers, she would tell the class to speak their minds when they had any questions or complaints. "Don't be shy," she says. "I have three daughters. They shape me up. So tell me what you think straight to my face. I'm used to it."

Me, I feel more adept at writing words than saying them out loud. I guess part of the reason I love singing words is that it's less scary than speaking them. These Irish songs will always be important to me because they're the songs I sing for her.

OUR FAMILY, LIKE ANY IRISH family, knows a lot of these songs. My sisters and I grew up hearing them on the Irish Hit Parade on WROL every weekend. Whether it's rebel songs or drinking songs, there's usually a plot, a girl, and a few killings. There are funny songs, like "The Wild Rover," that warn about the evils of dissolute living, although you have to get a pint or two into dissolute living to sing them. There are also the long, slow songs where people get shot or hanged or deported or haunted by the ghosts of Spancil Hill.

For me, these songs are mixed up with family memories, and as my sisters and I bring new people into the family, it means we bring these people into the songs. The first time I took Ally to Glenbeigh, my grandmother's old village in County Kerry, we sat in the pub as the guitarist sitting by the fireplace sang about wars and rebellions and ghosts. He did the latter-day classic "The Green Fields of France," a song that goes on for about a month. The chorus repeats the question: "Did they beat the drum slowly? Did they play the pipe lowly? Did they sound the death march as they lowered you down?" After seven or

eight verses, Ally whispered to me: "Have they lowered him down yet?"

Not quite yet. These songs go on and on, just like we do. Some of my earliest memories are visiting Ireland as a little kid, sitting around the pub watching my parents and aunts and uncles and cousins singing. I heard these songs with my grandparents. My dad's grandfather, the fifth John O'Brien in a row born in South Boston, used to play them on the mandolin. On fancy occasions, you'd hear them played on accordion by local legend Joe Joyce the People's Choice. I got to meet Joe Joyce one night in 1988, during a long night of drinking with my dad, shortly before he played my grandfather's ninetieth birthday party. He was surprisingly candid about his life's work. "You get tired of some of these old songs," he once told me. "You know, 'Danny Boy.' But you keep singing them."

When my family's together, everybody takes a turn singing—everybody has their party piece to trot out. I go for the fast ones; my brother-in-law John prefers ballads with high body counts. My toddler nieces sing "Call Me Maybe" or selections from *Annie*. (Still topping the little-girl charts after all these years, right? Amazing.) The set list might vary, but there are some songs you *have* to sing, and "Bold Thady Quill" became mine. It's an essential part of my life as a son. You better watch what you sing, if you don't want to sing it for the rest of your life.

When my grandparents came to America in 1924, they brought nothing with them except the songs. My grandmother, Bridie Courtney from County Kerry, hoped that she'd get a job, make some money, go back home, but there was really nothing to go

back to. My grandfather, David Twomey from Cork, swore he'd never return, and never did. He hated every minute of being a farmer; when I was a little kid, I asked him if he ever missed the farm, and he said, "My boy, I was so glad to be off it, I didn't know I was working." They came to America and got good jobs, she as a maid, he as a brake inspector on the New Haven Railroad; then after working his fifty years there, he became a security guard at a department store. They met soon after they arrived in Boston, at a Thanksgiving dance, and in classic Celt fashion married nine years later. By the time I was born, they'd both been living in America for forty years, but they both spoke with their native brogues, and they both loved all the old songs, a connection to the old country, "the other side," as they called it, and although they had vastly different memories of Ireland, they never thought of letting go of the songs.

My grandmother liked "Bold Thady Quill"; my grandfather preferred dance songs, rebel songs, waltzes. At that ninetieth birthday party, he took the mike to sing "Martha, the Flower of Sweet Strabane." When I was living with my grandfather, the year he turned ninety, I tried to turn him on to some of the rock bands I liked. The only one he could stand was the Smiths. During that time he told me many stories of the passage to America, two weeks on a boat, which is usually supposed to be a historically dreadful ordeal, except he said it was the happiest two weeks of his life up to that point. He'd never danced so much in his life. He had to wait until he was twenty-four to get out, which was extremely late, working his brother's farm and watching the Cunard ships sail out of Queenstown Harbor every day. When

his brother got married, he got his sister-in-law's dowry as his share of the inheritance. He spent it on his ticket to America and stayed on the deck for two weeks listening to the musicians play their way to the other side.

As long as I've been listening to rock and roll, I've been hearing that Celtic touch everywhere from the Beatles to the Clash to Bowie. I love Bono's tribute to Bowie: "Americans put a man on the moon. We had our own British guy in space—with an Irish mother." Dylan was an honorary Celt—he loved posing as Irish the way James Joyce loved posing as Jewish—but it wasn't until he wrote his *Chronicles* that I found out that the Clancy Brothers changed his life, as he copped their outlaw ballads and rebel songs.

All four of the Smiths were sons of the peat, which might explain why my grandfather liked "Please Please Let Me Get What I Want." Johnny Marr once said the sadness in his guitar came from the songs he heard in his neighborhood growing up. "I was sad when I was a little kid because the area where I grew up was very heavy. A young Irish community. A lot of drinking, a lot of music and a lot of melancholy in the music, which I was really drawn to. These really melodic Irish ballads, like 'Black Velvet Band,' which I used to love." Note: "Black Velvet Band" is one with a relatively upbeat ending, where the hero gets sentenced to seven years' hard labor.

One of the things I have learned from Irish music is that these songs are where we express our tempestuous side, no matter how strictly we might try to police our emotions in our own lives. We live out the lives in these songs—killing, boozing, carousing, weeping—that we fastidiously avoid when we're not singing

them. With an Irish song, you do not wonder whether it's a sad song or not. You can usually tell from the opening notes how sad it's going to be. In the same way, you can tell the festive songs are going to be *extremely* festive. As the old saw goes, the Irish songs are full of happy wars and unhappy lovers.

That's where we get the tradition of the Irish wake. When somebody dies, my Aunt Eileen in Dublin asks, "Did they put him down well?" In other words, did they sing and tell stories? If the mourners failed in this duty, she'll say, "Christ, they rushed him in and out of the church before he was cold."

We do not, as a rule, choke up. We let it rip. If we're going that way at all, we may as well go all the way. As the old song says, let's not have a sniffle, let's have a bloody good cry. (And always remember the longer you live, the deader you bloody well die.) Sometimes in an Irish pub I might try to sneak out after just a couple of pints ("not the full rosary—just a few Hail Marys"), and one of my cousins will clap me on the back and say, "Ah, it's as well to hang for a sheep as for a lamb," which is his or her way of saying, "You're not going anywhere." In these songs, at least, we approach our emotions with the same full-commitment approach we bring to a night down the pub. If you're going to hang anyway, hang for a nice big sheep. One night in Glenbeigh, long after closing time, I told my cousin Kevin to come stay at the guesthouse, rather than stumble back over the hill back home to Drom. He demurred. "Sooner or later, I will have to face an irate female. And I'd rather do it while I'm still drunk."

It's the same principle with these songs. Once you're in, you're in for the night. You follow the song all the way to the other side. So let's not have a sniffle. Let's have a bloody good cry.

THIRTEEN

11:32 p.m.:

Rock & Roll Fantasy

It's November 2002, and I am on a jet plane, crossing America en route to Hollywood. I am going to Rock 'n' Roll Fantasy Camp. For the next week, I will be a member of a band, for the first and only time in my life. We will stay on the Sunset Strip, rehearsing in a real studio, hitting the stage at the House of Blues, getting coached by rock stars. Maybe I'll even learn to play an instrument. Cowbell? Woodblock? Tambourine. That one's easy, right?

I'm officially attending fantasy camp for a possible article in *Rolling Stone*, which never comes to pass. (The article gets killed before a word is written—in fact, before my return flight. Why? Somebody famous dies and we lose the page, so the space gets cut. These things happen.) But I have bigger, loftier, crazier (and dumber) hopes for this week, and maybe that's because I'm more rickety and fragile (and dumber) than usual. I'm going through a spell of what is delicately termed "girl trouble," by people who are into terming things delicately, yet that is not strictly accurate since the trouble is me, and I'm a boy.

I'm not just hoping Rock 'n' Roll Fantasy Camp will take my mind off things—I'm hoping it will fix things, or at least turn me into a rock star. So here I am, tripping off to L.A. with insanely unrealistic expectations, which I guess is the only way anyone ever trips off to L.A. I don't know who my fellow campers will be. I'm not sure what playing in a band is like. I'm going as a journalist, but more than that, I'm going as a seeker, a musical incompetent who hopes to pick up a few tricks from the masters. In real life, I may sing like an air conditioner coughing out a pigeon, but they will pass their major arcana on to me. I'm going to learn a few guitar chords, I bet, finally crack how that stuff works. I will solve all my problems. Rock & roll will heal my soul. If that fails, I could always play the tambourine.

I can figure out this whole music thing. I can also figure out this whole love thing. The idea they aren't the same thing never would have occurred to me.

When I'm on my front stoop in Brooklyn, waiting for the taxi to the airport, my neighbors Charlie and Henry walk down Eckford Street, two of the many elderly Polish gents who shuffle around my block in the afternoons. They ask the question they always ask, which is if I have a girl. They see my bags packed and ask, "Where are you going? Where is the girl? You are young, my friend." I tell them I'm traveling for work. Charlie says what he always says: "Young is the time to sleep together!" They think I'm holding out on them. But I am not going to visit a girl, and I am not leaving a girl behind in New York.

On JetBlue, I read Swinburne's "Ave Atque Vale," his elegy for Baudelaire. But I get distracted by the VH1 Classic on my

personal in-flight video screen. I've never seen it before. For an MTV obsessive like me, it's an intense drug—so many videos I haven't seen in years, others I've hoarded on battered VHS tapes. As I contemplate my upcoming debut as a musician, I brood on my life as a fan, as these old songs on VH1 Classic clobber me. I drift between the poetry and the screen, which seem to flow in and out of each other. (Swinburne: "Our dreams pursue our dead and do not find." The Psychedelic Furs: "Heaven is the home of our hearts." I can't tell where one ends and the other begins.)

So I give up on the poetry and let the songs totally rip me to pieces, one tune after another, scribbling in my notebook with my light oxygen-deprived airplane head, crying great big loud ugly airplane tears. It's traumatizing for the nice old Russian lady next to me, who spends the whole flight watching the TV map as we inch closer to L.A., no doubt praying for a crash.

I am not in peak shape, obviously. I am taking a fucked-up rock & roll heart to Fantasy Camp. For some reason I worry this will hinder my experience, but if I used my brain for a minute, I would realize that a fucked-up rock & roll heart is pretty much the entrance requirement.

Over the next week, I will join a band. I will play the tambourine, which will leave gruesome purple bruises all over my thighs. It turns out that the tambourine is actually incredibly fucking hard, like so many other stupid things that look insultingly simple.

ROCK 'N' ROLL FANTASY CAMP: Isn't that redundant? In a way, I feel like I've been living in a rock & roll fantasy camp my whole

life. When I sing in the shower, I'm Al Green, or Taylor Dayne, or Thom Yorke. When I'm stuck in traffic, I'm John Bonham thumping out "Good Times, Bad Times" on the dashboard. I've seen a million faces, and I've rocked them all, though I've done most of it in front of my bathroom mirror, so I guess I've only seen one face, but I've rocked it a million times.

So band camp is my chance to take that air guitar to the stage. Rock 'n' Roll Fantasy Camp, the brainchild of rock impresario David Fishof, is based on the popular baseball fantasy camps, where average joes go to hit a few grounders to the stars (as in the great *Seinfeld* episode where Kramer drills Mickey Mantle with a fastball). Seventy campers pay five thousand clams apiece to ditch our real lives and jobs for a week. We move into the fabled "Riot House," the Sunset Strip hotel where you can still smell traces of the seventies' sleaziest rock-star excesses. We jam with the camp counselors, who are classic-rock vets: Billy Joel's drummer, Ted Nugent's guitarist, Peter Frampton's keyboardist, the bassist from Night Ranger. The dude who sang "Bad to the Bone." Bret Michaels of Poison. Vince Neil of Mötley Crüe. Sheila E. Like that.

At the end of the week, we all gather for a massive "battle of the bands" at the House of Blues, in front of an allegedly paying audience. For those about to make total assclowns of yourselves, we salute you!

When I check into the Riot House on Sunday afternoon, I have no idea what to expect. I resist the temptation to trash my hotel room (the TV is bolted down anyway), and instead I change into a clean purple T-shirt and practice my audition song, "Cat

Scratch Fever," a couple of times in the bathroom mirror. I look confident. This must be a hell of a mirror. And the tiles in this bathroom have magnificent acoustics. I sound awesome. I am going to burn this song to the ground.

The auditions are downstairs, in one of the hotel banquet rooms. "Relax, this is not a test," the brochure says about the audition. "All musical levels are welcome at Rock 'n' Roll Fantasy Camp." On a certain crude level, that's a bunch of baloney. Everybody here can play an instrument or sing, and everybody brought their axe, so I'm the douche who has to ask the roadies for a tambourine. I am already getting that in-over-my-head feeling.

My first impression of my fellow campers is that they are mostly white guys on the Lou Gramm/Larry David cusp. Many are here as a fiftieth birthday present, others for a sixtieth birthday or a wedding anniversary. For a few, it's a surprise gift—their wives drove them here and dropped them off. A few of the wives have stayed on for the week. (Around camp they're referred to as "the Beths.") About a half-dozen campers are women, most of whom are singers or cowbell players.

Everybody steps up to the judges' table and plays a song, after which the judges will split us up into eight bands. The head judge with the clipboard is Mark Rivera, the saxophonist in Billy Joel's band, a schmoozy Brooklyn guy fond of Catskills-style humor like "This is the Rolling Stones' 'Brown Meshuggeneh.'" I recognize him from the "Uptown Girl" video—he's the mechanic who bites his hand with desire for Christie Brinkley.

When they call my name, I step up to sing. My backing band:

Liberty DeVito on drums (another Billy Joel sideman), Bobby Mayo on bass (he played all those keyboard solos on *Frampton Comes Alive!*), and Derek St. Holmes on guitar. That turns out to be the problem. I suddenly realize I can't sing "Cat Scratch Fever" in front of Derek St. Holmes, who played on the original Ted Nugent version. I've desecrated this song countless times in karaoke bars, but I can't look this man in the eye and do this to his song. I just can't. "Hellooo?" Derek says. "What song are you gonna do?"

In desperation, I call out the first easy song that pops into my brain: "Roadhouse Blues," by the Doors. I have to confess to my backing band that I've never sung it sober before. "That's okay," Bobby Mayo says. "I've never *played* it sober."

Derek yells "Get this man a beer," and then he lurches into the riff. I do my best. No microphone, no beer, no shower tiles, no mirror in the bathroom, just me and my pitchiest Lizard King imitation. I keep my eyes on the road and my hand upon the wheel, but I'm driving the song into the ditch and I know it. By the second verse, my fellow campers stare at me like I'm Clint Eastwood in the opening scene of *High Plains Drifter.* Everybody feels a lot better about their chops right about now. When I'm done, the room is silent until a few campers pity-clap. A guy in a Sabbath T-shirt slaps my back and says, "That took guts." These are always ominous words, but especially when you hear them from a guy wearing Ozzy's face across his beer gut.

So what? We're all dreamers here. I figure, what the hell— some of them probably suck worse than I do. I'm wrong.

· · ·

SUNDAY NIGHT KICKS OFF THE camp festivities with a cocktail party where the counselors put on an all-star jam, cranking out oldies like "Mustang Sally" and "Back Door Man." To stoke my sense of jealousy, Derek St. Holmes and Jack Blades do an impromptu romp through "Cat Scratch Fever." Jack says, "I haven't played that one since the Damn Yankees!" Of course, he nails it.

The counselors are a fascinating bunch. In terms of the current pop charts, these guys don't exist. But right now they are unimpeachably famous, because they're in a Jonestown-style compound with seventy of the world's most hard-core arena-rock fans. There's a palpable sense of awe among the campers. Within these walls, everybody who was ever a rock star is a rock star for life. Rock & roll never forgets.

The professionals are happy to regale us with stories about the good old days of seventies decadence. Bobby Mayo has some hair-raising tales about the Frampton tours, when our hotel was truly the "Riot House" of *Almost Famous* repute. "One night I jumped off the roof into the pool," he recalls warmly. "It was fun. Well, I assume it was fun. I just woke up the next day and my clothes were wet."

There's also Marshall the Mean Roadie, who torments me all week. He spent years out on the road with Mötley Crüe and Guns N' Roses; he's said to be a living legend in the roadie biz. He supplied me with my high-end tambourine and maracas, but that means he sees right through me as a nonmusician, and he looks at me through his coke-vial glasses with contempt. He knows I write for *Rolling Stone*, so he keeps telling me Mötley Crüe groupie stories and then saying, "Off the record, man!"

Every single one of these stories I already know from *The Dirt*.

The cocktail party really takes off when Mark Farner makes his grand entrance. He was the front man for Grand Funk Railroad, and everyone can tell right away: This man carries himself like a rock star, pure confidence, all muscles and mullet. All week, he doesn't wear a single shirt that has sleeves. Tonight he walks in, not one bit surprised to see a room full of people waiting for him, and assumes they want a song. He walks right up onto the stage, picks up the nearest acoustic guitar, and strums the Grand Funk song "I'm Your Captain," which I haven't heard since I was a kid. You remember this one. "I'm getting closer to my hoooome," that's the chorus. Everybody in this room knows every word. We're with the band. Wait—we're *in* the band. We're an American band.

By the end of the night, some of the half-dozen female campers are already complaining about getting hit on by the menfolk, some of whom were clearly hoping for a little more "Hot Blooded" and a little less "Cold as Ice." One camper—let's call him Tommy—keeps orbiting another—let's call her Gina—and invading her personal space. She's the only youngish blond California girl here, and she has already shaken off a few dudes, but this guy can't take a hint. His wedding ring disappears somewhere between his second and third beer. It's comical to watch, if you don't happen to be Gina. He snuggles up to her and rests his beer on the table behind her, so he can casually drape an arm around her. I haven't seen that move since college. Neither has she. Gina turns her head to me and rolls her eyes over her shoulder. This could be a long night.

Gina and I become best friends all week. She's a metalhead and a paralegal. We hang out between rehearsals and trade Bon Jovi stories. Within five minutes of meeting me, she hands me her purse to hold so dudes will stop hitting on her. How can she tell I know how to do this? How can she tell I'm not going to hit on her? I have no idea. She just knows. It's one of the most maddening things in my life—people's first impressions of me tend to be more accurate than my own impressions of me.

When Mark Farner is up onstage singing "I'm Your Captain," Gina sings along—she loves this song. As that guy Tommy sidles up to slide a hand across her lower back, she turns to me again and mouths the words of the song: "Keep this stranger from my door."

Later, when he tries wheedling her up to his hotel room, she comes up with a classic exit line: "I need to go back to my room and take out my contact lenses." Unfortunately, she says this in the parking lot, where she gets overheard by Marshall the Mean Roadie. For the rest of the week, every time Marshall sees her, he yells, "Hey babe! I got contact lens fluid out in the van!"

JACK BLADES IS EVERYONE'S FAVORITE camp coach. In the eighties, he was in Night Ranger. In the nineties, he was in Damn Yankees. He's been married to the same woman for more than twenty-five years, which has to be either a symptom or a cause of his bizarre niceness. One night in Toronto, back in the eighties, Jack was out on the town with Mötley Crüe. He had just done backup vocals on *Dr. Feelgood*. Jack was feeling really metal, so when he and the Crüe hit the tattoo parlors in a drunken haze, he decided to

cap his evening by finally getting his first tattoo. But Nikki Sixx and Vince Neil wouldn't let him because they were *scared of his wife*. They said, "Dude, you're not getting a tattoo until Mollie gives us permission." It ruined the moment. (Vince confirms this tale later in the week, when I ask him. He says, "Mollie woulda *killed* me.")

Two of the many fascinating things about Jack Blades:

1. If anyone calls his band "NIGHT Ranger," he corrects their pronunciation: it's "Night RAYN-ger." Nobody except Jack has ever pronounced Night Ranger that way.

2. If anyone mentions Night Ranger's most famous song, "Sister Christian," Jack goes into this well-rehearsed disclaimer that he did not write or sing "Sister Christian"; it was written and sung by the band's drummer, whereas Jack wrote all their other hits. It doesn't come off as grumpy—more like he doesn't want to accept credit for someone else's song. But he's serious when he makes this speech, and it becomes clear why, since everybody, as soon as they meet him, raves about "Sister Christian." It must drive him nuts. But it's immaterial to me, since I am the kind of music geek who already knows not to mention "Sister Christian." My favorite Night Ranger song has always been "Don't Tell Me You Love Me,"

and I already know Jack wrote that one, and
it is a pleasure to see him puff up his chest
when I tell him how much I love it.

That defines the turf I'm on: This is the one spot on earth
where it is a social asset to be able to tell Night Ranger songs
apart. Being a rock nerd here is not a flaw or a quirk or a pathetic
disorder. It's good manners. This will probably never happen to
me again.

BRET MICHAELS IS OUR MOTIVATIONAL speaker Monday morning. "We
were the poor poor poor man's Kiss," he says. "All spandex pants
and leg warmers. It looked awesome at the time." C. C. DeVille
was also supposed to be here this morning, but didn't show, leav-
ing Bret alone to tell how he wrote "Every Rose Has Its Thorn"
in a Dallas laundromat after his stripper girlfriend dumped him
over the phone. He tells me, "For a real rock & roll fantasy camp,
you gotta pass out with a beer in each hand in a motel room full
of groupies. Maybe that's Week Two."

After that, the shuttle bus takes us to one of Hollywood's most
famous recording studios, S.I.R., for our first rehearsals. The
judges have assigned me to Band #4, which turns out to be nine
guys, nodding as we plug in and tune up.

Meet the band!

—**Scotty Seville** on guitar. He's thirty, a born Southern
rocker, with rooster-blond hair, leather boots, his name
emblazoned on his guitar strap. We can't stop calling him

"Scotty Seville"—it's such a rock name. He has a band back home in Charlotte, North Carolina, called Flight 6. His day job is working construction. For him, this camp is all part of a larger career plan. "I live for it, man," he tells me. "That's what I work all week for. That chance to play."

—**Ben** is a twenty-eight-year-old cinematographer, on guitar. He likes Southern rock but he admits, "That eighties hair metal is what I really love." We fail to convince the rest of the guys to play Cinderella's "Coming Home."

—**Jim**, a forty-four-year-old drummer from Tampa, where he runs a home building company and plays in a bar band called Seven Miles. He tells anyone who will listen, "Aaaah, there's only two things I give a shit about: my car and my music. Fuck the rest of it. Fuck it hard."

—**Jack**, forty-six, is one of the few bassists in camp, as well as the only black guy. He predicts (correctly) the camp photographers will hover around trying to get him in every picture for the next brochure. His band back home has the awful name Uncle Tom. (They had the name *before* he joined, he says, not that anyone asked.) Camp was a surprise present for him—his wife, Rose, drove him here, secretly stashing his bass in the trunk, telling him they were going to visit the in-laws. He's in an understandably cheery mood.

—**Rose**, Jack's wife, hangs out on the couch in the practice room, criticizing the rest of us and pointing out our mistakes. When we do "Good Lovin'," she has issues with the way I pronounce the word *lovin'*. At first I can't stand

her, but her critiques swiftly become not just endearing but inspiring. She really cares about this band. She's in love with the bassist and wants the rest of us to make him sound good. What's not to admire about that? Nothing. That's why Rose is the key ingredient of the band and I end up dedicating "Good Lovin' " to her from the stage.

—**Finn**, our shy and mysterious Danish percussionist, is too laid-back to rehearse. I don't hear him say a word all week. If you can believe it, he plays rhythm tambourine to my lead.

—**Fred** is a fifty-three-year-old financial advisor from Delaware, a master of the Hammond B-3 organ. He's an old friend of Mark Farner's—I think he did his taxes or something.

—**Oliver**, twenty, is a punk rock college student from Grand Junction, Colorado. He's a drummer, a big NOFX fan, and the only dude in the entire camp with piercings.

—**Ed Hill**, a seventeen-year-old kid from suburban Illinois, who got here by winning a Chicago radio station contest. He's too painfully bashful to say hi to the rest of us. He leans against the wall, hands in pockets, a guitar pick in his mouth so he doesn't have to say anything.

—**Me.** Nobody told me tambourine was so hard. I bang it against my thigh hard enough to do lasting damage. The doctors will shake their heads sadly and say, "He rocked too hard. He'll never come back."

Band practice gets off to a sketchy start. Ben and Scott both want to sing John Cougar Mellencamp's "Pink Houses," so we

spend almost two hours on it. All I get to do is yell, "Gulf of Mexicoooo!" I hate this song. Then, during a lull, Ed casually strikes up Jimi Hendrix's "Voodoo Child," and suddenly we realize he is some kind of demented boy-genius guitar freak. He goes into "Johnny B. Goode" and we all race to keep up with him, as he hams it up—he plays it with his teeth, plays behind his head, falls on his knees, the whole bit. Jack says, "The boy's possessed."

Suddenly brimming with confidence, we bash out every song we know: "Paradise City," "Sweet Home Alabama," "Break on Through," and about twenty minutes of "Wipe Out" to give the drummers some. This is crazy fun. As Fred plays the majestic organ intro to "Free Bird," I realize that I have just heard someone unironically yell for "Free Bird," and I was the one yelling it. Playing in the band is every bit the rush people say it is. Only the adrenaline keeps me from noticing, until I hit the men's room, that my thighs are swollen and aching and I will probably die. But damn, I am taking that tambourine down with me.

Over the dinner buffet, the campers jam on "Gimme Some Lovin'," with Mickey Dolenz on vocals and Spencer Davis on organ. A bunch of us sit in the corner with ziti on paper plates and we talk about our love lives. That happens a lot this week. It's surprising how we end up spilling our secrets to each other, almost like the rock & roll makes it a safe place to confess. It's like the erotic intimacy of jury duty—you can't talk about the trial, but you're cooped up together all week, and you end up telling each other things you don't tell your friends.

Sarah from Ohio is here because she needs to sort stuff out

and make some life changes. She needs to get rid of the boy she's dating and she needs to figure out how the next one will be different. It doesn't seem strange at all that she's telling this to strangers. This afternoon I watched her drop to her knees to moan the final verse of "Stormy Monday," so there's a degree of intimacy. We all have a lot to say about our love lives. For a few hours, the torments in our hearts are explained by the gospel of rock & roll. Every cowboy sings a sad, sad song.

Back at the Riot House, up in my room, seeing the gnarly purple welts all over my pale, naked flesh, I console myself that at least I don't have a girlfriend back home who'll want me to explain how I got all these bruises.

THE KINKS' DAVE DAVIES GIVES us a Q&A session, guitar in hand. It quickly becomes apparent that I am on music-nerd duty today, because nobody here knows any Kinks songs besides "Lola." So I raise my hand to ask some annoyingly precise questions about songs Dave actually wrote. "Susannah's Still Alive" is one of my favorites, a song about a tough old widow who still wears the locket of her dead soldier. Dave is surprised to be asked about it, but he plays it for us, and then he tells the incredibly sad, long, and true story of Susannah. (It's in his book, which I really wish I'd read before I met him.) She was the love of his life, but her evil parents tore them apart, and for years they never knew why. If I knew how sad the story was, I wouldn't have asked. But people ask him more questions about Susannah. Everyone buzzes about Dave Davies and his touching tale for the rest of the week.

Over breakfast the next day, we watch a screening of the

brand-new episode of *The Simpsons* where Homer goes to fantasy camp. (The biggest laugh comes when Keith Richards gives Homer a lesson on how to escape groupies.) Campers are already grousing about band politics and their goddamn prima donna lead singers. Having all these people around to talk music with is surreal. This is an environment where you can start a conversation with anyone and know that it will only take three minutes or so to arrive at the topic of Jon Bon Jovi.

When Gina and I natter over our Frosted Flakes about the deep cuts on *Slippery When Wet*, we're instantly surrounded by strangers eager to debate the merits of "Wild in the Streets" versus "Never Say Goodbye," or reminisce about live shows they've seen. Bon Jovi is easily the most popular and most discussed band here, more than the Beatles, Stones, or Zeppelin. (Oh, and "Wild in the Streets" is *much* better than "Never Say Goodbye.") Gina claims to have the true inside secret scoopola of why Alec John Such was kicked out of the band, but she and I will have to save that discussion for after camp because Bon Jovi–wise, these walls have ears.

Playing with the band is blowing my mind. I have become obsessive about my tams. Sorry—my tambourines. By now, my legs are in horrible pain, and I can barely walk. I start taking my tambourine with me into the bathroom, because I read somewhere that Eric Clapton used to do that with his guitar, so I learn to balance the tambourine on my head.

During rehearsal, Carmine Appice from Vanilla Fudge wanders in. I stand in back, shaking the maracas as we wail on one of Scotty's originals, a power ballad called "Flowers and Flame."

Carmine Appice stands and listens in his paisley top and purple velour pants, holding a cup of coffee. He does not smile. After our big finish, he glowers silently for a moment and then fixes his stone gaze on me. "Can you even *play* maracas?"

He seizes my maracas and demonstrates a basic shake. "You have to find a groove," he commands, making me play solo over and over while the rest of the band watches. For the next few minutes, he drills me in front of the guys, bringing shame upon us all. For the rest of the week, every time he sees me, Carmine lifts his arm and gives me an angry air-maracas shake.

I stay up late drowning my sorrows at the hotel bar drinking Jameson's with Nick, a forty-eight-year-old tax assessor from Florida. Nick's here because his fiancée called off the wedding and left him. He took the money he had saved up for the honeymoon and spent it on fantasy camp. "It's like Dave Davies was saying," he tells me. "Once you love somebody, you can't get them out of your system. You think you know somebody, but they always have a secret other side, but it's too late, they're already mixed up in your blood. You can never know them." I'll drink to that.

SOMETHING I AM LEARNING ABOUT myself: I am freakishly scrupulous about rock stars' feelings. I want them to be happy, even if I'm not a big fan of their music. I overworry about how rock stars feel. I didn't realize I was wired this way. It's a problem, not a virtue. Rock stars have enough problems without me.

A few years ago I met Johnny Marr in a bar and I had a sudden flash of overthunk fan etiquette: Maybe I shouldn't mention

the Smiths. He must get sick of hearing about the Smiths. Sad memories. He's heard it all before. Give the guy a break. So I felt obliged to tell him I once saw him play live with the Healers, a band he was in for about ten minutes, long after the Smiths broke up, although nobody remembers, because as even I have to admit, the Healers sucked for all ten of those minutes.

But "I saw the Healers once" turned out to be the Wrong Thing to Say. He was weirded out that I mentioned the Healers, and his face clouded up. He seemed uncomfortable, like he wondered if I was "taking the piss," as English people are wont to say. After that faux pas I couldn't really bring up the Smiths as a BT fucking W. So I stepped aside and watched, as every kid in the bar, dozens of them, lined up to tell Johnny Marr how much they loved the Smiths, and he was cool to every fucking one of those kids, and he loved hearing them say how much the Smiths meant to them, why wouldn't he, he wrote those songs, and I stood there feeling like Mr. Shankly or something, branded with the shame of having said the Wrong Thing to Johnny Marr, one of my favorite rock stars who ever lived, and one who I always daydreamed about sharing a pint with, except when it actually happened I was clumsy and shy and I blew it. Rock & roll is like that sometimes. Most times.

There are lots of musicians here this week, and I meet them all, either because they're down-to-earth people who like talking to fans (George Thorogood, what a mensch) or because they find out I'm from *Rolling Stone* and they want to complain about something somebody wrote when I was in kindergarten (nice to meet you too, Eric Burdon). They're all absurdly nice (except Eric

Burdon). Even when Carmine Appice chews me out it's because he cares. Sheila E gives me a pep talk about my sense of rhythm; she tells me she hears the tambourine sound as "ka-ching," because that's how she made her dough. I tell Bret Michaels about the Poison show in 1988 where he spilled beer on my little sister in the front row, and though it makes him nervous for a minute about *maaaybe* where this story is going, he claims to remember the show, the touching insincerity of which is almost embarrassingly sweet of him.

But no matter who it is, I ask too many questions. I have trouble turning down the volume on that *Rain Man* rock-geek thing. It's a sorry situation.

The rock stars are here to do music clinics, or to jam with the campers, or just to do grip-and-grin photo/autograph sessions. It's always interesting to see how some rock stars can handle this part of the life and some can't. Some actively *love* talking to fans; others put up with it like good sports; others roll their eyes. I have never seen a human being who isn't a fourteen-year-old girl do as many eyerolls-per-minute as Vince Neil.

Eric Burdon refuses to sign autographs except for people who are buying his new book, which isn't really how things are done around here. But it's funny to see his face when people ask him how he wrote hits like "House of the Rising Sun" or "We Gotta Get out of This Place" or "Don't Let Me Be Misunderstood," none of which he wrote. He only asks to talk to me after he hears there's a *Rolling Stone* writer on the premises, whereupon he shares his feelings about the two dullest topics any old rocker ever wants to discuss: 1) He's working on a new album that ranks

with his finest work, and 2) *Rolling Stone* never appreciated his genius in the seventies. Believe it or not, I *have* heard these before, and while I'm enough of a pro to listen sympathetically to the first one (which old rockers do often sincerely believe, and why not, good for them), the second sends my normally trusty eyeroll muscles into Vince Neil mode. The sad part is that Eric fails to exploit the rare (I assume) opportunity of being face-to-face with somebody under sixty who's a fan of his music, one who would have been happy to massage his ego by quizzing him about the gnome symbolism in "Spill the Wine."

George Thorogood is the opposite. He's easily the most articulate, generous, and ego-free of our guest speakers. He declines to sit on a stool ("folksingers sit on a stool—blues singers sit on a chair!") so he stands and shakes hands for upwards of an hour, letting us all pump him for stories about Muddy Waters and John Lee Hooker. Some dudes are just cool, I guess.

I'm so not one of them. I'm a combination of two horrific personality types, an encyclopedia-minded data-storage-facility rock geek and a cripplingly polite firstborn Irish son. It's a deadly combo, and it means being unable to chitchat with these musicians without making it all complicated. I'm overzealous to please in the most irritating way. When I run into Mickey Dolenz, and gush about the Monkees, I worry about his feelings. I want him to be marginally happier after meeting me than he was before. Why? I have no idea. It's got something to do with gratitude—anyone who goes through the dirty and dangerous business of spreading music through the world deserves a well-informed compliment. But what if he doesn't like to talk about

how much I love the Monkees? (It turns out he does. Nice guy, Mickey Dolenz.) I would hate to meet me if I were a rock star.

On Thursday, I meet one of my main men, John Waite, but I decide I shouldn't mention "Missing You," because I know he gets reminded of that song a zillion times a day and there are other songs I want to thank him for. So I tell him how much I love his version of "I'm So Lonesome I Could Cry," from his 1995 album, *Temple Bar*. Fortunately, in this case, it's not the Wrong Thing to Say. "I have to shake your hand for that," he says, and indulges me with a long discussion of his underrated nineties work, at which point he's the one who brings up "Missing You," as if he's suddenly worried I haven't heard that song. "I've never sung it without loving it," he says. "I'm lucky. A lot of artists have a famous song they hate."

Damn, John Waite. That's so horrible I can't even think about it.

I want the musicians to feel appreciated. I want them to feel people were paying attention all those late nights, all those lost years, when they must have felt like they wasted their lives on a dream. I want rock stars to be content, even though the gig of being a rock star is inherently contentment-denying and soul-crushing and bitterness-magnifying and satisfaction-thwarting, and even though it's well documented that nobody devotes their lives to music unless they are permanently insane. I'm just trying to make the most miserable people on earth feel a little less miserable. I'm asking too damn much.

Why am I like this? Is it because I want to show off? Is it because I want extra credit for all my extra listening? Is it an ego thing where I'm trying to impress them with obnoxiously

knowledgeable insights? Or is it because I want to reassure them their lifetime of music was spent wisely? I really don't know. But remembering which dude in which band sang which song, or knowing every dusty nook and cranny of their discography— it's like an obnoxious party trick I can't stop doing. This is the one thing I can do to make them happy, so it's compulsive. (If I do it and it bums them out, as in Johnny Marr, that miserable memory haunts me forever.)

Everybody knows the story about John Lennon walking into the fancy French restaurant where the violinist serenaded him with "Yesterday," which was a Paul song. John *loved* telling this anecdote in interviews. But I hear that story and I feel bad for the violinist. He wanted to make John happy. Nobody takes years of violin lessons so they can ruin John Lennon's dinner. He just played the wrong song. I know his pain.

I'm not alone, of course. Everybody here wants to thank the rock stars, in their own way. So this is the special thing I can do here, instead of actually playing the notes, which is what everyone else here came to do. These people can take the rock stars' music and echo it back to them. That's what I've always wanted to do, but can't. I seethe with envy when I meet Barry, the fifty-four-year-old dermatologist from Florida who played the organ parts on the Mark Farner jam. "That moment, 'I'm Your Captain,' with Mark—not only did I sing that with him, I sang it for him. I will carry that memory with me the rest of my life."

And I'm jealous. I don't even like "I'm Your Captain," but I'm jealous.

• • •

TONIGHT'S THE NIGHT WE TAKE it to the stage. Our final rehearsals are downright cocky. We're the only band performing an original song, the one Scotty wrote. All the other bands have heard about our teen guitar whiz, and they're pissed, which is awesome, so we officially dub our band the Unfair Advantage.

Fred sits at the Hammond B-3, working on his "Good Lovin' " solo. "I've been trying to get this down for twenty years," he mutters. An old hippie studio dude who resembles a tattooed Santa Claus offers to help. He slips out his cell phone and calls the guy who played the solo, the Rascals' Felix Cavaliere. Fred asks, "So how did you do that last trill?" He takes instructions over the phone and gets back to work.

As we practice "Good Lovin'," I dance around, sucking in my cheeks, shaking my hips, using the choreography known among my bandmates as "Rob's spazzy dance." My legs are on their last hobble, and under my jeans the hideous purple bruises have gotten worse, not better, and it seems obvious I will require medical attention and most likely amputation, but nothing will keep me from struttering out tonight. Stealing moves from a friend who used to model, I spin into a T-stance, and then whip around to bang the tam on my ass Benatar style. Seductive, trust me.

We have a last-minute rehearsal with Simon Kirke, the drummer for Bad Company. The camp wants to get video footage of us onstage with him later tonight playing the Bad Company song "Rock 'n' Roll Fantasy" for their promo materials. Simon tells us funny stories about partying with John Bonham. He has a foxy daughter in New York, who is the mortal enemy of a friend of

mine because they both made out with the same guitarist in the same band the same night after the same gig. For about a second and a half, I think he might be amused by this story. Fortunately, in a momentary lapse of reason, I shut the hell up.

During the breakdown, I hear Jim behind me drumming along, grunting out loud with the intensity of it all. I desperately want to prove to myself I'm part of this intensity, not just standing near it. It's important to me, personally, to be as into it as my bandmates are, not to be a pretender. I want to be inside the music. But does anybody really get all the way in? Does loving music as intensely as I do mean that I am really and truly part of the music, even though I can't play it? Or am I still on the outside? Is being into it the same thing as doing it, or is loving it being it, or what? Do real musicians agonize over these stupid ontological quibbles? Or is this yet another example of how I tax their patience? The possibility that I'm a dick, not for the first time this week, hovers before me.

Another band down the hall is rehearsing Journey's "Any Way You Want It." Somehow, that song, with its promise of infinite gratification, makes me feel a stab of melancholy. It's like the feeling Steve Perry must get when he meets a woman who loves to laugh and loves to sing but doesn't love the lovin' things.

WHEN WE TAKE THE BUS to the House of Blues, we're shocked to see hundreds of people in the crowd, only some of whom are relatives. (They're here for the all-star charity benefit jam that follows our Battle of the Bands.) The coaches are here to watch, too. "I've been in worse bands," Liberty DeVito tells me at the bar.

"Hell, I've been in worse bands that were getting paid." We're scheduled to go on last, and we already know it's to spare the other groups the humiliation of following us. When the first band hits the stage, mass euphoria sets in; after waiting all week, we finally see our new friends kick out the jams. Hey, that's Gina rocking the cowbell in "You Shook Me All Night Long!" That's Christy belting "I Want You to Want Me"! That's Dan shredding to "All Along the Watchtower"! I am so proud. Everybody buzzes around the room with a manic joy that's new to me, at least, trading "you rock!"/"no, *you* rock!" high-fives.

When it's our turn, like most American males faced with a live mike, I go into *Kiss Alive!* mode. "You wanted the best and you got it! The hottest band in the land: The Unfair Advantage!" We do our three songs: "Good Lovin'" (Jack sings the first verse, I do the second), "Flowers and Flame" (twice as fast as we played it in rehearsal), and "Johnny B. Goode," where Ben sings and Ed makes every guitarist in the room feel a little queasy, milking his whole teeth/knees/upside down/behind the head routine. The sweat pours out our bodies like the music that we play. For our grand finale, Simon Kirke sits in with us for the unofficial camp theme song, "Rock 'n' Roll Fantasy." My role is to yell "fantasy!" over and over, and somehow that feels right.

The next morning Gina will drive me to the airport. We will meet in the Riot House lobby and go get a nice long overcaffeinated, overpancaked brunch at Mel's Diner, which used to be the Sunset Strip rock & roll hangout Ben Frank's. She will spill her alleged Alec John Such gossip and I will feel a tremendous

sense of well-being, like everything in my life is absolutely good. We will head off to LAX in her convertible, blasting one of her bootleg live tapes from the *Slippery When Wet* tour, and I will think, here I am cruising down Sunset Boulevard, a cool blond California girl at the wheel, top down, sun out, listening to a Bon Jovi concert. This is the most American moment of my life. We will email next week and I will ask, because I know I will never get another chance like this, how did you form a first impression of me? How did you know I wasn't going to hit on you? She will reply, "I just knew." But I will ask, How could you tell I knew how to do the thing where I hold your purse? And she will write back, "No, you taught me the purse thing. I didn't give you my purse, you took my purse and held it so they'd leave me alone, so I knew," and I will remember it differently but she will leave it at "I just knew" and I will spend the rest of my life wondering what she means.

FOURTEEN

11:47 p.m.:

Hot Legs

1

Nice try, Oedipus, but there are in fact three ages of man:

1. He thinks Rod Stewart is cool.
2. He doesn't think Rod Stewart is cool.
3. He **is** Rod Stewart.

No man ever plans to turn into Rod Stewart. It just happens. There are days when I dread this fate. And then there are other days when I think every minute of my life I don't spend being Rod Stewart is a waste of time.

In his younger days, Rod the Mod was a rambling rock & roll rogue, a devil-may-care ladies' man charming the world with his tales of romance and adventure. By the time I got to him, Rod was used up, a grim blond Hollywood Casanova with a vacant jet-lag smile on his face that says "if it's Tuesday this must be

Wednesday." Yet this was my Rod. I was fascinated by his seventies album covers: his sozzled grin, the way he lounged around in pink satin kimonos, his hair spiked up in a state of permanently postcoital bed-head.

You can see your future in his dazed grin, the one he flashes on all his album covers. The grin that says, "I'm all right, me. The tonsils may be a tad roughed up and I can't get out of this leopard skin catsuit because it's been three days since I saw the Danish bird who zipped me in. She disappeared between the lobby and the limo. But don't worry, I'm just here to entertain. And now, if you please, the boys in the band and meself would like to sing you a song about me passion and me pain. It's called, 'Hot Legs.' "

Rod faces everything with this serene smile of detachment, as if his life is this great joke he's stumbled into. Rod's smile charmed me when I was a little boy. I had only the vaguest idea of what that smile meant, partly because I was too young to have a clear idea what alcohol was, and I knew nothing about hotel rooms, hangovers, divorce lawyers, paternity suits, stomach pumps, all the other clichéd accoutrements of a rock slut's existence. But it's not just a smug or self-satisfied grin, and you couldn't call it stoic or tragic: It's perpetually bemused.

Everybody likes Rod Stewart, especially Rod Stewart. "I think England is fed up with seeing its pop stars being humble," he mused in 1972. "Perhaps they should—what's the word—flaunt it a bit. Me, I've never been through a humble phase." Why yes, Rod, "flaunt it" is definitely the word, and give the man credit for sticking to his guns. He *still* hasn't hit his humble phase, and nobody would ever want him to.

As a kid, when "Hot Legs" and "You're in My Heart" and "Tonight's the Night" were all over the radio, I couldn't place Rod anywhere in the timeline of pop music. His hits resembled the Irish songs I heard old men sing in pubs, but they were also rock & roll. He didn't look or sound young, and his most famous hit, "Maggie May," sounded like he dug it out of a trunk in the attic. Everything about that song feels antique, with a mandolin solo that drops in from some other century. But it has never disappeared. You will hear it somewhere in the next week. It transcends time and trends.

Rod has songs everybody knows. But he also has songs nobody remembers, least of all Rod. He had his classic rock phase, his disco phase, his synth-pop phase, and his latest phase of mom-jazz oldies covers. His early albums are full of buried treasures that are funny ("Lost Paraguayos") or sentimental ("Love Lives Here") or both ("Lady Day"). But even in his Hollywood automatic-pilot phase in the 1980s, he had great pop-trash nuggets on terrible albums nobody ever played twice ("She Won't Dance with Me," "Oh God I Wish I Was Home Tonight"), or great hit singles forgotten a week after they dropped off the charts ("Passion," "Baby Jane," "Somebody Special"). Nobody cares about these songs and that's fine with Rod, so I guess it's fine with me. These days I hear him sing "Moon River" on my mom's radio, and that's fine with me, too.

A friend did Rod's hair for a photo shoot and reported that he was wearing see-through plastic flip-flops, yet that somehow gave her an even bigger crush on him. Rod doesn't care. He will always tease the ladies, with so much romantic wreckage not

even he could recall which ex goes with which song: there's Maggie May, Hot Legs, Shanghai Lil, Baby Jane, Rita, a big-bosomed lady with a Dutch accent, enough to kill or at least bankrupt a lesser man. Everyone's favorite Rod muse has to be the Swedish sex nuke Britt Ekland, who does the orgasmic moans at the end of "Tonight's the Night." According to her excellent autobiography, *True Britt*, she was introduced to Rod by Joan Collins, which makes all the sense in the world.

Some rock stars get tragic as time passes. That would never happen to Rod. He doesn't take any of this nonsense personally. In the immortal words of Elvis Presley, "Man, I just work here." That's Rod's attitude, too.

You can see that in his face and hear it in his voice: that sense of adulthood as something that sneaks up on you, in the middle of your adventures, and conquers you. You blink once and you're on a plane, or in an airport lounge, or onstage. Or you hear one of your old songs on the radio and you think, "Crikey, I was cool once. 'My body stunk, but I kept my funk'—who wrote that line? I did? How the hell did I do that?" Then you go out on the *American Idol* finale in a tux, flounder through "Maggie May," barely hitting your marks. For a second or two, you might even have the vague suspicion that you blew it somewhere down the line. Then you bite your lip and turn around and it's showtime.

You can hear it all in Rod's voice and see it on his face, that smile that says, "Wait, how did I get here?" Every guy knows that smile and what it means, because every guy knows that sensation—that feeling of being trapped in your own life. We

know that smile because Rod taught us what it looks like, and we recognize that smile when we see it in the mirror, or on the faces of our friends, at weddings, anniversaries, christenings, or ordinary afternoons. It's the smile of a man realizing he is no longer a kid, and although he has no idea how it happened, he's pretty sure it would make a cool story if he ever gets a spare minute to piece it all together.

Like most men, I first realized I was turning into Rod Stewart around the time I turned twenty-four. It's scary the first few times this feeling hits you, but then it starts to be funny, and that's when you catch yourself wearing that Rod grin. You have blundered into an adult existence you don't understand, and you can't tell whether you planned it this way or whether you screwed up big-time, though it's too late either way. The feeling waxes and wanes as time goes by. Some years are a little bit Rod, some are extremely Rod, some are moderately Rod.

But I can't rule out going Full Rod. No man can. Any male is just a couple of fate-kicks away from that, whether it takes a few divorces, a few cocktails, the wrong pair of leotards a few tragic degrees too tight, or just a life that goes according to the plans you made when you were too young to know better. One day you're a rock & roll rake, the next you're an L.A. roué trapped in that same crusty catsuit. How did you get here? Was this what you wanted? How much say did you have in this decision? What the hell happened to you? And what do you have to show for it all, besides that smile?

Like I said: No man plans to turn into Rod Stewart. It just happens.

2

The first time I truly felt Rod's love touch was a hot summer night, deep in the seventies, in the pinball room of a Holiday Inn in Dunn, North Carolina. My family was on our yearly road trip to Disney World, and we always stayed at this Holiday Inn because my dad figured it was located at the precise geographical halfway point between Boston and Orlando. So over the years I got to know that pinball room well: the Elton John "Captain Fantastic" machine, a couple of others, an air hockey table, foosball, all on a carpet that was Bubble Yum green. And a jukebox.

Every summer, we pulled into the motel parking lot after a long day on the road. I liked to loiter around the pinball room pretending I was staying at the motel all by myself, the way a young boy does. This night, there was a teenage girl playing the Captain Fantastic, a real seventies dream-weaver gypsy queen, feathered hair, blue jeans, hemp-braided belt. I only saw her that one night, but I bet even today I could pick her out of a police lineup and charge her with crimes of love. She commanded the jukebox, playing the same two songs over and over all night: ELO's "Sweet Talkin' Woman" and Rod Stewart's "Tonight's the Night."

I felt safe with "Sweet Talkin' Woman," which was one of my favorite songs. I could relate to ELO, and the way Jeff Lynne sang about falling in love with girls who walk too fast and talk too sweet and slip away before you can catch them. I also admired the cellos. But I didn't feel safe with "Tonight's the Night" at all. I was threatened by how much this older girl liked it.

The jukebox in North Carolina played "Tonight's the Night" complete with the forbidden line, "Spread your wings and let me come inside." Not exactly a double entendre—it's barely two-thirds of an entendre. But it was too much for the radio. The pop stations back home censored that verse. The only time I'd heard the "spread your wings" line was on TV, during the prime-time soap *Family*, as the soundtrack to a slow dance between Kristy McNichol and Leif Garrett.

This song has to be the most effective anti-sex commercial ever; it makes the act of physical love sound unbelievably sordid. They should play it in schools to drive down the pregnancy rates. Rod invites his virgin child into the parlor, pulls down the shades, and pours her a glass of wing-spreading potion. He disconnects the telephone line (probably because Jeff Lynne won't stop calling, begging her to come back). A brief interlude of gown-loosening, then it's upstairs o'clock. Somehow you just know how it will end: Rod passed out on the couch, pants down, snoring, while she goes through his wallet, copies his credit card numbers, and plugs in the phone to call her boyfriend back home in Strasbourg.

The girl in the pinball room loved both these seventies songs, even though they're so different. She clearly heard some part of her soul in them. I strained to understand what that was. Did she identify with the girl in "Tonight's the Night," or the seducer? Could she translate the mysterious vocalese at the end, where Rod and Britt sing sexy pillow-talk words in their secret alphabet? Were they speaking French? Or Swedish? Maybe sex-havers speak their own language, which the rest of us can't understand?

Maybe someday you'll translate this exotic language, I told my-self, crouched over the Duotron machine with my fingers sweaty on the flippers. You will spread your wings. Someday you will be as old and wise as Rod, and not only will you speak this lan-guage, you will forget you ever heard it as alien and forbidding.

P.S. Turns out it's just French. It's not that big a deal.

3

Rod was always different from the other seventies rock gods. He'd been around the world and seen it all. He was on the cover of the *Rolling Stone* with Britt. For *A Night on the Town*, the 1976 album with "Tonight's the Night," he has a champagne glass, a straw boater perched on his head, and that same dazed expres-sion. He doesn't even realize this is a photo shoot. He's just look-ing over the cameraman's shoulder, to see if the Swiss models are back with the limes.

For seventies kids, Rod had something else that set him apart. He had the coolest rock star rumor ever. Every school cafeteria was abuzz with the Rod Stewart rumor. The story goes, Rod col-lapses onstage at Madison Square Garden. They rush him to the ER, pump his stomach, and find . . . a *lot* of semen. Pints. Quarts. Gallons.

Nobody seemed to believe this tale, but everybody loved to tell it. Even Rod himself. "That story spread all around the fucking world!" Stewart chortled to *Rolling Stone* in 1988, still admirably amused by the whole thing. "It was so laughable, it never really hurt me. What could it have been? A fleet of fucking sailors? Or footballers? I mean, what the hell? *Jesus Christ!*"

"Laughable" is a telling word. When you're Rod, everything is laughable, including the fact that people all over the planet might be laughing at you. But he's 100 percent right: Nobody bought it. It was just one of those urban legends too funny not to pass on, like the Fonz getting killed in a motorcycle crash or Mikey dying from Pop Rocks (although, to be honest, I believed those). The stomach-pump story has made many comebacks over the years; sometimes it changes to a story about a movie star who goes to the ER with an object up his butt. The stars' names change—but this rumor was around before they were born.

Everybody loves these hospital rumors, even though nobody believes them. They never explain why a rich celebrity goes to a public hospital instead of calling a fancy doctor. Next time you're in the hospital waiting room, take a look around. Not a lot of rock stars there, right? You're not arm-wrestling Cher for that back issue of *Parenting Reluctantly* magazine, are you? Even as a kid, you know hospitals are miserable places where you don't run into celebrities, only other dumb kids who ate paint or played in poison ivy.

We all knew the stomach-pump story was phony, but we loved it. And I believe the reason was that we knew Rod would think it was funny, too. Even a worldwide rumor about his sex life makes him chuckle, like he's watching himself from a safer distance than we do.

4

"Hot Legs" is a song I first experienced in sixth grade, when I watched Rod sing it on a Cher TV special. I can find the clip

on YouTube, but I still can't believe it really happened: Rod cavorts like a burlesque dancer, wearing skintight red hot pants, a purple scarf, and nothing else. He slips behind the cocktail bar to drop trou and change into something a little more comfortable, like a shiny silver leisure suit, with the shirt knotted in his midriff. Then he dances off for a date with Dolly Parton. The seventies kicked ass.

Everybody says Rod wrote all his great songs in the early seventies, and that's basically true. He's the all-time most infamous case of selling out. He couldn't wait to leave his folkie days behind and go Hollywood. But he was already selling millions of records when he was all mandolin solos and tartan kilts. So you can't accuse him of doing it for the money—it's more like he sold out for self-expression. It took real artistic courage to sing "Hot Legs."

Am I going to argue his late albums are better than people think? No, because I've heard them, and they're exactly as flimsy as you'd assume. What, you think I'm gonna claim you're missing out by not listening to *Body Wishes*? Believe me, you have made a wise decision. If you don't do anything else right all day, you can assure yourself you avoided *Body Wishes*.

So what would it mean if I tell you that I love *Body Wishes*, which came out in 1983, and that it's slightly superior to *Camouflage*, vastly superior to *Atlantic Crossing*, about even with *Tonight I'm Yours*, though not quite as good as *Foolish Behaviour*? Would it make any difference in your life? It doesn't make any difference in Rod's. By 1979, when he released his greatest hits album, he had no problem putting "Hot Legs," "Maggie May," and "Da Ya

Think I'm Sexy?" all in a row, even though your ears might say these tunes don't belong on the same planet, much less the same record. And did he wear that pink satin kimono on the cover? Of *course* he did.

So picking your favorite Rod Stewart song feels arbitrary. I have a special fondness for "Hot Legs," although the vixen in this song is a very different character from the one who spreads her wings in "Tonight's the Night." (Since Rod is fond of associating "wings" with "legs," maybe he should have called this song "Hot Wings," which he could have parlayed into a lucrative chain of fried-chicken restaurants. Missed opportunities, Rod—everywhere you look, missed opportunities.)

But I'm not sure Rod cares any more about "Hot Legs" than he does for "Tonight I'm Yours," which is not the same song as "Tonight's the Night." Rod had a great eighties hit called "Passion," which is not the same song as "Infatuation." He doesn't sing about any particular woman he feels passion or infatuation for; he's infatuated with infatuation itself. He's doomed to repeat this endless cycle, which is why the chorus goes, "Oh no! Not again!"

Rod did a beer commercial in the nineties, and in a way it's his most personal statement. You see Rod trapped inside a beer bottle, singing one of his early folkie songs, "Every Picture Tells a Story." Then at the key line—"oh my dear, I better get out of here!"—he breaks through the glass. He finds himself onstage, puffed and powdered, in front of a huge crowd. He's singing the same song. Maybe he just traded one bottle for a bigger one. But this one is where he belongs.

5

So why does he keep going? There are easier paydays than working as hard as he does. Although Rod likes the money, that doesn't seem to be the part he's addicted to. Being addicted to stardom is very different from being addicted to the money. It's about being addicted to the *work*. It's hard for us nonperformers to even imagine how repetitive and grueling the job is. You can't do it unless you have to. The money and perks sweeten the deal, but nobody hangs in there as a performer unless the action is the juice.

Rod Stewart had a famous statement about this in the seventies, quoted by Greil Marcus in the classic *Mystery Train*: "If I couldn't perform I'd give up. It's not a question of the money side of it. I don't have to work for the rest of my life. I don't want to. But not having that ninety minutes up there anymore. Phew. I don't like to think about it. It frightens me." As Marcus adds, "To be the kind of rock & roll star Stewart is to be like a politician who campaigns every moment of his life." That's true. Rod's a bona fide hustler, because he lives for that ninety minutes. That's what stars do. For players and hustlers, tonight's the night.

There's a great story Roger Ebert tells about the old-school comedian Henny Youngman—in the middle of taping a TV show, on his break, Henny passed a private room that was hosting a wedding reception. He crashed the wedding, collared the father of the bride, and said, "I'm Henny Youngman. I'll do ten minutes for a hundred dollars."

I love that story because it shows how performers are wired differently than the rest of us, no matter how much we love to

step into their shoes for a few minutes. I'm sure Henny Young-man liked the idea of making an extra C-note on his lunch break, but what he really *needed* was to do his routine and get the laughs. Henny had to work. What performer doesn't? What they're hooked on is the hustle. I envy that.

I am very much not this guy. Karaoke turns you into this guy: the showman personality who is always on, who craves attention and will scrounge up a crowd anywhere. Henny was a joke machine. If the jokes were old ones, all the better—that made the machine more efficient. As he once said, "I don't tell jokes. I refresh memories." Rod approaches his own songs the same way. As the man sang, oh no, not again.

So maybe this is all a reason to see Rod as a case of betrayed principles. He should have quit while he still had some dignity. Maybe he's an argument that rock stars should have mandatory early retirement. But what can I say? I love Rod because I hate dignity. I do not believe rock stars should retire gracefully. I believe in milking it, running it into the ground, flogging the dead horse.

The way Rod keeps going, it strikes a chord with any man old enough to see himself in that moronic persistence. Rod keeps plodding, the way the rest of us keep plodding. Sometimes you feel like Rod Stewart and you wonder if you're trapped in that beer bottle. You feel like your life has turned into a show, with you as the hired entertainment, a clown doing tricks for the crowd. You can barely remember that blast of youthful inspiration that once made you think this whole thing was a great idea. You wonder if it's tragic to feel this way, and then you remember Rod and realize it's comic instead.

I love the way Rod keeps plodding because I'm a husband. We plod. It's what we do. You don't get to be Rod Stewart unless you have an element of the cold-blooded showbiz huckster, a little Henny Youngman in you. But you also don't get to be a husband unless you have some Rod Stewart in you—grinding through the years, getting off on repetition. The mental and emotional toughness that requires, which is always kind of a challenge for me, means fighting off the doubts. There are moments when you wonder if the life you've built is a trap, and if that clanking sound in your head is chains. But Rod is there to tell you to chill the fuck out. The clanking sound goes away. It's not the universe picking on you. It's nothing to make a scene about. Make the best out of a bad joke, laugh it off.

Like any rock star, any husband worries about Losing It. Rod exemplifies the attitude that Losing It is no big deal. He saw that fate coming, and he was already planning to get over it. If you're squeamish about Losing It, if you're hung up on dignity, if you sentimentalize the early days, you aren't going to hack it. In the short term, love and music are a romantic thrill; over the course of a lifetime, they're for hard-ass hustlers.

Rod will go to his final days with that beautiful grin. He will always look and sound like a guy who feels confused by his own existence. He could have made different decisions. He could have had more time. He will find it all hilarious. But all that means is he keeps turning into Rod Stewart. Like the rest of us. And I suspect—I always have—whatever Rod knows the rest of us will learn.

11:59 p.m.:

She Loves You

1

1983: You are seventeen years old, and you have collected many theories about the universe. But there's one thing you know for a fact. You are certain, as you will never be certain of anything else, that the greatest song in the history of the world is "She Loves You." By the Beatles. Obviously.

If anyone asks your favorite song, you will instantly answer, "She Loves You," and explain why in detail (which might help explain why nobody asks). Because you're a sullen teen boy, and this song is the sullenest, teenest, boyest song imaginable. Those drums. Those guitars. The wild mood swings in the vocals. You're the boy in this song, you think to yourself. This is *you*.

At some point in your early twenties, you're startled to realize that "She Loves You" isn't your favorite song anymore. You have switched allegiance to "I Want to Hold Your Hand." You are

now certain, as you will never be certain of anything else, that "I Want to Hold Your Hand" is your favorite song of all time, in case anyone asks. (Some people do ask—by now you have made friends who also like to talk about this stuff. One of them is the girl you hold hands with.)

You're not sure how "I Want to Hold Your Hand" took over from "She Loves You." The change happened gradually, without you noticing, and you're vaguely pissed. It's like finding out your right and left lungs traded sides—it might have no visible impact on your day-to-day life, but it still feels like a major decision you should have been consulted about. It's a big deal.

2

1963: John Lennon and Paul McCartney are in a hotel room in Newcastle, England. In a few hours, they'll be playing a concert with their band, the Beatles. Right now, they're sitting on their bed (the Beatles are still sharing hotel rooms on the road). They hold acoustic guitars, writing "She Loves You." Tomorrow they finish it up at Paul's dad's house, while Mr. McCartney sits in the next room watching the telly. Paul's dad thinks the song is corny. He asks them if "yeah, yeah, yeah" shouldn't really go "yes, yes, yes." They tell him no, no, no.

They take it into Abbey Road the next week. Their producer, George Martin, has his doubts. He asks, "Isn't this a bit unhip, laddies?" Paul insists, "It's great!" So they knock it off in one afternoon session, and it becomes their biggest hit, the best-selling single in the history of England. (It holds the record until 1977, when Paul tops it with one of his solo hits.) "She Loves You"

becomes their introduction to America on *The Ed Sullivan Show*. The "yeah, yeah, yeah" chant turns into their trademark. The Beatles become the four most beloved human beings on the planet and remain that way forever.

3

1975: The first Beatles record you own, a birthday present from your parents, is a Dutch anthology called *Beatles Greatest*. You spend hours listening to it, sitting on the living room floor next to the ancient record player. Although you don't realize it yet, only one of the speakers works, so you're only hearing half the music, but it doesn't matter. The best song on it is "She Loves You."

"She Loves You" is a song everybody knows, a song everybody has heard a million times. So it's easy to overlook how bizarre it is. It's easily the weirdest song the Beatles ever wrote.

The plot: There are two boys talking, a Beatle boy (John and Paul blending their voices) and a mean boy. The Beatle boy has a friend, who happens to be the girl in love with the mean boy. The Beatle boy was hanging out with her yesterday, listening to her talk about her broken heart. So the Beatle boy steps in as a messenger of love. He tells the mean boy to apologize and rejoice in her love. John and Paul sound so bitchy, as if they can't believe what an idiot this other guy is. But they love singing about the girl. When they switch the subject back to her, that's where they brighten up and turn into a "yeah, yeah, yeah" machine. That's why the song makes you feel happy, even though everybody at the end is alone and frustrated and bitter.

You have to admit: Teenage boys do not have conversations

like this very often. If you overheard this conversation on a bus, it would be the weirdest thing that happened to you all day. You would get to work and tell everyone, "Guess what I heard? Two teenage boys were talking about their love lives and one told the other to apologize to a girl. Kids today—they are so free and open with their feelings!"

But the generosity of this song is overwhelming. There's no hint that the Beatle boy covets this girl for himself. (That would be a different song—it would be "You're Gonna Lose That Girl.") For that matter, there's no hint that he wants the *boy*. (Then it would be Rick Springfield's "Jessie's Girl.") The Beatles just root for the girl to get what she wants.

All the pain flies away in the "yeah, yeah, yeahs" and "ooohs," as if they're trying to sing like flirty girls and seduce this boy into surrendering to love. The Beatle boy tries to translate girl language into boy language, repeating what the girl told him to say, yet making it irresistible to the boy who's listening. To bring these tormented lovers together, they have to become superhumanly pretty. Liverpool love ninjas, to the rescue.

There's a lot of misery in this song, but there's also fun, and the Beatle boy is having most of it.

4

1991: You are in your early twenties. You are young and in love and you spend a lot of time listening to "I Want to Hold Your Hand"—partly because of the Al Green version, partly because you're young and in love so you finally have ears to hear all the joy in the Beatles' version. The girl-crazy howls and drum

crashes, the brash confidence of it, the way the boy is on fire and will explode if the girl doesn't touch him right this second—this seems more complex to you, more urgent than any other song you can think of.

One day you're drinking tea with your mom and she asks why you want to marry your girlfriend. (You're just twenty-four—too young.) You're a rock geek, so you give a really arcane answer comparing your girlfriend to the Beatles. You quote a line that the critic Greil Marcus wrote about the Beatles, calling them "a rock and roll group that combined elements of the music that you were used to hearing only in pieces." This sums up your relationship. Needless to say, your mom thinks you're ducking the question.

If you ever told your girlfriend about this conversation (you never did—it just never came up) she would have gotten it. She's also a rock geek, the kind who also can quote Greil Marcus lines from memory. She'd love being compared to the Beatles, with a quote from one of her writer heroes. Maybe you should have told her.

Your mom loves the Beatles, too, but she isn't a rock geek, so she thinks you're chickening out of giving her a straight answer. You think you gave her the most honest answer possible. But you and your mom can both agree: You've just demonstrated why you're lucky you got someone to marry you.

5

1995: You are still in love, though not quite so young. You're twenty-nine and married and still in grad school. Love is ex-

hausting and it's hard work. You had no clue it would be so complicated. "She Loves You" sounds different now—when you hear it, it doesn't seem like there's such a big difference between the two boys in the song. Sometimes you even notice a warmth in it you didn't notice before. Maybe the Beatle boy isn't sneering at the other boy; maybe he's just trying to help him out. It's like Paul McCartney is putting a brotherly arm around your shoulder on the bus after school and saying, "Didn't you know, chum? Nobody told you before? That girls are like this? Well, now you know. Girls are crazy, and they do not get less crazy when you make out with them."

"It's too late, Paul. She doesn't love me anymore."

"Nah, it's not too late. She loves you. She just thinks you're a little dim."

"I guess I am dim, Paul. Can I call you Paul?"

"Of course."

"I think it's too late, Paul. I blew it."

"She still loves you. I *don't* love you, by the way. I think you're a wanker and she could find six of you for a shilling, but it's you she fancies and don't ask me why. I'd say you still have another eighteen to twenty-four hours to apologize before she finds someone else to cry about."

"Why?"

"I have no idea. Girls are like the White Album."

"What's a White Album?"

"Erm . . . that comes a few years later, but trust my time-traveling perspective here. A White Album is a double-album mess that goes on too long and has all these songs you think

should have been done differently. Moments you prefer to skip. 'Wild Honey Pie' and 'Piggies' and 'Revolution 9.' Those songs could give pot a bad name."

"Pot?"

"That comes later, too. It's a drug. Oh, and then there's my song about the raccoon, but I like that one."

"You're losing me, Paul."

"Girls are the White Album and they all have 'Revolution 9's. They have all that stuff you wish you could edit out. There's this *Anthology* documentary, many years from now, where everybody complains about the White Album. George Harrison thinks it should have been edited down to a nice, tidy single album. So does George Martin. Hell, even Ringo. And finally I lose me rag and I say, 'It's great! It sold! It's the bloody Beatles White Album! Shut up!'"

"Damn, Paul, how many White Albums did you make?"

"There's only the one, see. When you fall in love with a girl, she's the bloody White Album. That is what you whisper to yourself, when you don't understand her at all. You just keep telling yourself, she's the bloody Beatles White Album and there's only one of her."

"Is that true?"

"How would I know? That's what I tell myself anyway. If you can't deal with a White Album, you're better off with a girl who is a James Blunt album."

"Who's James Blunt?"

"Well, here's me bus stop. We'll get to James Blunt next time, or not. But we'll get to the White Album someday. And pot."

6

1997: It's the late nineties and you are alone. You are sad all the time, which is exhausting (in addition to everything else it is) and boring (ditto) and "She Loves You" is too sad to listen to at all. You are going back and listening to Beatles songs that you ignored in your twenties, like "Strawberry Fields Forever." You first heard this song one Christmas morning, seconds after ripping open the shrink wrap on *The Beatles 1967–1970*, aka the Blue Album. You've always liked "Strawberry Fields Forever," but now you're really hearing it for the first time. John sings like he's down and he doesn't want to talk about it. He feels old and used up. So do you. (He's just twenty-seven, you're just thirty-one, and yet here the two of you are, arguing over which one is wearier like a couple of old Irish ladies.)

John sounds sad, but he's also bored by the dullness and monotony of being sad. He sings about it like he doesn't want to talk about it because his sadness is the least interesting thing about him, even though at this point in his life it's practically the *only* thing about him. Nobody knows if he'll ever not be sad, including him. And he knows everyone around him feels a little guilty for being bored by how sad he is. (Misery might love company, but it's rarely mutual.) He doesn't blame them, because he's bored by it all, too.

So what does John think about all this whole sorry state of affairs? "I think I disagree." In your present mood, this seems like the most brilliantly funny line John ever sang.

Nobody knows if your present mood is just your present

mood—maybe it's not a mood, maybe it won't end. It shouldn't be that way. It's all wrong. At least you think you disagree.

7

Paul loves modern girls the way he loves modern rock & roll. Has any songwriter, male or female, taken so much joy in female company? He just relishes being around girls, whether or not he has any romantic interest, breathing in their presence. It's all there in the way he sings about the nurse in "Penny Lane," the one who sells poppies from a tray and feels like she's in a play. He's just dreamily noticing her, imagining what it's like to be her. He wonders what she thinks, and how she feels.

Who else sang about women this way? Nobody. If Mick Jagger wrote that song, the nurse would have been wearing fishnets. If Lou Reed wrote it, she would have sold him some pharmaceutical groovies. If Bob Dylan wrote it, "nurse" would have rhymed with "her longtime curse drives a velvet hearse."

Paul lights up when there are girls around and gets down in the dumps when there aren't. (Which can't be often. He's Paul McCartney.) He wants to hear their voices and learn their stories. He has zero interest in singing about men, unless it's "Band on the Run," with the Jailer Man and Sailor Sam. (Can you imagine what a terrible sailor that guy must have been? Sailor Sam lived in the *desert*. That's where you go when you have an anchor tattoo but you don't want anyone asking you to help with a boat.)

Paul likes to listen to girls, even after they go away. He still wants to think about the things she said and how they fill his

head. "You won't forget her," Paul sang in "For No One," not sure whether he was giving good news or bad news. But he was right. You won't forget her. What you do with that memory is up to you.

8

You once had a shrink who went to Shea Stadium. She brought it up during a session and you wouldn't let her change the subject. She guessed she was around twelve. The helicopter landed on the grass and specks of brown got out; she didn't remember any of the songs, just the roar of the helicopter. She asked, "Is this really necessary?" You insisted. So, she was a Paul girl. The Beatles played for thirty minutes, you kept her talking for forty-five, then you wrote the check and drove home. Eighty bucks you paid to hear that story, which is stupid, but you still kind of think it counted as therapy.

9

When John met Paul, they were both teenage boys who had lost their mothers. It's something they had in common. Did they ever talk about it? Nobody knows. But they both knew what it was like to love a woman and mourn her after she's gone. And as soon as they met, it was something they wanted to write songs about.

Their mothers both get mentioned in *A Hard Day's Night*. It's a strange detail in the movie, easy to miss. But early on, Paul gestures to his grandfather and says, "Me mother thought a trip would do him good." The road manager warns John, "I'll tell your mother of you." Neither John nor Paul flinches when the

topic comes up. (Okay, John flinches a little. Paul lowers his eyes to the floor, total poker face.)

Both scenes are agony to watch, if you have any affection for these two boys. How did this happen? It couldn't have been the screenwriter's fault—how was he supposed to know their mothers died? Did the director know? Surely not. If he did, he would have cut the lines. The filmmakers weren't sadists; they didn't want to torture the Beatles. They just didn't know. Nobody told them. Other people around the Beatles knew, though, and they must have thought about saying something, but then got scared and decided to wait for John or Paul to bring it up. Except John and Paul *didn't want to talk about it*. So they just played the scene. They were used to that.

When John and Paul began making music, they already knew about losing women they worshipped. How do you live with that loss? You learn to fill your head with their voices. It's the theme John and Paul couldn't shut up about, from "There's a Place" on their first album to "Let It Be" on their last. You listen to women talk, and when you lose them—when they leave you, or when they die—you replay their voices in your head to keep them close. You lie awake and tune in to those female voices, keep their hum running in your ears. She tells you she loves you. She tells you it's all right. You never weep at night; you call her name.

The danger is you can get trapped in this echo chamber, right? You can miss out on the sounds around you, out there in the world. You might miss the voice of the woman who's standing right in front of you, telling you something new.

For John and Paul, that meant learning to listen to adult women named Yoko and Linda. But it can be scary to turn down the volume on the past. For John and Paul, it meant breaking up the band. The transition wasn't clean or painless; it directly affected the lives of millions of people. John and Paul formed new bands with their wives and made records where they invited their wives to sing. No other rock stars ever made such a big deal about loving their wives.

Now and then, they must have wondered if they made the right decision. They must have had doubts. All men have them, and John and Paul must have felt them deeply, because they felt everything so deeply. Sometimes, late at night, they must have remembered the promises they made to those screaming girls and wondered if they were keeping them.

10

2013: By now you're older than the Beatles were when they broke up, older than John ever got to be. Your wife has gotten you into *Sgt. Pepper* and *Magical Mystery Tour*, neither of which you ever liked before you met her. "The goth ones," she calls them. These are the records that she loved when she was a sullen teen, with their creepy keyboards and lurid colors. Even the song "Magical Mystery Tour," which always sounded goofy to you, now rocks when you notice the drums. One Sunday afternoon, you sit around your favorite vegan lunch dump Foodswings, munching your soy chicken mozzarella sub, and they put on *Abbey Road*. It turns out she knows all the songs on side two. You didn't think anyone liked side two. You have chosen your mate wisely.

Your Beatles will change all through your life. Your personality changes; your world grows and shrinks and grows again. Your beliefs change. So do your friends. People you love fade away. Some of them fade back in. Your nieces and nephews are into the Rock Band video game of the Beatles, and they all want a turn at "Yellow Submarine." Your niece calls it "the boat," as in "I wanna sing the boat again!" When your wife sings "Helter Skelter" at karaoke, she sings the U2 version, with the skin-crawlingly embarrassing Bono introduction. "Charles Manson stole this song from the Beatles. We're stealin' it back!" But you start to like that one, too.

The Beatles remain universally hailed as the greatest thing ever, but somehow, you still think they're underrated. They're like Hawaii or *Hamlet*—even greater than everybody always says they are. For you and your wife, one of your favorite bands to listen to together is the Yeah Yeah Yeahs. You wear a Yeah Yeah Yeahs T-shirt when you ask her to marry you. She says yeah.

Now you're not sure how to hear "She Loves You"—it's so emotionally extreme, which is why it perfectly suited your teen self. You can't stick it on a playlist between two other Beatles songs without overpowering the other two. It doesn't fit in anywhere, like the kids in the song. Nobody sings it on *American Idol*. Nobody tries it at karaoke. The stop-start zigzag melody is too tricky. If this came on in a bar, people would "yeah" in all the wrong spots. Are there any other Beatles hits that nobody knows how to sing?

You owe this song a lot. You feel like the "She Loves You" guy helped turn you into the "I Want to Hold Your Hand" guy you

became later, and the "Strawberry Fields" guy you never wanted to be, and whoever you are tomorrow. Maybe someday (but not today) you will give up trying to understand the song, and just let "yeah yeah yeah" speak for itself. Then it will all make sense.

And yeah I said yeah I will Yeah.

SIXTEEN

12:04 p.m.:

Debaser

Have you ever stood in an airport parking lot and breathed in the air? I mean, really breathed it in, all the humid fumes wafting off the asphalt, the exhaust from the cars, the sickly odor of gasoline? Your lungs sucking it all in by the gulpful? Like you've been lost in the desert and you have crawled across the sand to an oasis? Have you ever inhaled the aroma of the airport parking lot like it's the sweetest thing you ever breathed in your respiratory life and thought, *I am in trouble*?

I was in trouble. I was at the Charlottesville airport, visiting my old stomping grounds for the first time since I had moved away a couple of years earlier. True, I had not done such a masterful job of building a new home for myself. But I had no idea I was in such wobbly shape until I got off the plane and stepped out into the air. I sat on the parking lot's smoking-section bench for a couple of minutes, gaping at the rolling hills of the Blue Ridge in the distance. I remembered every crag of that land-

scape. My head was spinning with memories and I wasn't even in the car yet. I breathed it all in. Two thoughts hit me—first, *This feels like home,* and second, *This is a parking lot. If this feels like home, I am in trouble.*

But it was a different kind of trouble I found that weekend, the sort that turns things upside down and then makes you wonder why you haven't been standing on your head so things could have gotten this way sooner.

I flipped for Ally's voice about twenty minutes before I met the rest of her. I heard her voice on the car radio, from the backseat of a battered Volkswagen stopped at a red light on Route 29. A bunch of my old friends and I were on our way to tour some of the local drinking establishments. But as soon as I heard the DJ's voice, my priorities for the weekend began to shift.

DJ Astrogrrl was in charge of the WTJU Friday night shift, spinning a tribute to the Pixies. Yet as she back-announced "Debaser," I was more intrigued by the DJ's voice. It was a brisk, businesslike voice, yet low and smoky. She made those Pixies song titles sound more enticing than I ever could have imagined. I casually spoke up from the backseat to suggest to my friends that perhaps, on our way to the tavern for the consumption of sundry frosty liquids, we should stop by the radio station. I had an urgent need to pass on my compliments to the DJ.

DJ Astrogrrl turned out to be WTJU's rock director, a grad student in astronomy; she'd moved to Charlottesville in the summer of 2000, two weeks after I'd left town. We chatted for a while in the record stacks, surrounded by all the overflowing shelves of vinyl. It turns out she was doing the Pixies tribute

show only because the scheduled DJ didn't show up, and she needed to whip up a show on the spot; so she just grabbed a handful of Pixies records and went on the air. (I will always be grateful to the jerk who didn't show up.) She was on her way to an astronomy department function, so she already had her coat on when I popped in to say hello. Lucky for me, she hung out for a few minutes, and we talked some rock-geek talk. I'm not sure how long it took for the Smiths to come up, but it was under two minutes.

A bunch of WTJU friends went out to dinner the next night at our local strip-mall sushi place, Tokyo Rose. I had spent my twenties at this place, because they hosted bands in the basement—some of the happiest nights of my youth had been spent bouncing off the walls here. Now I was feasting on pumpkin sushi and miso soup, talking to Ally Astrogrrl. She was a cool rock girl who filled me in on the details about the Milky Way's impending merger with Andromeda, an event that will form a new galaxy called Milkomeda. It's scheduled to happen in about three billion years, due to the gravitational attraction between the two.

I found this news a little startling. "Won't this have a drastic impact on the sun?"

"Well, the sun will run out of hydrogen in about five billion years," she assured me. "It's halfway through its life span."

"How does this affect the earth?"

"It'll get engulfed by the remnants of the sun."

"So what's your favorite Pavement album?"

When she answered *Wowie Zowie*, I somehow found that even

169

more disturbing than the news about the sun. I thought, "Well, I will never have a chance with this woman. I'm a *Slanted and Enchanted* guy. We are from different worlds." But the more we talked, the more intrigued I got. She told me she was coming up to New York in a couple of weeks—she was coming for an Interpol show. We agreed we should hang out, so I jotted down my email address on the wrapper of my soda straw. As the dinner wore on, and more rock-geek conversation flowed, I kept adding to the straw, making notes of bands and song titles I thought she would like. The whole table began to argue about the hottest men in rock & roll. Ally's nominees were Morrissey (naturally), David Bowie (no question), Sonic Youth's Thurston Moore (hey, that could be good news for me), and Depeche Mode's Martin Gore (that might be bad news). When she capped her top five with Dave Gahan, I decided I needed to reevaluate my personal relationship to white jeans and leather tank tops.

It was WTJU's Rock Marathon Weekend—in a music-crazed town like Charlottesville, that's one of the central events of the year. I had come to town to help out, DJ a few shows, answer the phones, file records, that kind of thing. But all I could think about was the fact that Ally was going to host a Depeche Mode tribute show on Sunday night. My flight home was that afternoon.

"Too bad you won't hear my show," Ally said. "It's going to be fun." She went on to discuss all the great B-sides Depeche Mode mysteriously left off *Violator*, and how it could have been a much better album if they'd included "Sea of Sin."

Back at the Econo Lodge, the first thing I did was frantically

call the airline to reschedule my flight. They switched my Sunday flight to Tuesday. It looked like I was sticking around town for a few extra days.

So right, this is trouble, I thought. *God, I missed you, trouble.*

I WASN'T SURE WHAT WAS going to happen. I wasn't sure what I *wanted* to happen. I wasn't sure what I was ready for. But I knew I needed to know a lot more about this woman. The next few days presented me with a finite number of opportunities to hang out with her, and I was going to pounce on them like Martin Gore on a crimping iron.

And I knew I was not going to blow it, whatever "it" was going to be. I had blown it before. My recent experiences with dating had taught me a painful lesson: I did not know much about how to be a boyfriend. Let me rephrase that. I knew *nothing* about how to be a boyfriend. I have no idea why I was so shocked about that—after all, I'd spent my twenties married. When would I have learned any boyfriend skills? I had spent all those years working hard on my husband skills, trying to get that job right. When I started dating again, after three years as a lonely widower, I figured at least my husband skills would carry over into new relationships. I knew a little about how to do this boyfriend stuff, right? Ah, no. I was devastated to learn that (brace yourself for a surprise) starting a new relationship is *hard*. Two people, two genuinely good people, can try to make each other happy but *fail*. In fact, they can make each other wretched.

I mean, when I was married, my single friends told me stories like this all the time. They kept telling me how lucky I was not

to be dating. Hell, I thought they were just trying to cheer me up. Now I was mad at them all for not warning me enough. I had a lot to learn. I had *everything* to learn.

Why was I just finding out about all this now? Because I got lucky early in life. I settled down when I was twenty-three. It was still the eighties. Milli Vanilli were about to win the Grammy Award for Best New Artist. That's when I had stopped learning how to be a single guy. So here I was, well into my thirties, trying to learn the basics other people study in college. Welcome back to earth, Major Fucking Tom.

So I didn't know what I wanted to happen with Ally—I just knew I wanted to find out. And I was determined not to blow it. Fear? None at all. I felt total curiosity. I felt total confidence. I was going to find out what happened next. All I needed was a plan. I knew how to make those. My plan, like most brilliant plans, involved Depeche Mode. I knew her radio show started at ten. So I would show up at the studio and hang out. That should be easy, right? That counts as a plan? I hoped so. It was a scheme, at the very least.

I couldn't sleep, so even though it was February, I opened the window of my motel room. The Econo Lodge on Route 29 is only one story tall, so when I stuck my head out the window, to gaze out at the rainy night sky, all I could see was the motel parking lot. It was only one day since I'd gotten off the plane, yet the dark landscape of Charlottesville seemed transformed. The black puddles in the parking lot were sparkling with stars I had barely noticed before. This place was different from the way I re-membered it. It wasn't like the old days. I guess that's one of the

things I had to come back here to figure out. There was no past waiting for me here; turning back the clock wasn't an option. My old home had changed while I was away, like I had. It wasn't offering me any escape back into the past. All it had to offer was the future, and I was going to have to find that out for myself.

I stared out the window. Another parking lot, another deep breath. Another lungful of the sweet taste of trouble.

SEVENTEEN

1:01 a.m.:

Dreaming of Me

Okay, so in the cold light of morning, I could tell it wasn't much of a plan. There wasn't much nuance to it. I was just going to drop by the radio station around ten, casually, you know, just to help Ally file her records. This was an obvious DJ-groupie move. But I had no problem with obvious. Time was tight. This was boy-say-go time. It was one of those times when, in the words of the old Depeche Mode song, tomorrow won't do.

I spent Sunday afternoon walking around some of my old haunts in Charlottesville, kicking through the winter slush on Main Street, listening to the radio on my Walkman. I ended up sitting in the McDonald's at the Barracks Road Shopping Center. How many evenings had I sat here over the years, back when I couldn't face the idea of going home to my empty widower apartment? It stayed open until midnight, when practically everything else in town was closed by nine, so this was a place where I had killed time on countless weekend nights, in the not-so-distant

past. I ordered two hamburgers and fries, just like in the old days, then sat at the corner table by the window, looking out into the empty mall. There were no other customers, which made sense since it was after dark on a Sunday night. My fries were cold by the time I got to them, so I nursed my coffee, staring out the window at the concrete McDonaldland playground where I had literally never seen a single kid play. I breathed in the soothing stop-and-lurch rhythm of the cars at the drive-through.

"I could sit here forever," I thought. "I don't have to go to the radio station. I told her I was leaving town today. I could skip the Depeche Mode show, sit here another two hours until McDonald's closes, then go back to the motel. I'd fly back Tuesday. Nobody would know. I could just sit here, and listen to her voice."

The wind rattled the window a bit, and I looked out again at the playground. Then I bused my tray. I got to the station a few minutes after ten, while DJ Astrogrrl was spinning the first song, "Just Can't Get Enough." I told her I was still in town because my flight was postponed because of the snow. She smiled and said, "Yeah, sure." (To this day she swears she was kidding—she believed me at the time. I have my doubts.) We hung out for a couple of hours, talking about music and books and science, as she cued up the records. We argued about which was Depeche Mode's best album (*Black Celebration* or *Violator?*) as well as the ever-controversial Vince Clarke question. She even played my Depeche Mode request, "Dreaming of Me." And we agreed that for next year's WTJU Rock Marathon, we should do a Smiths tribute show as DJ Shoplifter and DJ Backscrubber.

I was wondering if she had a boyfriend. She was wondering if I

was straight, given my enthusiasm for the Pet Shop Boys and my near-total recall of the Anne Bancroft filmography.

I had plenty of time on the plane to wonder what had happened to me. All my moves had been totally obvious—the most obvious ones in the book. What could I say? I like obvious. Subtle and elegant is for kiddies. I was an adult now. I did not have the winds of youthful innocence at my back. I knew all about being a subtle kid. I had done my share of hint-dropping and throat-clearing and better-never-than-now stalling when it came to women. I'd done the shy boy thing. I aced that course.

But I realized I wasn't that kid anymore. I was an adult. I'd been in love. I'd been married. I had all the subtle beaten out of me by the time I was old enough to rent a car.

I'd been that boy, for the first twenty years of my life. I'd dialed a woman's number, chickened out, and hung up during the first ring. I'd told a woman, "I really like your friend" while her friend was in the ladies' room, in hopes that the message would get passed along. I'd been an altar boy sighing over the girls during communion. I'd been told by a girl reclining on my dorm room bed, "I'm thinking the same thing you are—just *say* it," and couldn't guess what she meant. I'd been a college librarian, looking up my crushes in the computer to see what books they checked out. One girl I liked kept this book called *Sexual Unfolding* overdue for months and I kept secretly renewing it for her. I erased her overdue fines but never spoke a word to her.

I had been that kid. I'd proudly upheld the shyness-is-nice tradition. I had passed the torch to a new generation of bumbling fumbletons. I liked that boy, and I hoped I still had a lot in com-

mon with him. I was grateful to him for growing up to be me. He'd done me a lot of favors on the way, mostly by learning to get trampled by not-so-shy women. I had no regrets about being him. But I wasn't that boy now.

This was going to have to be adult romance, if there was going to be a romance, and this was going to be different. Whatever it was, I knew it wasn't going to involve dropping hints and cryptic clues. I had no patience for that now. I had been a man, a husband, a lover. I'd been through some things and shed some tears. There was no way to forget where I'd been. I couldn't go back to being vague and subtle even if I wanted to, which I didn't. I had enough problems of my own, adult problems, without going back to his. I had to be direct, because I knew from experience how love can be fleeting. Life is short. The sun is going to run out of hydrogen. I knew there was no time to waste getting cute. I was going to have to find out what it was like to do this kind of thing as a full-grown man.

I knew this would be trial and error. But it was something I wanted to try and err at. And I thought she might be someone I wanted to try and err with. I knew what I wanted. Was I supposed to pretend I was a confused kid? Was I supposed to act tormented about what I wanted? I wasn't confused. Just curious.

I hoped she was into obvious, too. There was only one way to find out. The extremely obvious way.

WITHIN HOURS OF MY PLANE touching down at LaGuardia, we'd already traded emails full of Morrissey jokes. My subject heading: "I left the South again, I traveled North again." Her subject

heading: "My only weakness is a list of crime." I still couldn't tell if she had a boyfriend, until a couple of weeks later, when she came to New York and we met for dinner. I wasn't sure whether this was a date or not—maybe it was just dinner with a new friend from Virginia? But I walked into the hotel lobby, and when I saw her shoes, I knew it was a date. She looked up from her book and smiled when she recognized me. Date shoes, date smile. I took her to see Erasure, since I knew she was a Depeche Mode fan. Andy Bell came out in a leather corset with a peacock tail. Halfway through the first song, his whole outfit was on the floor and he was preening in his underwear. I knew that meant it was going to be a good night. There were some irate Erasure fans behind me, who took offense (understandably) to the fact that I am tall, so they started punching me in the back and screaming at me, before they realized it was much easier to walk away and stand in front of me instead. I kept glancing over at Ally to see if this was stressing her out, but it wasn't, so I didn't stress, either. I admire a woman who can watch her date get savagely beaten by strange females and keep her cool.

We headed back to the hotel to meet her friend Marisa. They were having a girls' weekend in New York, which I was now shamelessly crashing. We went out bar-hopping on the Lower East Side, as I listened to them tell stories about the Catholic high school they had gone to back in Rhode Island. They discussed the locker they shared at St. Mary Academy–Bay View, the Sisters of Mercy who taught them there, and how the nuns influenced their fondness for the band Sisters of Mercy. They discussed the current whereabouts of their Catholic school uniforms. (I some-

how waited over an hour to ask, which I was proud of.) They re-
called their high school band Mary Tard Lincoln, which special-
ized in obscene parodies inspired by U2, like "Where the Sheets
Have No Stain," "Straddle and Come," and "I Will Swallow."

I met up with them again the next night and whisked them
off to Brooklyn for a late-night electroclash after-party. (Give
me a break—it was 2003.) We went to the "Berliniamsburg" part
at Club Luxx on Grand Street, with a live performance by the
synth-chick sex-robot trio W.I.T. I got to dance with Ally for the
first time, to New Order's "Blue Monday." Since she'd been so
bemused by how much I loved the Pet Shop Boys, I gave her a
mix CD of their finest songs, with a hidden Erasure track at the
end, "Oh L'Amour." Back in Charlottesville, she made me a mix
CD of her favorite Depeche Mode deep cuts. She put "Dreaming
of Me" on that mix, because she knew it was my favorite song
of theirs. But she also had a hidden track at the end, the Smiths'
"There Is a Light That Never Goes Out."

She came back to town a couple of weeks later for a job in-
terview at NASA, and this time it was just the two of us. We
went to a Ladytron DJ gig in the basement of the Tribeca Grand
hotel. We leaned against the wall and our heads were close and
it was time for our first kiss except I suddenly had a sense that
for our first kiss, we should be all alone. So I took her hand and
we raced upstairs, into a cab, where we somehow managed not
to kiss, either, until we were safely back in my apartment. I was
nervous, so I put on side one of *More of the Monkees*. Davy Jones
started singing "Look Out (Here Comes Tomorrow)."

"I really want to kiss you, Ally," I said.

She nodded. "I think you'd better, then."

Waiting for that moment had been a good idea. Everything about this night had been a good idea. The next few days were overflowing with good ideas, and they just got better. Things were looking up for me. It was obvious.

EIGHTEEN

1:12 a.m.:

Stop Draggin' My Heart Around

"So am I overdoing?" I asked my friend Melissa, as we walked down Mercer Street after dinner. We were on our way to the after-hours basement karaoke place in Little Italy, a walk we'd done many nights before. We knew that when we got there, we would sing "Stop Draggin' My Heart Around." Melissa loves to sing the Stevie Nicks songs, and this one is a duet, so I already knew I was getting drafted into Tom Petty duty. But there were a few other things I needed to know first.

"Why are you giving her shoes?"

"It's her birthday next week."

"You've kissed her, but you haven't slept together?"

"What makes you say that?"

"Oh, man. That's the *best* phase. All that anticipation."

"No, it's *not* the best phase. If it were that phase."

"But it is, right?"

"I am not presently disposed to discuss such a situation, if it

did exist. Besides, you know I would still buy shoes for her in other phases."

"I know you would. I know you will."

Melissa knew a lot about shoes. She worked at the John Fluevog store on Mulberry Street. I had met her years and years earlier, when she was working at the Fluevog store in Boston, on Newbury Street. She was married to the drummer she was dating back then. She knows a lot about everything.

"We were walking around window-shopping and we went to Kate Spade. I saw her pick up these patent leather Mary Janes. She kind of sighed. It was hot."

"She likes those shoes."

"So am I overdoing?"

"It's not the shoes. It's you noticing. She wants to know if you know how to notice a girl looking at something."

"I know her shoe size, too. It's seven and a half."

"How do you know?"

"I looked in her shoes while she was in the shower."

"Don't tell her that, okay? *That's* kind of overdoing."

"But the patent leather Mary Janes are okay?"

"You should pair them up with some fishnets. That would be hot. But save the receipt, all right?"

"Thanks."

"And don't say how you got her shoe size. She'll like it if you ask her for that direct."

"Thanks."

"You up for some 'Stop Draggin' My Heart Around?' "

Like I said, Melissa knows about everything.

• • •

ALLY WAS ONE COOL CUCUMBER. She was not given to dramatics. Things had been going really well for a few months. She had taken the job at NASA, so she was moving to New York at the end of the summer. We were going to be living in the same city. I thought this probably meant I was her boyfriend. But I was trying to take it slow and play everything as cool as Ally was playing it.

That was a challenge for me. I had no experience taking things slow. Like I said, I had never acquired any boyfriend game, so I had everything to learn. I was new at this, but I knew I wasn't going to blow it. I was not letting this woman drift away. I would master this whole dating operation. Wait—were we "dating" or "going out"? Did people even say "going out" anymore? I had no idea what the kids were into these days.

I called in all my female confidantes for emergency coaching sessions. I had put in so many late-night hours of listening to them complain about the guys they were seeing, giving them my perspective on things, following along with their DTR (Define That Relationship) discussions. Now I was asking them to return the favor. I needed a crash course in the basics. Like, the really *basic* basics.

My friend Niki spent an entire dinner patiently explaining the difference between "dating," "seeing," and "going out." It turns out I had it all backwards—"dating" was actually a commitment level way beyond "going out." Going out meant everything was so casual it was practically "seeing." Trying to learn the lingo was like trying to figure out the four bases.

"You aren't 'going out' anymore," Niki told me. "She is moving

to New York, so then you can be a couple. You're lucky you met her before she got here."

"I know."

"Really lucky. She would have dates by the time she got through baggage claim."

"You're making me nervous."

"Don't be nervous. Is she your Friendster yet?"

Ally had indeed accepted my invitation to start a Friendster profile, but like everyone else in the summer of 2003, she had set her relationship status to "Open Marriage." There was no resisting the comedy value of the "Open Marriage" setting.

"Relax," Niki told me. "She just needs a little time to play it cool while she figures out if you're for real or not. You're not like other guys. So she needs time to make sure it's not an act. She's a smart girl. She will figure it out."

"Thanks. She *is* a smart girl. Have I mentioned what she told me about the earth crashing into the sun in a few billion years?"

"Why, yes. You have."

I knew how much I had to learn. Meeting Ally made me want to learn. She made my head buzz with curiosity and a little courage to go with it. She filled my brain with things I had to know. How to make her smile, what numbers to dial—burning questions like that. I was not going to scare her away with overdoing or bore her with underdoing. I was going to get some love technique.

We had known each other just a few months, but she was a new experience for me. She did not want to have DTR conversations. She never asked loaded questions like "What are you

thinking?" or "Where is this going?" She did not seem to have any "We need to talk" crises. She never wanted to spend our time together analyzing the relationship or questioning the relationship. In fact, she didn't talk about the relationship at all. This made me wonder whether we were even having a relationship.

She had her own scientific method of dealing with emotional glitches. When she wanted something she wasn't getting, she approached it rationally. One night, when we were sitting around reading, she told me, "I would actually like to have a little more of your attention right now, if you have any more attention to give. I'm not saying there's anything wrong with the level of attention you *are* paying me tonight. If you want to continue at that level of attention, that's fine. But if you do have some more, I would love to receive that."

Believe me, after that she had my *full* attention. I had never heard anyone express their emotional needs so efficiently before. I mean, I was definitely used to various people in my life expressing that same desire for attention. But I was used to people (including me) expressing it in the traditional, old-fashioned ways, like crying in the bathroom or smashing a bottle or pretending to be mad about something that happened six months ago. Ally's way seemed dangerously attractive. So this was how adults did it? Exotic!

While I was waiting for her to move to New York, I came down with a case of mono. That meant that instead of hanging out in sleazy punk rock bars till 4 a.m., watching my friends defy the brand-new smoking ban, I was spending my nights comatose on the couch, sending her a lot of incoherent fever-headed emails. I

listened to WTJU online every Friday afternoon as DJ Astrogrrl did her weekly radio show, and she dedicated get-well songs to me like Depeche Mode's "Shake the Disease" and X-Ray Spex's "Germfree Adolescents." In my state of delirium, I mused about this girl and wondered how she could possibly be as cool as she seemed.

Every time she visited, she noticed all kinds of things about my life I'd missed. I must have walked down my sidewalk hundreds of times before Ally pointed out the graffiti somebody had written in the cement—the logo for the band Twisted Sister. This graffiti had to date back to the late summer or early fall of 1984; there was a very narrow window of time when Twisted Sister could have inspired that level of devotion. All these years, this message of love had been there on Eckford Street, beneath everyone's feet, all our shoes scuffling over it without noticing. When Ally pointed it out to me, I felt like Twisted Sister themselves had blessed our bond.

That summer, right before she made the big move to the city, I realized we were a bona fide couple. It was the first time the cops showed up for us. I guess there's always something romantic about that, right? The first time the cops bust you for making out, you're officially a couple.

It wasn't much of a bust, to tell the truth, but it was enough. I was visiting her down in Charlottesville. She invited me to see the telescope where she worked, in the woods of Observatory Hill. I was tingling with excitement just being in the laboratory, as she slowly refracted the dome. It was just like *Young Frankenstein*. She sat at the telescope, adjusting the lens, so she could

show me the sky, the way she saw it. She would find a star or a constellation, focus the lens on it, and let me take the seat. All of this was new to me. I was used to looking up at the sky, but not with the sense that I knew what I was looking for. She was showing me patterns that I had walked underneath for years; finding me new points to focus on, new ways to see the entire universe.

After a couple of hours at the telescope, we had the urge to step out into the night air and look up at the stars. We stretched out in the tall grass on the side of the hill, as she pointed out the same galactic patterns she had shown me with the telescope. We took a fresh look at them with the naked eye. Fortunately, that's all that was naked when the cops came. Not real cops, just university police, but they still seemed disappointed we weren't nude tripping teen runaways. We couldn't stop giggling as they gave us the flashlight. We were so happy to be together tonight, it seemed comically strange to remember that other people even existed.

The idea of going to jail together seemed romantic, but since this was university property, all they really wanted was to see some university ID. I thought it would be funny to pull out my old grad school card, which I still had in my wallet. Ally grabbed the card from my hand as the cops drove off—she'd never seen a photo of me at such a tender age. We studied it together. Damn, I was young in this picture. I was twenty-three. My first day of grad school. A mere boy, with my whole life ahead of me. And here I was now, a full-grown man, in love with this full-grown woman. We were a couple. Anyone could see that. But there was nobody else watching on Observatory Hill now, nobody but us.

So we ran inside and sat back down at the telescope. We had the rest of our night wide open, with an entire sky to explore.

SHE LOVED THE KATE SPADE patent leather Mary Janes. I wasn't overdoing, after all. Once I gave them to her for her birthday, she wore them the rest of the summer. She was wearing them the night of the aforementioned Lower East Side karaoke loft party, the one where somebody allegedly brought the vial of liquid mescaline. The room was full of aspiring musicians, aspiring actors, aspiring designers, aspiring models aspiring to bang the aspiring rock stars, and so on. I assumed I was especially fascinating at this party, since everybody I chatted with stared intensely into my pupils and nodded. One of the aspiring actresses kept gushing, "You are *fancy!*"

Since it was 2003, everybody in the loft sang the latest hits by the Libertines and the White Stripes and Hot Hot Heat. There was no stage, just two mike stands on the floor, gigantic room, high ceilings, and an even higher audience. I sang AC/DC's "Dirty Deeds Done Dirt Cheap" with a Lower East Side playwright and an Australian bassist. It's always a fun, effective pick, with all those Bon Scott screams. (Even if you have to wonder, just how many dirty deeds did Bon have in his repertoire? I count only two, homicide and fornication. That's enough to go pro?)

Ally got on the mike to do Blondie's "Rapture" all by her lonesome. Maybe it was all the dilated eyeballs, but I saw lots of downtown scenesters, people who'd been too cool to remember my name the other forty-six times we'd met, staring in awe at this girl as she rapped the Debbie Harry poetry about the man

from Mars who eats bars and cars and guitars. I thought, "Hey, it's not just me. Everybody else is crazy about this girl, too." Considering that she barely knew a soul in the room besides me, it was impressive courage. She made some fans that night—for years I ran into people who asked me about Rapture Girl. Afterward I joined her for "Total Eclipse of the Heart," and it was an honor to be on her team.

She loved the Mary Janes so much, I couldn't remember why I had been so afraid of overdoing. Was I afraid to get the size or style wrong? Or was I afraid of getting caught paying too much attention? Was it the fear I wouldn't be able to keep up that level of attention? All of these things, no doubt, plus lots of others. The fear I was making a big deal out of nothing. The fear I was pretending to be much more tasteful and fashion-conscious than I was, setting her up for disappointment. The fear I was setting a boyfriend standard I couldn't live up to. There were plenty of valid reasons to be afraid. That's probably why she was so impressed. My friend Melissa had been right—it wasn't the shoes, it was the way I'd noticed her liking the shoes.

Shoes are still one of those female languages I have struggled to comprehend. I wish I could advise my adolescent self to learn how to talk about shoes; it would have been useful to learn that whole vocabulary at a young age. But I still work at it. Last December, I was in line outside a designer shoe boutique in Soho that was having a word-of-mouth sale. When I was young, I didn't know sales like this existed, much less places like this, but a friend tipped me off, so here I was, hoping to pick up a surprise for my girl. The shop only held twelve customers at a time,

so when one person left, another was allowed inside. The line was forty women deep, looking like one of those 1980s Alphabet City heroin dealer lines you read about, determined to tough out the arctic-tundra weather. Everyone had brought a book or a pair of headphones; everybody came prepared for a Stalingrad-level wait. I was the only male in line. Inside the boutique it was like the mosh pit at a Black Flag show, everyone throwing elbows and kicking ankles. There were no rules except the law of the shark pool: Eat the wounded. Women were stepping on my hands while climbing on me to get a clearer shot at the merch. I felt lucky to get out of there with some seven-and-a-half pumps and my teeth. Once again, I get scared of overdoing, then end up finding out overdoing is the only thing to do.

NINETEEN

1:32 a.m.:

Wouldn't It Be Nice

So my friend Jacob calls me up. He wants to meet.

His new girlfriend is dangerous, just his type. I like this one. After I met her, he called me while I was still in the cab. "She will kill you," I said. "Then she'll bury you in a shallow grave with the knife still sticking out of your heart. Then she'll dig you up so she can kill you again."

How could this go wrong? Somehow it's going wrong. Joshua wants to talk tonight, so we meet at a bar in the East Village. They've been broken up for three days.

"Remember that night you came over for dinner? She was mad."

"I could tell. She didn't say a word all night."

"She was mad before you got there."

"She had her arms folded. Mad girlfriend arms-folded. What was she stewing about?"

"She was mad all night. I kept asking what was wrong and she

wouldn't say. It wasn't until four hours after you left that she came out and said why she was mad. She said, 'I found a condom. In the kitchen trash. A used condom.' I said, 'Show me.'"

"Was it there?"

"It was a tea bag. That's what she was mad about."

"That doesn't prove you're innocent."

"She was mad all night. She had to stay mad longer because it was a tea bag. Eight *hours*. So we broke up. We're meeting for a drink tonight."

"I'm not sure this is a good idea."

"You need to come with me. Make sure I leave by midnight."

"This is stupid."

"I know. Don't leave me there."

It's already twelve thirty when she shows up. The three of us sit in a booth for twenty minutes or so. There's a bar trivia night we're trying to ignore. Occasionally Jacob's girlfriend leans back to whisper a clue to the booth behind us, just because she knows she looks hot at that angle. One-third into the second drink, they're kind of not broken up anymore, and I grab my raincoat.

There are no cabs on Avenue A tonight, so I walk up to the L train. The sidewalk is full of ostentatiously disappointed girlfriends, mad about something, three or four paces ahead of the boys trailing along, with those determined angry-haughty stomps, arms folded in that showy way. It's February, drizzly, windy, so their arms would have been folded anyway, but if you've been a boyfriend, you can see the difference.

You know the German term *schadenfreude*, which means secretly finding relief or even pleasure in someone else's misfor-

tune. There is a similar phenomenon that I like to think of as *schtraight-boyden-freude*, which is when you see other men's girlfriends and you feel a certain guilt-riddled joy in not being that woman's boyfriend.

This is not an admirable trait, but you can't avoid it, especially when you're walking in New York. Every block seems to have one of these girlfriends. You see the stomp-and-follow and you feel a certain relief you're not in this scene, not this time, anyway. You try to act like you don't notice. Some nights, especially weekends after eleven, every street serves up a schtraight-boyden-freude smorgasbord.

I am grateful for my girl. I could tell her this story but I will probably tell her something else about today instead. I will probably describe walking up Avenue A, the rain, the headphones, the puddles seeping into my socks, the songs I listened to, the wind. When I get home, she's asleep. The next day, she will ask, "So how's Jacob?" I will say, "He's great," and it will be the truth.

JACOB AND I FIND EACH other exotic. He's a woman magnet, so we're at total opposite ends of the romantic spectrum. So we're fascinated with each other's love lives. We are driven by anthropological curiosity to observe each other's mating games. He finds my choices just as bewildering as I find his. We were talking on the phone in the summer of 1991, at the absurdly tender age of twenty-five, not that it seemed that way at the time, a few weeks before my wedding. (He couldn't make it, as he was at his French girlfriend's country house.) While we talked, I had the Beach Boys' *Pet Sounds* playing, from "Wouldn't It Be Nice" all the way

to "Caroline, No." I quoted the line about how Brian Wilson is trying hard to find the people he won't leave behind, because that's the adventure I was on. Jacob made sad clucking noises. "I never should have let you listen to that album."

Maybe a husband needs a pet womanizer, just as a womanizer needs a pet husband. It helps protect you from the delusion that other people are having more fun than you are, a delusion that seems to create at least 40 percent of the misery in an American's life. Like Humphrey Bogart says in *Casablanca*, Jacob is like other men, only more so. When he's on the prowl for another danger girl, I make a wish list for him: I think I should have a say in who he chooses, since I have to listen to him complain when it blows up. That French girl's name still makes him jump like a World War II veteran when a car backfires.

But he never listens, because deep down he believes I have no idea what I'm talking about when it comes to women, and he's probably right. He's never aspired to be a husband, just as I've never aspired to be a womanizer, and neither of us has it in him to function anywhere in between. We admire each other's commitment to one particularly insane kind of devotion, but we each think we're the one having the fun.

Being part of a couple is the most mysterious of human experiences, and yet nobody really seems to get how it works. Nobody knows how good love goes bad, or the more baffling question of how good love goes good. You often hear the words "they finish each other's sentences," yet I've never been able to understand why this is supposed to be a good thing. In my experience, trying to finish a woman's sentence means taking your life in your

hands, and if someone finishes one of mine, it's usually "I've heard this one" or "Sorry, dude, you lost me when you compared Bell Biv DeVoe to Alfred, Lord Tennyson" or "Your head is so far up your ass right now you could play your prostate like a kazoo."

Another thing people say in praise of couplehood is "She calls me on my bullshit." Again, I'm not sure why that's a positive thing. I, for one, have zero trouble finding people to call me on my bullshit, especially since my bullshit is not really the hard-to-notice kind. I can barely walk around the block without getting called on my bullshit. (Today, for example, I went down the street to Uro Café for a coffee and two of my fellow pedestrians snickered at what I was wearing. But since that was a hot-pink T-shirt for a band called Nuclear Power Pants, I can't blame them.) So that old phrase is still not really a sufficient description of how people live together successfully.

There is a lot about love I will never know, just because I have been lucky in love. Everyone I've fallen for has been a solid gold, true-blue good person, someone who was kind and admirable, whether we got along at the time or not. So I have no idea what it's like to be cheated, mistreated, played, betrayed, used, abused, lied to, painted blue, led astray, walked this way, shot through the heart, sliced apart, run over with a Dodge Dart, deceived by the deception of which she was practiced at the art, etc.

Sometimes this makes me miserable about how much I've missed out on, as a music fan. There are lonesome songs I can sing along with, and happy songs and desperate songs and angry songs and dumped songs that have been near to my heart at one time or another. There are "ever fallen in love with someone

uldn't have fallen in love with?" songs and "tangled up in blue" songs and "good lovin' gone bad" songs and "prayin' for the end of time so I can end my time with you" songs. All those songs I've lived out for a night or three. But songs about falling in love with someone mean who does you wrong and treats you like dirt—those are science fiction to me. I sing along with them the way I sing along with songs about robbing banks or shooting up with Andy Warhol or knowing how to dance.

But if I'm being honest, the things that bring couples together will always terrify me more than the things that tear us apart. They will always be harder to explain. They will always keep me up later. Love gone wrong has inspired so many great songs, but somehow, love going *right* is what's bizarre. It exposes deep freakcraft in the universe. As far as I'm concerned, "some people are very kind" is the scariest line Bob Dylan ever wrote. Compared to that, his breakup songs are kid stuff. Some people *are* very kind and there's nothing in the universe to explain why.

It's a mystery how people lose each other—but to me, it's an even stranger mystery we manage to stay together, or to collide together at all. And that's the part I'm always more curious about.

I WAS TELLING A BUNCH of my *Rolling Stone* editors about my personal stash of *Welcome Back, Kotter* episodes. I know, right? Take a moment to swallow your jealousy. Yes, my hoard of *Kotter* reruns from the seventies, lovingly preserved on VHS, taken along every time I move. (They just don't look right on DVD.) I worship the sweathogs and that sassy Vice Principal Woodman. I particu-

larly prize my copy of the Nick at Nite *Kotter* marathon from 1999, when they were doing "Marathons to the Millennium," and showed six solid hours of *Kotter* reruns, including the classic where Vinnie Barbarino runs for student council president, with the badass Juan Epstein on the ticket as Secretary of Fear. Juan's campaign slogan: "Vote for Vinnie . . . And Nobody Gets Hurt."

I assumed my editors were laughing out of jealousy at my outlandish good fortune in still having these cultural treasures in my possession. Instead, my editor Will Dana said, "I can't believe you have *Welcome Back, Kotter* tapes in your apartment—*and* you still got someone to marry you!"

Okay. I deserve that. I'll wear that crown of fools proudly. But don't we all have *Kotter* tapes in our closet? Or their spiritual equivalents?

My wife does not share my sweathog fetish, so I don't watch them when she's in the apartment, just as I don't play Cat Power or vacuum while we're both home. But the important thing isn't that we're freakazoidal about the same things—it's that she's as freakazoidal about her stuff as I am about mine, and that enthusiasm can't help but unite us, even if the object thereof doesn't. If two people are twisted enough to connect on a deep level, it's only natural there will be lots of angles where they don't connect at all. Yet in some abstract way, all that enthusiasm just feeds into the connection between us.

When you come into a relationship as a full-fledged adult, you bring your lifelong enthusiasms. Ally is a woman of many enthusiasms, some on the earth and some in the cosmos. (One of the first things she said when we got engaged was "I'm going to have

the same initials as the American Astronomical Society!") Her enthusiasms are part of our bond, whether I share them or not.

It seems like that's part of the overall pattern of adult love, one of the things that make it different from the kid version. When you fall in love as an adult, you're less embarrassed about how hard you have to try. You're not as hobbled by trying to hold on to that youthful cool. There's no pressure to pretend it's all happening according to some cute sequences of rom-com coincidences. You're not so shy about getting exposed as calculating and crafty in your effort to make good things keep happening. If you find an emotional connection with somebody, you want to find the sources for that connection, and you want to keep those sources strong. You can't plan around random attacks of good luck; you want to make patterns where lucky things can happen regularly. If you want hotness in your life, you learn to build a fire and keep it going. You don't run around with a pack of matches in your pocket, chasing clouds and hoping you get struck by lightning.

As Yeats wrote, to fall in love is to enter "into the labyrinth of another's being," and that also requires you to tough out your way past any doubt and confusion that follow you around. There is always a minotaur in a labyrinth. And the labyrinth can get scary, which is why it's easy to get hung up on a fantasy, or a memory, to avoid the complications of a real-life lover. I've always loved how in that same poem, "The Tower," he asks, "Does the imagination dwell the most / Upon a woman won or woman lost?" Yeats immediately answers his own question by saying that if it's the woman lost, that just means you were too much of

a chicken to deal with a real woman. You missed your chance to brave the labyrinth.

So you get less shy about how hard you have to try. And you don't bother hiding your *Kotter* tapes. Sure, they expose some of my appalling deficiencies. But my appalling deficiencies are all I have to offer. Is there such a thing as romantic love that does not depend on somebody embracing my deficiencies? I hope I will never find out.

TWENTY

1:46 a.m.:

Some Other Time

I like being a husband. I found (against my will) that I could live alone, when forced to; I got competent at that, but not to the point where I really liked it. I hated dating and I don't make that great a boyfriend. What I really enjoy is being a husband. When a conflict comes up, I do not like to sit up until dawn bickering about it or analyzing it; that's what boyfriends and girlfriends do, and they can have it. If it makes her mad when I use her toothbrush, I do not need to discuss why. I just stop using her toothbrush.

Finding problems interesting is for boyfriends and girlfriends. I prefer to *avoid* problems, because I am lazy. If I think a task might be annoying, I will avoid doing it while my wife is around. We both hate grocery shopping, so we stick to a strict policy of going to the grocery store alone. One of us shops, or the other does, but we don't do it at the same time. The supermarket brings out the least attractive side of my personality, the side that gets

flustered when people clog the frozen-foods aisle or park their carts in front of the peanut butter. Do I want my wife to see me like that? Not if I can help it. And I *can* help it. Whatever annoys me at the supermarket, I leave it there, so it doesn't enter into our relationship at all.

It was my wife who brilliantly proposed the "no housework together" rule, which means if one of us gets the urge to vacuum, the other goes for a walk. I'm sure we could *learn* to enjoy scrubbing the tub together. And we could also probably learn to have tedious discussions about the relationship. There are *lots* of annoying things we *could* do. We just *don't*. We're not rookies. We're lifers.

As the then-married singers in the punk rock band X sang in "Some Other Time," one of the all-time most useful songs about how to be married, "We can draw the line some other time." And being married means there will always be some other time.

I am by no means endorsing this emotional toolbox, nor my apparently permanent inability to put a serious effort into changing. I'm just trying not to be coy about it. Problems that don't get fixed, situations that neither get resolved nor go away, and annoyances you live with year by year—that's the engine knock of a long-running relationship. Treating these situations as challenges to be faced, or mountains to be climbed, or projects to be completed— that's what boyfriends and girlfriends live for, I guess.

I have to be honest. I am not one of them.

I AM (AS I MAY have mentioned) an Irish male. If you know anything about Irish males, you know there's something we usually

have in common: We don't want to talk about it, whatever prob-lem "it" may happen to mean at the moment. "Not talking about it" is one of our specialties, right up there with "talking about everything else *except* it."

We have been known to pride ourselves on not overreacting. We like to imagine that the women in our lives count on us to be dependable, resilient, cool in a crisis, yet that is partly why they can also find us exasperatingly cautious. We don't ask for help. We like to ignore our problems, and hope they go away. They usually do. A few years ago, my uncle Dermot back in County Kerry got *gangrene* on his leg and didn't see the doctor for six months. He just kept working the farm and waiting for the leg to get better. When it turned purple, he finally showed it to my cousin, who dragged him to the croakers. They managed to save the leg. To Uncle Dermot, this proved he was right to put it off until the right time. I'd be lying if I said I didn't relate.

(That's why I love *Mad Men*: Roger Sterling is the most au-thentic Irish guy I've ever seen on TV. Historically speaking, his character should be a WASP, but that's not how John Slat-tery plays him, and the writers write for Slattery. He helps me understand myself a lot better, like when he accidentally blurts out a secret to Don Draper. "I was *going* to tell you. No, I wasn't. I thought you knew. I'm sorry I told you, believe me." Oh, damn right I believe him.)

My grandfather had a cool head, and it's one of the reasons the women in his life adored him. It's also one of the reasons his grandson adored him. He tried telling me many times that I had the same Irish male pathology he did—the "Twomey temper,"

where you stew in a silent rage, as opposed to the "Courtney temper," which is where my grandmother came in, and did not involve silence at all. When she got mad, she blew up, but then she was done. She didn't nurse a grudge. My grandparents held it together for sixty-two years, and they were always very different this way. My grandfather said I inherited his Twomey temper instead of my grandmother's Courtney temper, which he warned was bad luck for me.

The men in my family seemed to take pride in not losing their shit, and my early conception of what it meant to be a *man* as opposed to a *boy* had largely to do with managing your temper and handling your grievances one at a time. (Little boys—they're petite rage queens, or at least that's how they seemed back when I was one. When I try to remember the boys from elementary school, they blur into one long *Real Housewives* marathon.)

When I was into my teen years, my grandfather had one of his buddies from the New Haven Railroad over for tea. When I came in to say hi, the railroad guy said something along the lines of "Your grandson is very tall." My grandfather said, "Yes, and he doesn't fight, either." He nodded proudly. This was a very strange comment to me at the time. I guess I had never heard my grandfather boast about me to a stranger. (He never had to—my grandmother handled the bragging-about-her-grandson business like it was her life's work.)

This is the way old Irish men talked when they were bragging about their grandsons? These were two tough guys, born in the nineteenth century, on Irish farms where their families and neighbors routinely died of malnutrition or the flu. Guys who

escaped to America, only to face the Depression and break their backs to build the twentieth century. He was proud of me for not getting into fights? I was under the vague impression that this was one of my more eccentric character quirks. He didn't say "he doesn't drink" or "he doesn't smoke" or "he gets good grades," he said "he doesn't fight," and that blew my mind at the time. In my grandfather's eyes, that meant I was a man.

The comment made more sense to me as I got older. These guys had seen hardship. They had seen weaker men snap. They had seen families turned to paupers because a male had failed to keep on keeping on. My grandfather valued steadiness and fortitude. And Lord knows he needed it, as he was married to my grandmother.

Eventually, this was how I came to see husbandhood. Part of the job is keeping a cool head and not overreacting to temporary crises. Again, I'm not trying to defend this pathology. I'm just trying to be explicit about it. And I'm aware it's a pathology that can make for a truly terrible boyfriend. It's one of the reasons why I'd rather be a husband. Being a boyfriend is much, much harder for me than being a husband. There isn't even much overlap in the skill set.

I WAS WELL INTO MY thirties before I found out I made a mediocre boyfriend. It was a dismal lesson to learn.

That's when I decided to try couplehood again, even though I wasn't sure I was ready yet. I'd been a widower on the shelf too long. The grief still clouded my heart, even after three years. But I met a really cool woman who lived across the country.

On weekends I flew out to the Midwestern city where she re-sided (let's call it "Minneapolis"), except we had this fundamental incompatibility (let's call it "me being a bitch"). Was I out of practice, or just still hung up on the past? Either way, I had never experienced relationship troubles like this, and I was a total amateur trying to resolve them. She was a good person. I was a good person. We didn't get along. It was a shock to me after years of being happily married: failing as a boyfriend. What a letdown. It must have been how Michael Jordan felt when he left the NBA for baseball, only to discover he couldn't even hit the minor-league curve.

On Sunday nights, I flew back to New York in a miserable mood. At the Minneapolis airport, before my flight, I would drift over to the game room with the *South Park* pinball machine. It became my regular Sunday night therapy session. It was always strangely comforting to drop my quarter in the slot and see the lights come on, put my fingers on the flippers and play. Now this was a challenge I could handle, one where I got better with practice. This I could get right. If I lost the ball too early, Chef's voice would yell, "Stop draining your balls so fast!" At the end of the game, Kyle always piped up to say, "I learned something today." It was soothing somehow.

I began making excuses every Sunday so I could get to the airport earlier. I would spend hours at that *South Park* machine, with my carry-on bag and my boarding pass, and think, "Maybe this is who I am now. I used to be good at being somebody's husband. I made a woman I loved smile for a few years. I had a nice run, but it's over. This is me now. The guy who's good at playing pinball in airports."

After we broke up, she mailed me a present for my birthday: a box of brownies. Not a baked batch of brownies—a box of Duncan Hines brownie mix. A strange gift, maybe, yet it was an incredibly kind gesture, and it made me really happy. I displayed the box on the kitchen counter in Apartment 7Q, where it brightened up the room for a few days. In a way, it was the ultimate compliment—a sign that someone saw unbaked potential in me. Even in my ramshackle emotional state, somebody had high hopes for me, to the point where she could picture me taking on a project like opening a box of brownie mix and shopping for eggs and finally turning on the oven I used to store cassettes. But it was not to be. When my birthday rolled around, I spent it at home alone, in front of the TV, watching Britney Spears and LL Cool J host the American Music Awards. Midnight came. I was thirty-five. I threw the brownie mix away.

All the things I thought I had already learned about love? I didn't know a thing. I was going to have to learn it all over from scratch.

I SUCK AT FIGHTING. I have never really learned how to talk and be mad at the same time. If I have angry words to say, I need time to rehearse. I can't improvise when my head's dizzy with adrenaline; I have to cool down and then write out a script. I found this trait very difficult when I was trying to be a boyfriend, because in my experience, boyfriends and girlfriends often spend a lot of time fighting. Husbands and wives seem to spend a lot of time avoiding fights. This might be a bad thing, for all I know, but it seems to be part of why I like being a husband better. That's just a limitation that comes with the mentality I got from my grand-

father: If you freak out over trivial everyday grievances, how are you going to handle *real* problems? And being a husband means there will always be real problems.

Why am I wired this way? Is it a good thing (I am patient, I am an oasis of peace, I dig in for the long haul and ride out the tough times) or do the negatives outweigh the positives (I'm emotionally lazy, I avoid conflict, I make problems worse by smoothing things over)? Did I get this way on purpose or was it something I was born with? Should I try to learn a different approach? I really don't know. But these are central questions of my life, so naturally I keep seeking the answers through music.

That X song might be my favorite song ever written about marriage, even if the married couple who wrote it ended up divorcing a few years later. John Doe and Exene Cervenka sing "Some Other Time" together on *Wild Gift*, the 1981 punk rock landmark by their band X, and though the song lasts barely two minutes, every second of it feels real. You can hear all the terror and desire in their gutter-poet voices. "Some Other Time" is still woefully obscure, despite all the years it's been a source of comfort and sustenance and wisdom for me. In a perfect world, it would be universally acclaimed as a classic, but then, it's a song about living in an imperfect world, as half of an imperfect couple. The couple in the song stay up all night talking each other out of breaking up. They have lots of good reasons to fall apart, but why waste tonight? There's no rush. They'll always get another chance to fall apart some other time.

Sure, you could draw the line and say, "That's it, enough is enough, I'm sleeping on the couch tonight." But in this X song,

the man and the woman decide to stop talking about their problems and just stick together for one more night. Who knows, they could be dead tomorrow. Maybe tonight they can just keep each other cool, until that panicky feeling subsides and in the morning all the anger just looks like another silly dream. The song tells you that there will always be good reasons to break up. Deciding to get married doesn't make those go away; it just forces you to keep riding them out. But if you need to break up, don't worry—tomorrow will be another chance to break up or stay together.

Being a husband is scary. That should be obvious, it seems, but I guess sometimes it isn't. We have everything to lose. We have made promises. We have given hostages to fortune and challenged fate to a dance-off. We have chosen a future full of loss. Husbands are always scared—a little, or a lot, or constantly, or sporadically. There's a certain wariness built into the job description.

Gertrude Stein put it best in *The Mother of Us All*, her opera libretto about Susan B. Anthony. "Men have kind hearts when they are not afraid but they are afraid afraid afraid." I do think Gert got this one right. I do the best I can to ignore the fears and let them drift past like clouds. But when you marry somebody, you are guaranteeing that you will have real problems, a future full of them, the kind that involve death and disease and grief. As husbands, we have *planned* on major anguish. We can't afford to use up our patience all at once, or over things that aren't all that important. I know other husbands are afraid of this stuff. I have been afraid of it, too, and when bad things really did

happen they were even worse than I could have imagined. My nightmare came true and I can't tell any husband he should be *less* afraid. Our fears are totally justified.

Men have kind hearts when they are not afraid but they are afraid afraid afraid. I say they are afraid, but if I were to tell them so their kindness would turn to hate. Yes the Quakers are right, they are not afraid because they do not fight, they do not fight.

Nobody tells you how scary it is when you become a husband. There's a strange culture of silence around the whole experience. This is partly because, well, we don't want to talk about it, do we? And it's partly because it's all too scary to talk about. That can make us feel alone with our fears. That's why I've always been obsessive about songs that tap into this husbandly angst, because it's so taboo to talk about anywhere else. Kurt Cobain and Biggie Smalls wrote great songs about that—both guys my age who'd already left their wives widows by the time I became a widower.

There's a great old garage-punk song by the Music Machine, called "Masculine Intuition," that really nails it. The husband in this song worries about things that never used to bother him. He's ashamed to fuck up in front of his wife, he can't live up to all his promises, and the only feeling he can trust is his masculine intuition, which tells him, "Keep coming on strong," whatever that means. There's something lonely in that angst, just as there's something traumatic about loving somebody until death do you part. It rips you up just to feel that intensely, to tell that person, or tell the world. That does savage things to your heart.

• • •

THERE'S A COUPLE I KNOW who've been married for more than fifty years—I met them down at my parents' place in Florida. They were high school sweethearts. He was telling me about her in the pool. "Something she still doesn't understand about me is that I'm good for about three hundred words a day. When I've gone through those, I'm done. Fifty years, and she still thinks I'm holding out on her."

He didn't sound like he was complaining, more like bemused, as if he were describing something funny about her golf swing. She was at the other end of the pool, so I couldn't hear what she was saying about him. I'm sure they weren't resolving anything and I'm sure they don't care.

Something I really enjoy about the company of older couples is that they really have given up on getting everything right. They don't sweat the imperfections. Sometimes it seems like they're good at just plain ignoring things that younger couples get fixated on. They don't need to keep discussing the relationship—they can't spare the breath. And I guess that makes sense. Marriages, by their very nature, reward dogged persistence. Marriages involve "counting stats," not batting average or ERA. The longer you stay married, the more you have to give up on the idea of perfection. And the more you probably relate to rock stars with long and tattered discographies, people like Smokey Robinson or the Kinks or Neil Young who make a hundred messy records rather than a few perfect jewels.

I have to admit, husbandhood suits me because I like thinking long-term. I like knowing that if today wasn't so great, tomorrow is another day. I like knowing that if today was glorious,

tomorrow will be ordinary. I like knowing that these days will stretch out into a future so long that we will have lost count when we hit the thousandth or the ten thousandth, knowing that our problems will be temporary ones, knowing that there will be more time together. I like ruling out panic as an option. I like knowing that I can count on my wife to stand strong with me when we face the death and hardship and loss that we have guaranteed that we will face. There are always excuses to give up. There are always reasons to draw the line. But we can draw the line some other time.

TWENTY-ONE

2:02 a.m.:

New York, New York

As you can probably guess, I do not embarrass easily. My capacity to feel any kind of embarrassment is appallingly absent. I could claim I'm working on developing a sense of shame, but it's a little late for that, given the hours I have already invested in wearing my Orchestral Manoeuvres in the Dark tour T-shirt. It's a flaw in many ways, but it does help with the sangfroid required for karaoke.

There's only one karaoke crowd that has ever made me feel truly intimidated. The old people—the Wednesday night crowd at Del Tura in Fort Myers, Florida, the age-qualified community where my parents spend the winter. Or, as the residents like to call it, God's waiting room. These old people party harder than any of their grandchildren do, and they do not mess around. They cruise around from bungalow to bungalow in their golf carts, looking for any fiesta that appears to be under way. When they say they're coming by for drinks at four, those bottles are

popping at 3:59. When Charo comes by to do a concert in the bingo hall, everybody shows up and gets their coochie-coochie on. And tomorrow morning, the ladies in the pool are going to debate, in rigorous detail, how much work Charo has had done. I pray I will be as cool as them when I grow old.

And these people *love* their karaoke. Wednesday night is not for dilettantes. It's not for the visiting kids or grandkids, either. You better get there early and get your request in. The lounge fills up by seven, everyone putting away their pitchers of Yuengling as the mike gets passed around. The first time I visited my folks down at Del Tura, I couldn't wait for Wednesday night. I thought I was going to coast, to be honest. I thought everybody would think, "Oh, how sweet, here's Mary and Bob's kid, he's going to sing." I thought I would reach back, way way back to the mellow gold of the seventies, charm them with some Kenny Rogers and Neil Diamond, as an example of cross-generational outreach. I suspected I might get bonus points for being the youngest person in the room. I certainly expected to get a few pats on the head from my mom's mah-jongg squad.

Ah, no. It does not work that way at Del Tura. Their karaoke scene is four hours a week, for however many Wednesday nights they have left. Every minute counts. If you are taking a turn at the mike, you are taking up valuable oxygen that belongs to someone else, and you have to earn every breath of it. Tough crowd. But then, who the hell gets to be old without being tough?

As for that seventies gold malarkey, think again, rookie. These people are doing the forties and fifties classics—you know, *real* music. It's mostly country songs, plus pop standards and a little

old-time rock & roll. Nobody gets up on Wednesday night unless they have their Eddy Arnold and Patsy Cline and Johnny Cash down tight. Even Merle Haggard is a little green for them. Try Lady Gaga in this room and you are begging for a poker-faceful of Yuengling.

Since I'd already filled out my request slip and handed it to the guy, it was too late to back down, especially since I was conspicuous as the only customer who did not recall the Truman administration. I'd quickly detected that my Kenny-or-Neil concept did not fit in with the house rules, and switched to something I thought was foolproof: Frank Sinatra's "New York, New York." How do you mess up this song? Everybody likes it. All you do is say, "Start spreading the news," and the news spreads itself. My mom and dad even saw Frank do this one on the "Ultimate Event" tour of 1988, with Liza Minnelli and Sammy Davis Jr. (Dino dropped out.)

It worked. I did fine. I took it seriously and made eye contact and respected the song, which was the main thing. I didn't bust out any jazz fingers, which seemed like bad manners, given how many arthritis-themed conversations I'd had that week. I even got a handshake from my folks' hardest-partying neighbor, the guy who flies a Fighting Irish pennant and decorates his porch with a granite sculpture of a dog wearing shades Spuds MacKenzie–style.

For the rest of the night, the regulars kept stepping up and singing, reaching back through the decades. They kept the karaoke DJ hopping until eleven, when he had to pack up his laser discs and head out. They sang the songs that they went out danc-

ing to when they were young. They sang the songs that reminded them of courting. They dedicated songs to their spouses, many of whom were dead. They were fearless in facing up to all the memories in these songs, memories that have been building up longer than I've been alive. These folks spend all week waiting for this night, their turn, these memories. They're not waiting around for next week. They don't have time.

These are old people who love music. They fill me with awe. I am nervous to sing for them. I want them to like me. I want to be them one day.

WHEN I WAS A KID, I loved that book *Watership Down*, the one with all the psycho warrior rabbits. I loved how the rabbits can only count on their paws, so in their math system, any number that's more than four, they just call "hrair." In the lapine language, it literally means "a thousand," but these bunnies can't tell any difference between a thousand or five. Those numbers blur together into one. Hrair has always been a useful number for me, especially when answering questions like "How many beers did you have last night?" or "What time did you get in?"

Hrair is handy for music fans, because that's your rock & roll age once you get past twenty-four. After that, it's all the same age: hrair. If you still love music at twenty-four, you always will. Even if you check out for years at a time, fandom comes back around. You're stuck with it. You won't get sick of the songs you already like, but you will always want to hear songs you haven't heard, whether it's buried treasures from before you were born, or whatever great new band just plugged in their guitars for the first time last night. And your age will always be hrair.

When I was twenty-two, just barely old enough to get into rock clubs, I couldn't believe my older friends when they told me stories about hearing Jimi Hendrix or Television or the New York Dolls live. *So lucky*, I thought. *I was born too late.* I met a grizzled British punk guy in a club in Boston who saw the Sex Pistols live, or was at least willing to make up stories for the gullible little American boy he was attempting to pick up. (Sorry I stiffed you, Alex! I thought you just wanted to scam my cigarettes.) I began thinking of these people as "hrair," because I was just a tenderoni too young to know any better. Anybody older than I was, a little or a lot, their ages mashed into one fuzzy abstraction. But within a couple of years, I was hrair, too.

Once you reach that point in your life, you may not be the target audience for new music anymore. But that just means you have to scrounge a little harder to find it. You don't necessarily want to make a religion out of it; you just want to keep participating. Music isn't an accessory to a lifestyle—it's part of a life. It's not a youthful phase you go through. And that's one of the reasons karaoke got so big. There's no way to age out of karaoke. It doesn't recognize time or history. All music, whenever it came from, whoever made it, it's all *right now*.

In addition to everything else it is, karaoke is a way for people to keep connecting to music as they get older. Music responds to a lot of human needs, but one of those is public communication—feeling like you're part of an audience, connected with other people who care about the same things. That really has nothing to with reliving youth, or prolonging youth, or anything to do with youth at all. (Well, it might have something to do with trying to *sleep* with youth—but if that's your

goal, I hope you have better luck than the guy who told me his Sex Pistols stories.)

It's definitely no coincidence that the karaoke boom of the early 2000s happened alongside the decline of radio and MTV, after the great nineties music explosion ended. For years, new music was in the air, whether you were an active consumer or not. You could dabble in a couple hours of MTV a month and get a free cheat sheet, enough to bluff your way through a chat at the dentist's. You could participate in music just by turning on your car radio. You didn't have to chase it down. It came to you.

When the radio and MTV were on the job, people loved to complain about them. But we all accepted the idea of pop music as a social fact. It was out there, getting airplay, and even if you didn't like the song, you could respect that at least it was popular. The Top 40 was a place where music fans from different corners of the pop world could check out each other's styles and see what was worth heisting for themselves. Even if you didn't consider yourself part of, say, the Pearl Jam audience, or the Snoop Dogg audience, or the Reba McEntire audience, you knew these audiences existed, and that if you overheard their songs on your friends' or neighbors' radios, it was (at the very least) something to talk about. I always think of something Beck said in the nineties, when someone asked him why he mixed up all different strains of music on his records: "I'm just trying to connect with the in-laws."

But as the 1990s turned into the 2000s, new music got harder to find. You couldn't browse at the record store because you couldn't find a record store. It was easier than ever for a music

fan to get stagnant and keep vegetating in the oldies, just because you couldn't count on the radio for what the sizzurp-sippers or headbangers or line dancers were blasting this week. Even the biggest pop hits weren't quite inescapable. Something was lost there. And that's part of why karaoke blew up the way it did.

Nobody wants you to be an expert on music, or on *anything*, when it comes to karaoke. You get zero bonus points for having a big record collection or knowing your Sinatra trivia. You do not get extra credit for explaining how "New York, New York" was Liza Minnelli's jam before Frank swiped it, or how Liza sings it for Robert De Niro in the Scorsese movie of the same name. You don't need a clever theory about the song's cultural resonance. You just need to get up there and start spreading the news and sing the damn song.

The technology may have changed, but that fundamental human need is the same: We need to share music with other people. That's why karaoke crosses all generational borders, and that's why Del Tura has the most hard-core crowd I've ever seen. Those are lifers.

None of those people care about my expertise as a music journalist or my collection of Dylan bootlegs. Nobody even gives me a pass based on my mom's mah-jongg skills. When I get up to sing "New York, New York," I have exactly three minutes to show and prove I'm worthy to hold that mike in my mind. The only thing that impresses them is what I give to the song, right now. They have no time to waste.

The Wednesday night folks have been loving music for sixty or seventy years now, and yet their favorite song is always the

one they're singing tonight. However many Wednesday nights they've got left, they are going to cram those full of music. They are going to be fans for as long as they breathe. Nothing can take that away from them. It's too late for that. I feel honored to sing with them.

TWENTY-TWO

2:16 a.m.:

Forever in Blue Jeans

You can't talk about karaoke very long before you delve into the topic of Neil Diamond. It just can't be done. He is the colossus. There are loads of famous singers who inspire legions of karaoke devotees, but Neil has made more converts than any other individual. He is the Colonel Kurtz of the whole karaoke cult, shining his heart-light right into the heart of darkness. You sing a Neil song, and you know what it's like to kneel before a god. We worship him, we give him thanks, we praise him for his glory.

Like most red-blooded Americans, I've been a Neil fan all my life. His songs were a radio presence; it's like he was always there. But ever since I got into karaoke, it's a different level of fandom. Now I wear the man like a velvet suit under my skin. Partly it's because his songs are so perfect for karaoke, it's like he scientifically engineered them for that purpose, even though he was a star before karaoke was even invented.

Every karaoke singer has a vocal doppelganger, and mine is

Neil Diamond. When you start singing, you find out whose voice suits yours and who doesn't, and you don't always get to make the decision. A friend of mine has a voice right in the Lionel Richie range, so we always make him do the Commodores songs, even though he was never a big fan before. You follow your voice wherever it leads you, even if it's against your will. (Or against all odds, if it's Phil Collins.)

But whoever it is, you find your voice by reaching for theirs. The voice gets into your soul and this guy means more to you than he ever did before. Your doppelganger becomes your spiritual mentor. And that has turned my personal relationship with Neil Diamond into some kind of obsession.

It's not that I actually sound like him. That would require decades of training and a third lung. But his songs are very forgiving for my flaws—slow and low, with lots of dramatic pauses where I can catch my breath. His songs tend to have cool talking parts, heavy on the consonants. But they always explode into louder-than-a-bomb choruses, jumping up an extra key for the final fade-outs. Neil likes to drop one line on your head, wait a beat to let it sink in, and then drop another. He commits to every line with total intensity. You can't half-sing the Neil, or do it ironically. You have to let yourself become Neil. You can't sing it like a "warm evening in March," or even a "toasty evening in June." Your emotional thermometer has to go all the way up to *Hot August Night.*

That's why it took the karaoke era for Neil to take his true place at the top as a pop legend. He's the ultimate example of a star who sounded like he was already doing karaoke when he recorded his own songs.

Something in Neil Diamond speaks to the boy in you and commands you to answer as a man. Something in Neil's voice says, "Enough with the small talk, kid. You've mumbled at the floor too long. That tongue-tied high school boy thing was cute for about ten minutes. Stand up straight and look that woman in the eye. Knock off the chitchat and say what you mean."

Neil's intensity can be intimidating, so you might accuse him of being excessive and hammy. But that's when Neil speaks to you again. "Right, kid, James Dean got away with mumbling at the floor and he still got the girls' attention. You as hot as James Dean? Didn't think so. Are you a genius? Are you a movie star? No? Then speak the hell up. Give that girl a piece of your mind. That girl will be a woman soon, and if you want to be the man, you need to start getting her attention now. Not tomorrow—*today*. Tell her something good. Say it loud. Say it proud."

So when you sing a Neil song, you can hear Neil coaching you, guiding you, mentoring you. Neil wants to make you a louder person. If you're a boy, Neil wants you to sing like a man. He gives it to you straight. "Look in the mirror, kid. Or merely behold your image in the reflective sheen of my gaze. You can't worry about whether you are good enough to sing this song. You can't hem and haw about whether you are worthy to hold this mike. You must belt. Act like you planned every second of this. Look at the woman when you sing to her and *mean it*."

That intensity is what makes him the ultimate entertainer. His live classic *Hot August Night* is truly frightening in the way you can hear the rapture he provokes in his audience. There's a moment where he says, "Tree people out there—God bless you, I'm singing for you, too!" The liner notes explain he means the fans

outside the theater, the ones who couldn't get tickets and had to climb the nearby trees to catch a glimpse of their hero. That's how much Neil adores his audience—he even sings for the free-loaders. But then, aren't we all tree people in Neil's forest? Can any of us claim we deserve him? No, we cannot.

Maybe Neil was thinking of the Bible story about Zacchaeus, in the gospel of Luke, where the tax collector climbs a fig tree so he can see Jesus preach. (Yeah, but did Jesus ever make a live album?) Either way, you can hear the messianic fervor in his voice. He's a take-charge guy. Even when the lyrics are pure drivel, Neil sings every line with ferocity.

And that's why "Forever in Blue Jeans" might be the ultimate karaoke anthem. It can scarcely be overstated how ridiculous this trifle is. "Honey's sweet, but it ain't nothing next to baby's treat"—Neil not only wrote that line, he *kept it in the song.* Now, if you or I were trying to write a hit, and we came up with a lyric like that, would we say, "Hey, I think that's a keeper—our work is done here"? Ah, no. We would immediately crumple the paper, burn the tape, and never mention it to even our closest friends. We would take a hot shower. We would question our major life decisions. But Neil not only held on to that line, he turned it into a massive worldwide smash.

How did he do that? By singing the whole thing like a man. He attacks "Forever in Blue Jeans" like he thinks Bono is just some drippy-nosed whimpering child. Even when he gets to the "honey's sweet" line, he comes on like Samuel L. Jackson bellowing, "I hope they burn in hell!" You hear it and you believe. And to sing it, you have to believe, too.

The karaoke mentality brings out that hammy Vegas over-the-top belter in your soul. Karaoke is not the venue to get mellow or introspective; it's no place for James Taylor or Carole King or Paul Simon, much as I love them. You have to bring the Neil. It makes you engage with your own emotions on a more extravagant level. And when that spills over into your everyday life, it brings out the sequins in your soul. This is something I get from karaoke, and over time it's come to be something I *need* from karaoke.

IT WAS ONLY AFTER I started singing Neil songs, night after night, that I needed to see the man live for myself. The next time he came to Madison Square Garden for a two-night stand, I had a plan. I talked Ally into coming along to the second night, which was a coup since she's not really living the soft-rock lifestyle. But I went to the first night by myself, so I could sit alone up in the darkness and cry my eyes out to those songs. I figured Night One would leave me all cried out, so I'd be able to face Night Two bravely and not embarrass my wife.

Night One went according to plan. I skipped a Dylan show that same night so I could sit in the nosebleed seats of Section 424, surrounded by nice old ladies who told me stories of how many times they'd seen the man together. (Along with their second-favorite, Sting, and surprisingly, John Mellencamp.) Neil was the master performer I'd always imagined—now *this* is a star, I thought. Now *that's* entertainment. He had a conveyer belt to rotate him around the stage, so he could project to every corner. He dedicated "Forever in Blue Jeans" to the fans who

bought tickets behind the stage: "Can you believe they *paid* for these seats?"

But he sang to them, too. He sang "Sweet Caroline" three times in a row. (Note: I don't mean he did a triple-sized version. I mean he began and ended the song, in its entirety, *three times*.) Then some roadies came out and set up a dinner table at the corner of the stage, with a white tablecloth, silverware, candles, a bottle of red wine. Neil sat down, lifted his wineglass pensively, and sang the first line of "You Don't Bring Me Flowers."

I had a clear view of the hippie guy on the other side of the arena, right across from me, waving his hair to "Crunchy Granola Suite." I drank buckets of beer and wept like a baby to "Brother Love's Travelling Salvation Show." Even the other cheapskates around me in Section 424 must have been a little horrified.

On the second night, I was sitting with the same bunch of ladies, who looked relieved to see I had a date this time. I figured I had unloaded the tear ducts, so I would be able to face tonight like a dry sponge. Unfortunately, my tears began to gush from the opening bars of "I Am . . . I Said." I cried all over again, even though Neil did the same songs, with the same stage banter. He busted out the bit where he says, "People always ask me, Diamond, why don't you retire? Why don't you quit touring the world and making people happy with your songs?" We all screamed *"Noooo!"* on cue, even Ally. There was no shame in my sobs.

If I hoped to pick up any secret tricks I could steal when performing these songs, I went home empty-handed. But that was all right. Everything Neil wanted to say, he'd already taught me in the karaoke bar.

TWENTY-THREE

2:35 a.m.:

Let Me Entertain You

Karaoke has a lot to answer for, but in terms of its long-term cultural impact, here's an underrated side effect: It killed the Hollywood slow clap. At some point, the movies gave up on the old-fashioned eighties slow clap scene and replaced it with the inevitable karaoke scene, where awkward characters would express their bottled-up emotions in song. Suddenly, it wasn't good enough to have Corey Haim open his locker and find a varsity football jacket (*clap*) and wonder if it's a prank (*clap*) only to realize (*clap clap clap*) his plucky quest to make the team has won the respect of his high school classmates (*clap clap clap*), including but not limited to Charlie Sheen and Winona Ryder (*clap clap clap*) and the whole school is giving him a heartfelt round of applause. *Woo-hoo! Try it on, Lucas! Way to go!*

Also, in the nineties, people stopped saying "way to go" entirely. This was a good move, nineties.

It's amazing how karaoke scenes became such a Hollywood staple so fast, in movies and on TV. It wasn't a gradual evolu-

tion: Once "the karaoke scene" arrived, it was a necessity. Every flick had one, from romantic comedies to crime thrillers. These scenes always work because they combine emotional exposition with the basic pleasures of watching famous people do stupid shit. It's an easy three or four minutes of filler to throw into any screen narrative, with a guaranteed payoff, whether it's going for quick laughs or quasi-unironic poignancy. It's like putting a horoscope in a magazine or cat photos on your blog; it's so automatically effective, requiring zero effort or ingenuity, it seems stupid *not* to do it.

The karaoke scene also became a popular trope because there are so many different ways to play it. It can be slapstick, as in *Shrek* or *Rush Hour 2*. It can be sensitive, like Ewan McGregor singing "Beyond the Sea" with Cameron Diaz in *A Life Less Ordinary*, or ominous like Jim Carrey doing "Somebody to Love" in *The Cable Guy*. It can be romantic, as in *500 Days of Summer*. Or it can be totally inane, like Gwyneth Paltrow and Huey Lewis in the "karaoke king by day, serial killer by night" drama *Duets*. And yes, that one really happened.

It just goes to show how people were jonesing for karaoke to hurry up and arrive, without even realizing it. (In *When Harry Met Sally*, they didn't even have the word *karaoke*—they had to call it a "singing machine.") Every teen film of the eighties would have been so different if karaoke had existed. Consider the Duckman. If *Pretty in Pink* had been made a few years later, when he would have enjoyed access to karaoke equipment, Duckie wouldn't have to settle for lip-synching "Try a Little Tenderness" in the record store for Molly Ringwald. He could have sung his own version.

But karaoke was about to take off like a dirty shirt. And once it did, the slow clap started to look as quaint as a bolo tie with a powder-blue tux.

You saw *Lost in Translation*, right? There's no slow clap in that movie, right? It doesn't end with Bill Murray kissing Scarlett Johansson dramatically on the sidewalk, inspiring a crowd of bystanders to burst into applause? Of course not. Instead, there's a karaoke scene, and it's completely brilliant, possibly the saddest karaoke scene in any movie ever. Bill Murray, who spent all those years on *Saturday Night Live* mocking lounge singers, plays it straight with the Roxy Music song "More than This," expressing all the romantic yearnings he can't share with Scarlett in any other way. Meanwhile, Scarlett dresses up in a purple wig to do the Pretenders' "Brass in Pocket." There couldn't be a better picture of how karaoke works in the public imagination. It gets at the emotional essence of it: Sometimes you can only confess the truth about yourself when you're pretending to be somebody else.

A real historical turning point was the short-lived and soon-forgotten MTV show *The Blame Game*. You might remember this show, or you might not, but most likely you wouldn't admit it if you did. It was on weekday afternoons, right after *Total Request Live*. I'm not ashamed to say *The Blame Game* kept me chuckling through many a dreary afternoon in the late nineties, as I sat in a catatonic stupor on my couch, caked in despair and Cheetos dust. Somebody besides me must have been watching, right? Maybe not, actually. (Where's the DVD box set, MTV?)

The Blame Game was set in a courtroom where supposedly

real-life ex-couples would go on trial to see whose fault it was that they broke up. A judge in a black robe presided over trials like "The Case of the Tube Top Tease." Like most courtrooms, this one had a DJ, plus a live studio audience, all of whom were probably mad they couldn't get tickets to *Singled Out* instead. Each of the exes had an attorney (Kara for the ladies, Jason for the gents) as they gave testimony and got cross-examined in the "You Did It—Admit It" section. After the audience voted on the verdict, the loser had to kneel and beg for forgiveness, or else get their mug shot printed in magazine ads with the headline Do Not Date This *Blame Game* Loser!

But the best part of this magnificently cheap and crummy show, the scene that kept me on the edge of my seat, was the scene toward the end where the exes would testify in the Karaoke Chamber. Each litigant would step into the booth and sing a popular song, selected to express their feelings about their side of the breakup. The guys would usually pick something by Pearl Jam or Ugly Kid Joe; the ladies would go for Alanis or Toni Braxton. The only time I ever saw a gay couple on the show, the loser sang Madonna's "Love Don't Live Here Anymore." (It was also the only time I ever saw an actual forgiveness hug at the end, and I would have acquitted that dude, too, just for that song. Oh, the healing power of Madonna.)

My favorite Karaoke Chamber testimony was the Southern belle who had broken up with her boyfriend because he'd told her he was a virgin (he wasn't) and because he was a jerk (he was). For his testimony, he picked Green Day's "When I Come Around." She stepped into the booth to sing a cheesy nineties

soft-rock ballad, Jann Arden's "Insensitive." I vaguely remembered disliking this song on the radio, but in the Karaoke Chamber, it was deep soul. This girl wailed it like every line was getting wrenched from her heart, ascending straight to overshare heaven. She wasn't just off key—she didn't even drop by the key for a visit. It didn't matter. Even the judge was wiping away tears. The Green Day dude didn't stand a chance.

After *The Blame Game*, the deluge. Like the brilliant karaoke scene in Britney Spears's maiden cinematic voyage *Crossroads*. (Yes, I realize I can't stop mentioning this film. It is important. What can I say?) In this fine feature film, Brit's on a cross-country road trip with her high school girlfriends, and their car breaks down in New Orleans, and they need a whole bunch of cash to get it fixed, y'all! So they enter a karaoke contest, which Britney wins easily with the first song of the night, her version of Joan Jett's "I Love Rock 'n Roll." The bartender, played by old-school rapper Kool Moe Dee (how ya like him now?), passes a tip jar through the crowd, netting a prize of four hundred dollars for Brit and her cronies. That's right: A room full of drunks in New Orleans shell out four hundred dollars for Britney *not* to take her shirt off! See, I told you! Movies are awesome!

The scene is perfect in its way, because you don't believe a second of it, which makes it just like the rest of the movie, but you can tell what's going on and why. Because karaoke is a dip into the unreal, the unrealness of the movie catches up with the unrealness of the scene and they coalesce into a moment of oddly convincing emotional truth. The same thing happens in the David Lynch movie *Mulholland Drive*, where the torch singer

does a Roy Orbison song in Spanish and whispers, "Silencio. No hay banda." Except even David Lynch is about one-twelfth as creepy and disturbing as Britney singing "I Love Rock 'n Roll."

Jennifer Love Hewitt has a similarly great moment in *I Still Know What You Did Last Summer*, where she sings the bustiest, most foreshadowing-intensive version of "I Will Survive" to appear in any horror movie. She's singing, to entertain her group of school chums who are on a tropical vacation trying to forget their big guilty secret (the one about what they did last summer). But then the lyrics on the karaoke screen mysteriously flash the words, "I *still* know what you did last summer!" Eeek! I wouldn't be too sure about all that surviving you have planned, JLH.

And yet that's only my second-favorite bad karaoke scene with Jennifer Love Hewitt. I might be the only person who remembers *Time of Your Life*, her spin-off from *Party of Five*. Just like Britney, she's trying to find herself, which means she wants to go on a long journey, meet her long-lost mother, and bang some hot dudes. (Although instead of Kool Moe Dee, her guardian angel turns out to be RuPaul.) So she moves to New York City and moves in with Jennifer Garner. In the first episode, she gets a job waitressing at the local karaoke bar, the one where all the single hot guys hang out. She gets peer-pressured into making her karaoke debut, with the world's shakiest version of R.E.M.'s "It's the End of the World as We Know It (And I Feel Fine)."

I have to admit, I loved this scene. I had a copy of the pilot as a VHS screener tape, so I kept rewinding and rewatching that scene for days. The sight of Jennifer Love Hewitt chanting those rapid-fire R.E.M. lyrics was touching despite itself. It dares you

to guffaw at how ridiculous it is, and yet I couldn't. I cried actual tears watching it. (So did Michael Stipe, I bet, although for different reasons.) It was even better than the episode of *The Golden Girls* where Bea Arthur sings jazz standards for the boys at the Rusty Anchor.

But really, it all goes back to Natalie Wood in *Gypsy*, a stage kid who's been overlooked and ignored all her life, dressing up to do her first burlesque routine, only to be mesmerized by the sight of herself in the mirror, mumbling, "I'm pretty, mama! I'm a pretty girl!" It's one of the most wrenching scenes in any American movie.

Natalie Wood sings "Let Me Entertain You" in the burlesque parlor, completely dazed by the feeling of having people notice her for the first time. She spins around a few times. They're yelling for her to take some clothes off, but she doesn't even notice. She gets so wrapped up singing "Let Me Entertain You" that she forgets to take anything off except a glove. Her mother yells, "Sing out, Louise!" Nobody watching can tell how profound this awakening is for Natalie Wood, or why she seems like she's in a trance. Nobody truly understands her except the song that she's singing. And for a couple of minutes, it's all she needs.

TWENTY-FOUR

3:02 a.m.:

Knowing Me, Knowing You

Bury my heart at Planet Rose. Under the zebra-stripe couches, under the crusty red velvet carpet, under a bar stool. A piece of me will always be there. Where the bartender charges two dollars per song while watching the World Cup on mute. Where the tipsy Eurotrash girls flash their breasts for songs. Where the round mirror-lined wall forces all the different parties to sing to the entire room. No private corners here—it's a fishbowl karaoke-quarium.

How did we get here tonight? It started last night when we trucked out to Ding Dong Dang in Koreatown. They give you free Snickers and Milky Way bars and the songbook has tons of 1990s "Ordinary World"–era Duran Duran. But they were full. What's up with that? They're *never* full at Ding Dong Dang! So we motored next door to Music Story, where they give you free bowls of popcorn and cheese-puff balls, and where the sign on the wall promises, YOUR STORY IS ABOUT TO UNFOLD! (Remark-

ably similar to what Rod Stewart tells his virgin houseguests.) The book offers nineteen different Stryper songs. How is that possible? How could the devil himself know nineteen Stryper songs? It also has Swedish metal-guitar pioneer Yngwie Malmsteen, whose songs barely have any words at all, besides *death* and/or *Viking*.

After a late night at the Music Story, we're a bit hoarse and shaky. But we came out to the East Village tonight for a friend's birthday party at Planet Rose, or as we call it, Wet Hoes. It's 6 p.m. on a Sunday, when the place is usually empty, but there are three different crews, each of which was hoping for a private party. There are the Eurotrash girls, who improvise dirty words to show tunes, as in their version of "Summer Nights" from *Grease*. ("Met a slut with blood on her knees, met a whore with so many STDs," etc. Ladies, where *did* you learn English?) There's an all-male group of eight college bros, which is unusual for any karaoke place. They came to sing "Gimme Shelter" and "Sweet Child O'Mine." There's us, distinguished by the goth fashion, the pizza boxes, the cake, and the birthday girl. Nobody goes home until she does her ABBA song. And her Depeche Mode song. And about a dozen Monkees duets with Ally. Face it, the birthday girl is going to keep us here a while.

There's also a couple on a date, who look mortified. They sing one Sublime song and make their escape.

Everyone adapts to sharing the room. We clap for the other parties. The bartender favors the Eurotrash girls, and keeps moving their sticky Post-it notes to the top of his wall, but then, they're probably the regulars. When the birthday girl's boyfriend and

I sign up for Hall & Oates's "Did It in a Minute," the bartender puts on "Say It Isn't So" by mistake and we roll with it.

But when our friend busts out the ABBA classic "Knowing Me, Knowing You," she doesn't have to wonder whether she's getting an "uh huuuuuh." She will get all the "uh huuuuuh" she can handle. The audience knows that part of the karaoke code is giving the singer the sing-along response she needs. We turn into an army of Björns and Bennys. She turns on her Agnetha. (Or Anni-Frid? I never can tell the ABBA ladies apart.) For every "knowing me, knowing you," she gets a queen's ransom of "uh huuuuuh." See that girl. Watch that scene.

That's the beauty of karaoke. It's always a little taste of being the star, but a lot bigger taste of being the audience while you wait your next turn to be the star. It's five minutes of being Agnetha and an hour of Björn and Benny. If you're so needy you can't wait around, this isn't your jam. If you don't enjoy the listening-to-drunk-strangers element of karaoke, you don't like karaoke. You can go sing in the shower.

Hey, we *all* have a song in the queue. We all have our Post-it note on the wall. We came here to be stars. But it goes deeper than that—we came here to make *each other* stars.

IT'S FAIR TO SAY THAT anybody who knew me for the first three decades of my life would be stunned to see me in karaoke mode, because I was always such a shy, bookish lad. Definitely the quiet type. I mean, I liked to think of myself as mirthful and articulate, just because I read a lot of Oscar Wilde. But there's no hiding the truth—I was just an indie boy who wouldn't say boo

to a goose. I was the kind of kid who grows up watching *Animal House* and thinks, "Man, I can't wait till I get to college—so I can argue with Donald Sutherland about *Paradise Lost*! His reading of John Milton's poetry is utterly inadequate. And it's not fair to claim Milton's jokes are terrible, because there aren't any jokes in *Paradise Lost*, although there are some real laugh riots in *Areopagitica*."

Making the transition from quiet to loud is something many of us go through in adulthood. It's fair to say karaoke was part of that transition for me. Also? It's fair to say I used to begin half my sentences with "it's fair to say." Somewhere along the line, deep into my thirties, I grew up into an adult who cared a lot less about what was fair to fucking say. How did this happen?

It's often surprising for me to remember this transition happened. I recently learned that I have a reputation around the *Rolling Stone* offices for "lacking an indoor voice." I was stunned to hear this at a drunken office Christmas party, where several of my colleagues agreed I have one of the least-indoor indoor voices around. Me? (True, I get asked to pipe down, but I assumed that was a matter of content rather than volume.)

Just a couple of years ago, I got asked at a West Village coffee shop to take my phone conversation outside, because I was laughing way too loud. This was a totally justified and reasonable request. The sad part is that I wasn't even on the phone. I was reading a book, one I'd already read like six times (Chuck Klosterman's *Eating the Dinosaur*), but apparently I couldn't tone down the volume. So rather than embarrass the elderly customer who'd walked over to express his understandable request, I sheepishly

walked out *pretending* I was on the phone, hiding the book under my scarf and talking to it. (I have problems. Oh, tell me about it.) I read the rest of the chapter on the sidewalk outside Equinox Fitness Center, where nobody minded my laughing except the models and pigeons. But I do have to admit that the question "how did this happen?" did cross my mind. It often does.

The quiet-to-loud transition seems to be an Irish tradition. It happened to my grandfather. David Twomey could talk a hole through a brick wall. I spent hours listening to him tell stories, pausing only to puff his pipe, punctuating his pauses with "so" or "and if I did" or "anyway." Yet he didn't say a word until 1961, when he was sixty-two years old. The transition was instant. He worked on the New Haven Railroad as a brakeman, and one day, as he told me, they asked him to train two engineers from the Philippines. He spent a day riding up and down the east coast with them, explaining what he was doing. Their English wasn't so good, so he had to repeat himself. He began speaking and kept it up for the next three decades. Conveniently, this was when my grandmother started to go deaf.

My Uncle John, never short of words himself, heard a different version of the story. In this version, the transition happened in the Woods Hole railway yards in Falmouth, Massachusetts, on Cape Cod. The guys were arguing, and they decided to settle the debate by asking Dave Twomey, since his sons went to college. "That was his ordination," Uncle John says. "He started talking that day and never shut up."

I love how my grandfather told two contradictory versions of this tale. (Why would he tell one story when two would do?) But

in both, the ordination took one day. My mom grew up with him as the strong, silent type; I never met that guy. If he ever asked himself "how did this happen?" that's one question he kept to himself.

WITH KARAOKE, WE GET A chance to listen as well as sing. It makes all the difference, really. We can always sing to ourselves when we're alone, but we go to karaoke for something different. We want to be part of that audience. It's the call and response. We want to hear the echo. We like that "uh huuuuh."

My three sisters were the first voices I sang with, in the backseat of the car on so many family road trips. That's where we sang "American Pie" and all the songs from *Joseph and the Amazing Technicolor Dreamcoat*. For a long time, my sisters were the *only* voices I ever sang with. But I never gave up the fantasy of rocking out and making the world dance. I took piano lessons and clarinet lessons. Right next to my desk, I still have a guitar I'll never learn to play. Every year, I think maybe this is the year I figure out the whole "chords" thing. As for bands, forget it. I have been failing to bluff my way into bands since seventh grade. Sometimes friends of mine let me sit in for the occasional gig as tambourine boy or backup shouter. But the whole reason musicians form bands is to protect themselves from people like me.

Yet with karaoke, this fantasy of music communion comes true. There are so many tawdry places I have crawled to get that fix, and I have to admit I remember every one of them fondly. Radio Star in Koreatown, where they give you tambourines and bring you nachos all night. Winnie's in Chinatown, where they

always seem to stiff you on your song after you pay up front. Second on Second, where I wrapped my bones around the stripper pole for the world's sluttiest version of "Ignition (Remix)." That sketchy basement in Bushwick, where they let people smoke and only enforce two rules: No "American Pie," no "Stairway to Heaven."

My voice might not be a thing of beauty, but so what? It's like Keith Richards said: "I don't have a drug problem, I have a police problem." Well, me too. I don't have a singing problem—I have an audience problem. Except not in the karaoke lounge, because there all is forgiven. That karaoke microphone—whoever you are, it just wants to make you happy. And whoever hears you through that microphone, they want to make you happy, too. Karaoke might be the least complicated emotional interaction Americans permit themselves to have. It's like an airport on Opposite Day. We hang out with randos in a confined public zone, and yet we agree to let everything in that room be awesome. All the flaws are forgiven.

The karaoke microphones help mask the flaws, because they're full of echo and reverb. It's the audio equivalent of the soft-focus lenses they must have used on *Dynasty*, when it was time to make Joan Collins and Linda Evans look like dewy cantaloupes. Anybody sounds better with these microphones. But it goes much deeper than that. I can always sing to myself in the shower. We all can. So what is it about karaoke that we get together to share?

I guess that's one of the mysteries I keep coming here to understand better. We all sing to ourselves in the car or the elevator. It chills us out when we're scared, bored, lonely, doing the dishes.

We do it to tap into the elemental hum of the universe, as Wallace Stevens might have put it—he had his poetic vision of the whole earth as "a child that sings itself to sleep." But something different happens when we sing together.

That's why there's no predicting what kind of emotions are going to come out in the karaoke chamber. The night Teddy Pendergrass died, I sang "Turn Out the Lights" for him; the weekend Clarence Clemons died, we did "Tenth Avenue Freeze-Out." The night after we got the terrible news about the late great Adam Yauch, we couldn't find enough Beastie Boys songs in the book to satisfy us, so we dialed up songs they sampled—"Superfly," "When the Levee Breaks," "That Lady," "Stop That Train"—and tried to rap the MCA parts over them. It's the Irish wake tradition: singing them on their way. It's not the kind of emotion you expect to share in a place like this. But it happens.

Look close at a karaoke microphone sometime. Hold it up to the light. That thing is a disco ball, isn't it? All these glittery facets, each one beaming starlight around the room. That mirror ball on the business end of the microphone—you sing into it and every facet reflects you and the screaming audience in your head, as the mirror gets jammed up with all your friends. Sometimes you can feel like every voice that ever rocked your soul is flowing out of your lungs tonight and sweeping you along. Knowing me, knowing you? It's the best we can do.

TWENTY-FIVE

3:16 a.m.:

The Spirit of Radio

Rush fans have a word for them: Geddycorns. These are the ladies who love Rush, and they are called Geddycorns because they are rare and mythical creatures rarely witnessed with your own eyes. If you spot a female fan at a concert, you will have a story to tell. I have known a few Geddycorns in my life, and part of why they love Rush is being part of that male audience. A friend read my book *Talking to Girls About Duran Duran* and said the story of her life would be called *Talking to Boys About Rush*.

All my life, Rush has been emblematic of the kind of cultural phenomenon that only appeals to testicle-havers, but it's only in recent years that Rush have come to symbolize maleness itself. Although Rush have been around for more than forty years, they're more popular and beloved than ever, thanks to the documentary *Beyond the Lighted Stage*, which is constantly on VH1 Classic in the weekend-afternoon hangover slot. Everybody I know has watched this movie at least six times, whether

they like the band already or not. (It's pretty much impossible to watch it and *not* like the band.) Guitarist Alex Lifeson has the best line in the movie, on their fan base: "In the early stages, it was very young, almost one hundred percent male. And then, as the years went by, it remained one hundred percent male."

But what's changed is the way people relate to this band and everything it symbolizes in our culture. You might not be able to stand their music, but that no longer matters so much. Somehow, making sense of being a man has come to mean making sense of Rush.

Female Rush fans tend to have a touch of defensive pride, which is understandable. Among the ones I've known, quite a few grew up thinking Geddy Lee was a girl because of his glass-cutter high notes and androgynous name. The indie-rocker Juliana Hatfield once told me in an interview she learned to sing by imitating him—her first band in high school, the Squids, did covers like "Red Baretta." But the idea of Rush as a three-nozzled spray can of chick repellent is part of the band's mystique, as well as their stigma. In the movie *I Love You, Man*, Paul Rudd is trying to impress his fiancée with his ability to bond with other men. So what does that mean? He has to learn to rock out on the bass to "Tom Sawyer" with his bro.

If you find manhood mysterious, the odds are that you will also find Rush mysterious. But you will find both of them pretty mysterious if you approach them with any kind of honesty. (And after all, isn't it really just a question of your honesty? Yeah. Your honesty.)

These days, my main connection to Rush is the fact that my

wife is a fan, ever since she heard "The Trees" was on the Rock Band video game. We like to sing "The Spirit of Radio" at the karaoke bar. But her main jam is "Free Will." And every time it comes on the car radio, as I indulge her by not changing the station, I marvel at the fact that Rush has turned into a band I have learned to embrace because of the woman in my life. How did that happen?

IT WAS A WOMAN WHO introduced me to Rush: Miss Blake, my sixth-grade music teacher at Pierce Elementary School. The seventies, obviously. A typical 1978 suburban public school scenario—we studied *2112* in music class, while in English, we spent the whole year studying *Lord of the Rings*. Our teacher believed that spending the golden hours of our childhood frolicking through the Shire with orcs and hobbits would make us peace-loving members of an agrarian future society. Instead, it gave me a lifelong grudge against wizards.

Miss Blake always seemed so mild-mannered, with her corduroy smocks and beaded necklaces and straight black hair. I never thought of her (or any teacher) as a rock & roller. She usually brought in classical records. But one week, she happened to ask, "Has anyone heard of a band called Rush?"

To my surprise, I was the only kid who raised a hand, and even then I'd never heard their actual music: I'd seen the newspaper ad for their latest album, *A Farewell to Kings*. I was intrigued by how dangerous the band members looked on the album cover, which probably gives an idea of how dangerous *I* was. The name Rush was also associated with a drug the older kids smuggled

into school—bottles of amyl nitrate with a lightning bolt and the word RUSH on the label. So I assumed their music was scary-older-dude stuff, full of drugs and the occult.

We spent all afternoon listening as Miss Blake taught us to appreciate the "rock opera" format by playing us *2112*. These songs had a plot, about a future society where music is banned and Geddy Lee defies the elders by learning to play guitar. His squeak-of-the-damned voice made the whole class giggle, as Miss Blake talked us through the libretto and explained the symbol-ism in "Temples of Syrinx."

I heard tons of Rush in my college dorm, because we all lis-tened to the local rock station WPLR, which apparently stood for "Plays Lotsa Rush." My Rush friend (every North American male has a "Rush friend") was Arun, now a neurosurgeon. He explained (Rush fans love explaining things) how the drummer Neil Peart wrote the lyrics, even though bassist Geddy Lee was the one who sang them. Arun could elaborate the Rush phi-losophy, with the individual's struggle to choose free will in a conform-or-be-cast-out world. Over the years he has kept me up to date on how Rush have revised their philosophy, as their ideas keep changing in response to a world where changes aren't per-manent, but change is.

I was officially opposed to Rush at the time, so I enjoyed goad-ing him about the band's flaws. In all these friendly arguments, I developed a real affection for the band, as well as an admiration for their devotees, so I guess I was a casual fan. But casual Rush fans do not really count in the grand scheme of things. Real Rush fans are the hard-core believers, one of the most doggedly loyal

audiences in the business. And then there are the people who hate Rush just as passionately, who for lack of a better collective noun we can call "the rest of the world." The singular thing about Rush isn't how beloved they are. It's how hated they are.

ARE RUSH THE MOST HATED band of all time? The answer is simple: yes. (Not the band Yes, although they're in the top twenty.) Rush are easily, beyond any rational dispute, the most intensely despised rock band who ever existed. Women famously hate Rush, but most men have hated them just a little less fervently. In a way, that hatred is as impressive as the loyalty of their fans. Hating Rush was a blast. These days I like Rush a lot, but I miss hating them. We will never agree on anything the way we agreed on Rush.

Rush are not so hated these days, because of *Beyond the Lighted Stage*, which has to be one of the best rockumentaries ever made. The band members are extremely lovable in this film—lifelong friends who never argue about anything except the keyboard solos. (Apparently certain members of Rush are the only people on earth who think Rush *should* have keyboard solos.)

They're also up front about their lack of appeal to any female audience. Even when they pack a stadium full of fans, the clitoris count will be in single digits. The only person in the movie who mentions sex is Gene Simmons. He tells stories about the seventies, when everybody else was chasing groupies ("you could even be an ugly bastard like me and get laid!") while the Rush guys went back to the hotel to read books.

So how did these huggable schlubs get so widely detested?

Blame it on the radio. In a saner world, Rush would have stayed a cult band; they could have kept stoking their quirks for their sizable cult audience, while normal people just ignored them. That's what King Crimson did; it's what Gentle Giant did. It's what all the other bands like Rush did. But it was not possible for normal people to ignore Rush, because the radio was shoving them down people's throats.

For reasons that remain murky, they got constant airplay, way out of proportion to their actual record sales. The details of how this happened are lost in the history of glittering prizes and endless compromises, but somehow, Rush snagged some kind of sweetheart deal where they became one of corporate rock radio's flagship bands. So they got hyped on the airwaves on the same level as Journey or Styx or Genesis, bands that were much more popular and went down much smoother. And that created massive resentment among people who were not full-time Rush fans. There was a sense that Rush were getting forced on innocent bystanders.

At one point in the movie, Billy Corgan asks, "Why was this band marginalized?" That absurd question can only mean the guy never heard any rock radio back then. Anyone who was stuck in the suburbs can tell you it was impossible to get through an hour without getting strafed with "Tom Sawyer" or "Limelight" or "The Spirit of Radio."

All this overexposure was out of whack not just in terms of their actual popularity, but also in terms of their *potential* popularity. For better or worse, these guys weren't crowd-pleasers— they didn't fade into the background. Rush provoked a strong

reaction, which is why they generated such ill will. It wasn't Rush's fault. All these guys wanted to do was keep making cult music for their cult audience. But Rush came to symbolize everything oppressive about corporate radio.

Rush fans are admirably protective of their heroes and resent everything written or said about them. Despite all the cushy treatment the band got from broadcast media, Rush fans still feel picked on by the rest of the world. I hope (and assume) they will never give that up. Rush fans thrive on that sense of deprivation. It's like how Christians love the Jesus-fish symbol, so evocative of how early Christians were persecuted by the Roman Empire, despite the fact that Christianity has been running shit since the Roman Empire made it the official religion of the world in A.D. 312. Christians would rather feel oppressed than oppressive; that's why they decorate their cars with stickers that say "my boss is a Jewish carpenter" instead of "my boss is the Emperor Constantine," and that's why they like Jesus fish better than IN HOC SIGNO VINCES decals. Can you blame them?

But these days, nobody gets forced to hear Rush against their will, so there's no reason for anyone to resent the music. This changes everything. We are on our way to a world full of people who kinda-sorta like Rush, which might be the most tragic possible fate that could befall this band. When nobody hates Rush anymore, and it's sad to think the day could ever come, they will be undeniably less Rush-like than they were before.

ONE OF THE WEIRD THINGS about being a lifelong music fan is how you find yourself starting to enjoy music that used to feel oppressive.

My *Rolling Stone* colleague Alexis Sottile has brilliantly dubbed this "Rockholm Syndrome." After years of being held hostage by classic rock radio, you catch yourself drumming on the steering wheel and saying, "Hell yeah, Lynyrd Skynyrd," or "Wow, you're right—all in all, it *is* just another brick in the wall! Thanks, the radio!"

It's a post-adolescent phase most of us reach, after we get mature enough not to depend on music for all our self-validation. Your fandom gets less dogmatic, as you forgive the bands you used to hate. You might grow up resenting classic rock as The Man. But then you come down with a case of Rockholm Syndrome, and now when you hear "Melissa" in the car, you don't jam your middle finger into the preset buttons. Instead, you think, "Whoa, Gregg Allman. You catch a free ride on a freight train, then you complain each car looks the same? You are so *demanding*! How does Sweet Melissa put up with you?"

In its advanced stages, this can get ugly. For me, it means the shaggy hippie-burnout rock that I inexplicably began loving around the time I hit thirty-three and started buying Moby Grape and Quicksilver Messenger Service records. After years of anti–Grateful Dead hostility, I began musing about how the *Europe '72* lineup was superior to the two-drummer setup of *Blues for Allah* or *Wake of the Flood*. My teenage self would be horrified to learn I spend as much time listening to Jefferson Airplane as I do listening to the Jesus and Mary Chain.

But who ever thought it would happen with Rush? Not me. Ten years ago, I was in Toronto covering a music festival to benefit the city after the SARS epidemic. The big names at SARS-Stock were

the Rolling Stones, AC/DC, and Justin Timberlake, but there was no question who the heroes of the day were. There was an unbelievable surge in the crowd when Rush hit the stage, their first local appearance in years, and they began with "YYZ," their instrumental tribute to their hometown. (It's Toronto's airport code.) I was out in Downsview Park, amid half a million Canadians standing in a field, everybody playing air telegraph to the main riff, which Arun had explained to me years ago was Morse code for the letters YYZ. (He also explained why it was pronounced "Y Y Zed.") I never expected to feel so much joy in Rush's presence. For that matter, I never expected to see so many Canadians feeling such raw emotion.

"The Spirit of Radio" is in the karaoke book at Sing Sing, and it has gone from a once-a-year comedy pick to a regular staple. Everyone sings along, which wasn't the case a few years ago, and the openhearted pro-music sentiment of the lyric really comes across with multiple voices. (Also, it has the same guitar riff as Lou Reed's "Sweet Jane," plus the same lyrics as the Pet Shop Boys' "It's Alright." Never noticed before.) The modern machinery of the karaoke room brings out something undeniably personal in the song: emotional feedback on a timeless wavelength.

TWENTY-SIX

3:46 a.m.:

Ziggy Stardust

I am always amazed at the transformative powers of karaoke. A night of karaoke is just like Ovid's *Metamorphoses*, except with twice as much Stevie Nicks and 70 percent more Lionel Richie.

In all those ancient Greek and Roman myths Ovid writes about, people always get warped by engaging in unknown pleasures. One minute you're having sex with an ox, and then it turns out the ox was Zeus or Apollo or some other god in disguise. And now that you've had scrotal knowledge of a god, you get transformed into a tree, so that you may bloom forever beside a fragrant waterfall. A tragic fate, to be sure, but it has to beat sex with an actual ox.

In the karaoke universe, we can be whoever we want. We express ourselves by turning into colorful and disastrous parodies of pop stars who are already appalling parodies of human beings, and somehow that's how we end up as our most sincere version of ourselves. When you step into the song, you're not sure who you're going to be on the other side.

But first you have to get past "the guy."

An acquaintance with a fairly extensive drug habit once told me that when you're looking to score while traveling, any country you're in, you ask around for "the guy." Wherever you are, it always means the same guy. K-junkies are also dependent on "the guy," whether that's the bartender who programs the discs or the KJ who picks your song. But sometimes, the rock star whose song you're approaching is "the guy." You do the guy's song and you want to make the guy proud. You're not trying to out-sing him or her—you're just trying to pay a little respect, shine back a little of their light. You have to step to the guy if you want to *be* the guy.

For me, the guy is David Bowie.

I see Mr. Bowie as the patron saint of karaoke singers, because he had no business ever attempting to be a real vocalist. He had nothing special in the natural-talent department: He just decided to be somebody. Dozens of somebodies, and by listening and singing along, we can turn into those somebodies, too. So I always have to do "Ziggy Stardust" at least once per karaoke binge. It's my entrance antiphon, the opening hymn that returns me to my duties. Right in my tessitura. I sing my first song and turn into Ziggy. It's like the old AA saying: "You take the first drink, and then the first drink takes the second drink." Except I sing the first song and then Ziggy sings the second song. Which will probably be TLC's "Red Light Special," which means Chilli, T-Boz, or Left Eye will be picking out the song after that.

It's usually the one I end with, too. That final "Ziggy played guitaaaar" is like the moment when the priest says, "The mass

is ended, go in peace." Bowie understands how all that works—
how music is a place you go to explore the transmutations of
personality. I might be a total Ziggy Stardouche, but I can crash
Bowie's world and become a slinky vagabond, shaking my God-
given ass. No other rock star has made himself so easy to copy,
since he's just a copy of his own fantasies. For him, the pop
glamour of being somebody isn't something you earn: It's some-
thing you steal from all the other somebodies who've caught
your eye, whether it's Andy Warhol or Jimi Hendrix or Marlene
Dietrich or that girl you spotted in the ice-cream parlor, the one
who smiles at him while drinking her milk shake, not knowing
she was going to end up the star of his next song.

But it all starts for me with "Ziggy Stardust," just like it all
started there for Bowie. This was the song where he turned into
a real-life rock star, by pretending to be a fictional one. Pretend-
ing to be a singer was his first grand scam, the one from which
all the others followed. He makes it seem simple, because it is.
He's the only rock star who ever pretended to be from outer
space in order to seem *less* weird. "I don't want people looking
at me and thinking, 'I could do that,'" Oasis's Noel Gallagher
mused in 1996, at the height of his fame. "I want them thinking
'I could *never* do that.' When I was a kid I thought my pop-star
heroes came from outer space. I didn't think they were like me.
When I saw Bowie on *Top of the Pops*, I thought he came from
Mars. I was disappointed when I found out he was called Jones
and came from Battersea." I feel you, Noel.

"Ziggy Stardust" is the perfect Bowie theme song: a sex outlaw
too cool for this planet, in a tragic melodrama narrated by one of

his band members. (All of whom are nicer and smarter than he is. And better adjusted. And more talented. But not as cool.) This was the role that made Bowie a huge international icon, at a time when he was basically a forgotten one-hit chancer who'd scored a few years earlier, with "Space Oddity," and then disappeared. It's the last song he sang on the last concert of his last tour, in 2004. (After that, he basically retired until he surprised everyone with his excellent 2013 comeback album, *The Next Day*.)

It's always funny that for a rock artiste as gabby and articulate as Bowie, he's never been able to explain the plot of his big famous concept album. The closest he ever came was his *Rolling Stone* interview in 1973: "Ziggy is advised in a dream by the infinites to write the coming of a starman, so he writes 'Starman,' which is the first news of hope that the people have heard. So they latch onto it immediately. The starmen that he is talking about are called the infinites, and they are black-hole jumpers. Ziggy has been talking about this amazing spaceman who will be coming down to save the earth. They arrive somewhere in Greenwich Village." Translated into English, this means, "Drugs are fun!"

But it's not so hard to hear what's going on in this song, and most of Bowie's songs, which is that people look up into the sky for answers, which they have been doing for millions of years. "Ziggy Stardust" doesn't really tell us anything about Ziggy, just like "Starman" isn't really about the Starman—it's about the badly adjusted kids who hear him and get closer together as a result. I love the moment where the kids are talking about the "Starman" and one of them says, "Hey that's far out—so you heard him too?"

It's a story about the audience, which took not just real imagination for Bowie (who had basically *no* audience at this time) but real heart, too. He understood that the listeners were the stars, not them, and they were just tuned in to hear a tarted-out, glittered-up version of how they wanted to be.

That's part of the reason Bowie is the ultimate karaoke-friendly rock star: He understood how being a music fan means dreaming of being somebody else. He showed how easy it was to slip into other people's disguises—as Oscar Wilde would say, for him, "Insincerity is just a means by which we multiply our personalities."

ONE FUNDAMENTAL QUESTION I GET from David Bowie: Is singing for *women*? Is singing something women do? Is it something men also do, but *for* women? If you're a guy and you're singing karaoke, there are probably women in the room. It's more traditional as a girls' night out than a gang-of-dudes thing. Do women just like music more than men do, and sing it with more commitment, more passion, more realness? When you're a boy, do you have to fake a bit of that female realness in order to be anyone at all?

These are questions I've pondered all my life, which is probably one of the key reasons I turned out a Bowie freak. He was certainly the rock star who had the most fun pretending to be a girl. He brought out into the spotlight the gender-bending that was always part of rock & roll, going back way before Elvis showed up to his first audition in a pink suit or Jackie Wilson mastered the art of fainting onstage. If you watch the Marlon Brando biker

movie *The Wild One*, the movie that laid down the code of hypermasculinity for fifties kids like Bob Dylan and John Lennon, you see all the biker rebels rioting and brawling and looting. But it isn't long before they've broken into Mildred's Beauty Salon and started dressing up as girls. One of the bikers wears a mop on his head and says, "That Mildred gives the best perms!" It's amazing—rock & roll masculinity had existed for barely *forty-five minutes* before it was already turning into a drag show.

And it's stayed there ever since. In fact, if you're looking for a one-line description of a rock star, it could be "a boy who wears what women tell him to wear." This is rarely why a young boy dreams of being a rock star, but that's what the job is. A rock star sings like a girl, wiggles like a girl, emotes like a girl, wears whatever he found on his girlfriend's floor. (As Slash put it in his memoir, "We borrowed shit from chicks.") Boys are usually more comfortable when we're hiding behind machines, but a rock star lets his girlness hang out. Bowie didn't invent this. He just did it a little sluttier.

When listening to "Ziggy Stardust," it's strange to recall how glamour-starved his audience was. We like to imagine a seventies Bowie show as a glammed-out freakfest—it's certainly how Bowie wanted his fans to picture themselves. But when you see the amazing 1975 bootleg documentary *Cracked Actor*, it seems that most U.S. Bowie freaks were in fact bearded, long-haired kids in overalls, not looking so different from any other rock crowd. At one point, one zonked hippie kid in flannel and corduroys raves to the camera about Bowie's messianic power: "He's from his own universe! The Bowie universe!" The camera guy

asks if the kid is also from the Bowie universe. He replies, "No, I'm from Phoenix."

The glitter was all in their heads, because the Bowie school of glamour was a way of *perceiving* the world, not really dependent on dressing up at all. Bowie's glamour hit American kids the way potable water hit medieval peasants; they had no idea how thirsty they were. But he was even more thirsty for them. Bowie was desperate for these kids to like him. Even in 1973, a British reporter for *Melody Maker* was taken aback by how friendly and sincere he got when accosted by female fans. "They're the salt of the earth," Bowie says. "Those girls. They don't sit each night and compare notes of groups, criticizing lyrics, asking if it's valid. They just play the record—yeah, and maybe they dance. I love them. I love them dearly."

That comes across in songs like "Ziggy." Bowie aspired to make those girls dance. He kept singing about girls in space, and how the only way he had to communicate with them was making them dance. (He puts it honestly in "DJ," one of my favorite Bowie songs: "I got a girl out there, I suppose. I think she's dancing—what do I know?" It takes a rare rock star to admit he's wondering if the girls are dancing, and an even rarer one to admit he's too zonked out to know.) With Ziggy, he gave himself over totally to the dancing girls, and let himself go.

That's the mood I'm going for when I sing "Ziggy Stardust," even though it's usually just in a rent-by-the-hour room. The big ending—"Ziggy played guitaaaar!"—turns us all into David Bowie. It's not my voice, but it's a voice I can steal, a voice big enough to crawl into and disappear inside for a while.

TWENTY-SEVEN

3:55 a.m.:

About a Girl

Ally had her bachelorette party at Sing Sing. It was a month after the wedding, which was a shrewd move, and I was invited, which wasn't. Her girls got a big private room and gathered there at seven. My marching orders were to call at eleven and see if the party was still raging, but the bachelorettes weren't even close to the final countdown. They were mostly rocking the nineties jams—Nirvana, Hole, Snoop, Pixies, Liz Phair, Whitney, the Beasties. There were so many songs loaded up in the queue, by the time your pick rolled around you'd completely forgotten requesting it.

These bachelorette bacchantes showed no signs of slowing down until I stepped up to sing Alanis Morissette's "Ironic." That's when everybody said "look at the time" and started rummaging through the coat pile. I didn't even get up to the line about "ten thousand spoons when all you need is a knife" before the front desk abruptly switched the sound off. It was 4 a.m.

Some nights you plan ahead for an exit where everybody goes around and sings one last song, but that's a relative rarity. Other nights you all just abruptly run out of lung steam. This was one instance where the place was closing down and the staff wanted to go home. Sometimes they're friendly when they throw you out, knocking on the door to give you a few minutes warning, and sometimes they just cut off the equipment mid-verse. Only once a few years ago did they send the security guy in, and that was probably understandable considering we were on our third "Paradise City" in a row.

But the end comes too soon, and everybody wishes they had time or energy for a few more. You want to get one last song in, but there's always more you have lined up in your head, songs that you'll just have to save for next time. You have to trust there'll be a next time. You know there'll always be more songs to sing.

In September 2006 I asked Ally to marry me. I'd been biding my time while she finished up her dissertation and got her degree; she was back down in Charlottesville the summer before, deep in the lab. Back at home, I was plotting my own kind of endgame, because I wanted to spend my life with her but wanted to do this right. I didn't know how she felt about marriage. Maybe she was against it as an institution. We'd never discussed it. We'd often shared fond fantasies of what we'd do when we were old together, but for all I knew, she wanted to leave this to chance. While she was in Charlottesville wrapping up her graduate work, I was planning a strong and convincing pitch. As my friend Carrie urged me, "You have to give her a *story*." This was no time to be

half-assed. Pretending you arrived at things by coincidence and good intentions, bumbling into them without a plan: This is the way of tender-hearted, apple-cheeked youth. Pretending to do things by accident is what you do in your twenties. That pretense consumes a lot of your energy then. And it makes sense in your twenties, because it gives you a degree of plausible deniability in case you fuck it up or get fucked over. It gives you the Pee Wee Herman "I meant to do that" escape clause. But in your thirties, when you're confident about what you want, it's harder to talk yourself out of making the bold move that will help you get it. I had no desire to talk myself out of this at all. So I needed a plan.

Ally got her degree in August; we celebrated by going out in Charlottesville to Baja Bean's karaoke night, where she did Depeche Mode's "Master and Servant." A few weeks later we took our celebratory trip to Palm Springs, California. I had a ring in my bag, which I sweated over every step of the airport security process, every hour of the journey. On Saturday we drove up to Joshua Tree National Monument and stopped for lunch at a Del Taco in Desert Hot Springs. There was a sticker on Ally's french fries indicating she was a winner for a free burrito. The sticker proclaimed, TASTY NEWS! YOU'RE AN INSTANT WINNER!

We drove around in the desert, with the top down, basking in the afternoon sun, the welcoming waves of the yucca trees and chollas and ocotillos. We blasted the Sirius radio, switching back and forth between the Elvis station (it was "Soundtrack Saturday," this one dedicated to the music from Elvis's 1963 film *Fun in Acapulco*) and 1st Wave, the vintage new-wave station. Ally was relaxed; I wasn't. I was at the wheel, looking around

for the right place to execute my plan. I had a ring in my pocket. I was wearing a Yeah Yeah Yeahs T-shirt, with little *Y*'s all over it, which must have been an unconscious attempt to send a subliminal "yes" message.

We stopped and hiked a few trails, but none of them was secluded enough or serene enough. We climbed a hill, yet this wasn't a job to do on the side of a hill. There were a few hours to go before sundown, and it was still blazing hot, but I was sweating in agony. We rolled onto a dirt road through the Queen Valley and Morrissey came on the radio singing "Suedehead" and I knew this was the place. I pulled over and we walked to look at a particularly inviting Joshua tree, the gnarls of its branches reaching up into an infinitely blue sky at all kinds of skewed angles. We could see miles in all directions, all the way out to the snowcapped San Bernardino mountains, knowing we were the only human beings anywhere near here. The air was so silent we heard a desert raven flapping its wings as it slowly crossed the sky over our heads. The ring was still in my pocket and the soil was barely steady under my feet. The idea that I could still chicken out and put this off for another time throbbed in my brain. But there were so many yuccas and Joshua trees reaching up and spreading their arms to form a Y, we were wrapped in a million yesses. Five minutes later, the ring was no longer in my pocket, and all the trees seemed to be waving their arms in the joy of it all.

After an hour or so, we saw a dust cloud in the distance growing bigger. It was a park ranger who had spotted our stopped car. He just wanted to know if our car broke down or if we needed help; we didn't. We did the wedding fast, just three months later,

on December 30 (birthday of Michael Nesmith *and* Davy Jones). We had fun reviewing the candidates for our first wedding dance—"Heroes"? Too long. "There Is a Light That Never Goes Out"? Too somber. We went with the Jesus and Mary Chain's "Just Like Honey." And a month later was the bachelorette party, with Ally belting Nirvana's "About a Girl" to the break of dawn.

It feels strange to remember how I used to think it was too late for me. I thought I'd had my shot. Maybe I would be able to re-create some of the things in my life that had been lost, but the surprise, the urgency of being that happy would be gone for good. Now I have the experience of being a husband, at a different time, as an adult. And yet everything seems new. The experiences of marriage are still surprising for me, and while this means I am often confused about what the hell I'm doing, it means I'm continually awed by how different it is.

Trying to live in the past didn't work for me, and it's only now that I fully realize I'm incredibly lucky it didn't. Because it would have been all too sad to miss out on right now. That would have turned the past into a fraud. It would have meant all my happy memories were a lie. It would have meant all that time and all that love was a waste, leading up to a wasted future. It would have been the ultimate betrayal of everything I thought my whole life was about and everyone I cared about. All the people who loved me, in all the times and places of my life—all the people who made a lover out of me—they would have all been wrong about me. And it could have happened easily, just like that. It's scary to think of how I could have gotten stuck pining for the past. I was lucky to get a second chance. I thought I was too late, but it turns out I was just in time.

I have gone from feeling right at home in my twenties to feeling like I'm nowhere at all, and then back to feeling at home, but a totally different home. So I love with a different heart. I'm a different person in a different place. Like a record, baby, right round round round. A second chance is more than anyone deserves, but a second chance is what I have. Many people get to this place, via death or divorce, and none of us exactly *planned* to get here, but here we are.

Ally and I have made our home together. We love it here in Greenpoint, the place where Polish dudes in convertibles pull over to try to pick up Ally in the mother tongue. I don't speak Polish, but I'm pretty sure they're saying, "Is this skinny Irish dude bothering you?"

We love everything about this place. The neighborhood even has a record store where the clerks still have that hilariously unreconstructed old-school "your taste sucks" attitude. I love that. I never thought I'd miss that aspect of record stores, but now it makes me all gooey and sentimental, even when it's directed at me. These days, encountering record clerks like this in real life is like meeting a butler who says "Very good, sir," or a criminal henchman named Rocko. Let me share some verbatim dialogue from my local record store. Me: "Where do you keep the James Brown albums?" The clerk: "Yeah, we're not that kind of record store." Verbatim! Once upon a time this would have infuriated me. Now it makes me feel excited, like I'm a little kid visiting the Indie World exhibit at Epcot.

By now Ally's been here almost as long as I have. We've been here long enough to see the deli around the corner go from Lucky

Seven to Beer Mania to Kestane Kebab. We run into friendly people everywhere, including people who drifted up from Virginia; my first set of neighbors in Brooklyn heard my voice through the walls and recognized it as one they'd heard on the radio in Charlottesville. In retrospect I know that my previous failed attempt at making a home for myself was my fault, not that neighborhood's. I guess that place was a crate I packed myself into so I could mail myself to a saner, safer moment in the future. And I guess this is it. Ally and I have made a crate full of memories here. We have heard a lot of music here, seen a lot of bands. We make new memories in new songs. We hear the old songs and we tell each other stories about places we've been and strange things we've seen. All those people, all those lives, where are they now? They're in us and here we are.

IF ALL MUSIC DID WAS bring the past alive, that would be fine. You can hide away in music and let it recapture memories of things that used to be. But music is greedy and it wants more of your heart than that. It demands the future, your future. Music wants the rest of your life. So you can't rest easy. At any moment, a song can come out of nowhere to shake you up, jump-start your emotions, ruin your life.

You might be tempted to feel it's too late for you. But ultimately, that's what karaoke is there to remind us. It's *never* too late to let a song ruin your life.

Acknowledgments

Writing a book is a journey, and as they say, a journey of a thousand miles begins with one step. Then another step. Then about twenty minutes of sitting on the ground saying, "Steps suck. Where's the bus?" The point is, journeys are complicated and friends are the best. So thank you to everybody who has helped me.

My genius editor Carrie Thornton kept inspiring me to sing my life with her unbounded brilliance. My genius agent Daniel Greenberg brought all the relentless energy he exhibits while air-drumming along with *Sticky Fingers*. Thanks to all the great people at It Books, especially Cal Morgan, Kevin Callahan, Michael Barrs, Shannon Donnelly, Heidi Metcalfe, Tina Andreadis, Brittany Hamblin, Shannon Plunkett, and Jarrod Taylor. Thanks as well to Brian Tart, Phil Budnick, Amanda Walker, Christine Ball, Carrie Swetonic, Jay Sones, Monika Verma, Gregg Kulick, and everyone at Levine Greenberg.

Gavin Edwards read countless drafts of this book with all the wisdom, cheer, and patience he brings to listening to me sing "Hot Legs." He is the Freddie Mercury in the "Under Pressure" duet of my life. Thanks, Gavin.

One of the smartest moves I made as a young lad was picking Joe Levy as my hero. I'm always aiming to make him glad he

taught me to write. He offered sage advice on every line of this book and helped keep me sane, as he always has. Thanks, Joe.

Gratitude to all my comrades in song, especially Caryn Ganz, queen of noise. Nils Bernstein, for the rebellious jukebox in his soul. Jennie Boddy, for endless love as well as "Endless Love." Marc Weidenbaum, for the ukelele. My friend, brother, and teacher Joe Gross, for knowing what to do. Jenny Eliscu, for the night we did "Let Me Blow Ya Mind." Melissa Eltringham, for the night we did "Dim All the Lights." Chuck Klosterman, who beats the drums of my brainpan like Alex Van Halen attacking a flaming gong.

My colleagues at *Rolling Stone*, past and present, are always an inspiration. Will Dana is both the Donald Fagen and the Walter Becker of magazine editors, and writing for him is a countdown to ecstasy. Sean Woods is the man. Alison Weinflash has profoundly influenced my thinking about Rush and much else. (Including the fact that David Coverdale had a brunette period. Don't even.) Andy Greene combines endless erudition with endless curiosity, which in his case adds up to endless wisdom. Thanks to Bill Crandall, Alexis Sottile, Christian Hoard, Jon Dolan, Simon Vozick-Levinson, Monica Herrera, Nathan Brackett, Brian Hiatt, Jonathan Ringen, Josh Eels, Coco McPherson, Jonah Weiner, Tom Walsh, John Dioso, Eric Bates, Gaylord Fields, Marielle Anas, and David Fricke. Very special thanks, as always, to Jann Wenner.

Thanks to Jim Steinman for writing "Total Eclipse of the Heart." Thanks to Bonnie Tyler for singing the hell out of it. And that guy in the video with the glowing eyeballs. You frighten me.

But thank you. Rebecca Odes and Craig Marks for "99 Luftballons" in 2001. Alex Pappademas for singing "No Scrubs" at the same party. Everyone from Rock 'n' Roll Fantasy Camp, especially David Fishof, Ed Hill, and my bandmates in the Unfair Advantage. And the long-suffering yet impeccably professional staff of Sing Sing.

For checking my head in a thousand ways, I embrace Matthew Perpetua, Darcey Steinke, Kevin O'Donnell, Sean Howe, Chris Molanphy, Evie Nagy, Jeffrey Stock, Allison Frank, Sasha Frere-Jones, Tanya Selvaratnam, Sarah Durham Wilson (of Daily Do It Girl), Jen Sudul Edwards (for "White Rabbit"), Lizzy Goodman (I knew you were trouble when you walked in), Doree Shafrir, Niki Kanodia, Maria Sherman, Caryn Palmieri, Douglas A. Martin, Asif Ahmed, Bill Tipper, Michaelangelo Matos, Melissa Maerz, Phil Dellio, Julie Klausner, Ed Park, Nick Catucci, Andrew Beaujon (for his trenchant commentary on Rod Stewart), Brian Raftery (for his excellent and informative history Don't Stop Believin'), Jonathan Lethem (did you read his Talking Heads book? holy crap), Robert Grossman (for "Highway to Hell"), Dr. Liz Leininger (for dropping frog science), Arun Amar, Alfred Soto, Mark Oppenheimer, Thomas Inskeep, Anna Mello, Mr. James Hejduk, Radha Metro, Stephanie Bird, Phil LaMarr, Katherine Profeta, Dan Snierson, Andrew Jaffe, John Gould, Marc Spitz, Sarah Grant, Tom Nawrocki, Laura Larson (she is the champions), Caitlin Wittlif, Rebecca Keith, Melissa Febos, Marisa and Dave Bettencourt, Ellen Carney White, Karen Spirito Augustyn, Stephanie Wells, Bernie Kaminski, Hilary Spiegelman, Amanda Verdon, Isabelle George Rosett, everybody at WTJU, everybody

at Enid's (where they like *Sandinista!* even more than I do), plus Tyler Magill ("cows are the silent jury in the trial of mankind"), Adam Busch, and Josh Krahn for letting me sing onstage with them at Tokyo Rose in the spring of 2000.

Robert Christgau and Greil Marcus, the greatest rock critics ever, must get weary of being mentioned in the same sentence so often but I guess that's the price of being the greatest ever at something. They were the ones who made me want to write about music and all these years later they're still the best. What a stroke of luck to discover their words at a young age.

Thanks to the gentlemen of Duran Duran: Simon Le Bon, Nick Rhodes, John Taylor, Roger Taylor, as well as Wendy Laister and Katy Krassner. The Beta Band, for giving me my opening line with "The Hard One." Taylor Swift, for turning my nieces into guitarists and songwriters. The Brazilian guy sitting two tables behind me in the coffee shop who "couldn't help" noticing I was typing about Neil Peart and spent twenty minutes telling me how many times he's seen Rush. You epitomize that which is awesome in all of us. And Spandau Ballet, for urging me to take my seaside arms and write the next line.

Since the topic of alcohol comes up a time or two in these pages, a salute to my sober karaoke commandos for always putting the "riot" in "sobriety."

Musicians are the greatest. Thanks to everyone who strums a guitar, bangs a drum, toots a horn, licks a flute, bothers a piano, presses record on a boombox. Thanks to every DJ who played that song that time and every band who demolished that room and every scribe who spread the word and every fan who showed up and shut their phone off and felt the noise. Like Joe Strummer

used to say, we are the Clash. Silence is the bad guy and silence is gonna lose.

R.I.P. Adam Yauch, Teddy Pendergrass, Luther Vandross, Eugene Record, Poly Styrene, Alex Chilton, Davy Jones, Donna Summer—so many of the great voices I breathe in whenever I sing their songs. R.I.P. lots of cool people. Nobody's forgotten you, trust me. R.I.P. Teena Marie and thanks for "Lovergirl."

My deepest gratitude and love goes to my family. This book is dedicated to the three women who made me lucky: Ann Sheffield, Tracey Mackey, and Caroline Hanlon. My sisters were the first voices I ever sang with. I always hear their voices in my head and carry them in my heart. There is nobody else in the world like them, not even their rock-star daughters, and I thank them for their awe-inspiring love and support and patience. Thanks to my beloved mom and dad, Mary and Bob Sheffield, for giving me my sisters and the rest of the world. Thanks to Charlie, Sarah, Allison, David, and Bryant Mackey; Sydney, Jack, Maggie, Mallory, and John Hanlon; John Grub; Drema Gross; Buddy and Nadine Crist; all the Twomeys, Sheffields, Durfers, Govers, Courtneys and the rest of my family. Thanks to Donna Needham for "Super Trouper." Thanks to Sean, Jake and Joe Needham; Jonathan, Karianne, Ashley and Amber Polak; Tony and Shirley Viera.

Most of all, thanks to Ally, my favorite thing about the universe, for inspiring me, for never getting tired of watching the "Church of the Poison Mind" video, for sharing this planet and its music with me forever. I just wanna be your lovergirl. I just wanna rock your world.

ABOUT THE AUTHOR

Rob Sheffield is a columnist for *Rolling Stone*, where he has been writing about music, TV, and pop culture since 1997. He is the author of two national bestsellers, *Love Is a Mix Tape: Love and Loss, One Song at a Time* and *Talking To Girls About Duran Duran: One Young Man's Quest for True Love and a Cooler Haircut.* He also appears regularly on VH1. He lives with his wife in Brooklyn.